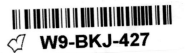

THE PASTEL BOOK

THE PASTEL BOOK

Materials and Techniques for Today's Artist

BILL CREEVY

WATSON-GUPTILL PUBLICATIONS/NEW YORK

After receiving his M.F.A. degree from Louisiana State University in 1968, BILL CREEVY was awarded a Max Beckmann Scholarship to study at the Brooklyn Museum Art School, where he later became a member of the faculty. He started experimenting with pastels just for fun, and eventually they became his favorite medium—partly because he finds them ideal for working from the imagination.

Creevy is a Master Pastelist of the Pastel Society of America. He has given several one-man shows, and his work has received awards in many prestigious national and international juried shows as well. His pastel paintings have also been featured in several magazine articles and appear in numerous public, corporate, and private collections. He is listed in *Who's Who in American Art*.

In writing this book I had lots of help from my friends, and I really appreciated it. So thanks to Bob, Ellen, Christy, Emily, Jack, Rallou, and Steve, and especially to Rosemarie and Dennis.

I'd also like to thank Diane Tuckman, Richard Frumess, and Pierre Yann Guidetti for sharing their knowledge of pastels with me.

Finally, I'm particularly grateful for the collaboration of Candace Raney, Janet Frick, Areta Buk, and Ellen Greene. Their outstanding professional skill, clarity, style, and intelligence brought the many aspects of this book together in a truly unique way.

Art on first page:
TWO ATOMIZERS
Pastel on paper, 8 × 8" (20 × 20 cm).
Collection of R. and M. Kellner.

Art on title page:
Photograph by Tom Haynes.

Art on opposite page:
GULFSTREAM
Pastel on paper, 8 1/2 × 28" (22 x 71 cm).
Collection of James and Suzy Goldman.

Copyright ©1991 Bill Creevy

First published in 1991 in the United States by Watson-Guptill Publications, a division of BPI Communications, Inc., 1515 Broadway, New York, NY 10036

Library of Congress Cataloging-in-Publication Data

Creevy, Bill
 The pastel book : materials and techniques for today's artist / Bill Creevy.
 p. cm.
 Includes index.
 ISBN 0-8230-3905-6
 1. Pastel drawing—Technique. 2. Artists' materials. I. Title.
 NC880.C74 1991
 741.2'35—dc20 90-49248
 CIP

Manufactured in Malaysia

First paperback printing, 1999

2 3 4 5 6 / 04 03 02 01 00

This book is dedicated to the memory of my father, William C. Creevy,
who spent so much of his spare time with me, especially when it mattered the most.
Although he probably didn't know it, he gave me the best training
an artist could ever have: a long and happy childhood.

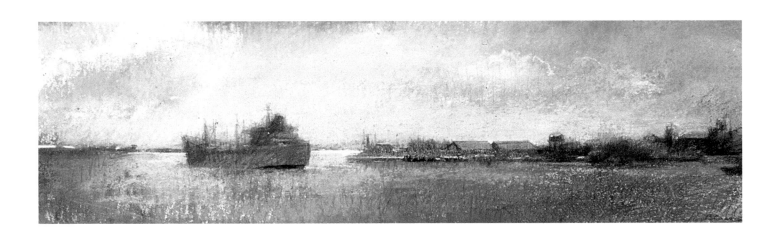

CONTENTS

INTRODUCTION

The essence of pastels is the aesthetic experience of drawing with color. If you love drawing—or if you love pure, vivid colors—you will love working in pastels.

I myself love to draw. I have learned that drawing is essential to my development as an artist, the key that unlocks my creative ideas and releases those undefinable flights of imagination that ultimately lead to paintings. I am always amazed that what begins as a mere doodle can eventually lead to a fully resolved painting.

This book will help you approach pastel painting in your own way, to achieve your own personal artistic goals. Pastels are a highly responsive medium, ideal for the artist whose ideas must be executed as soon as possible. With pastels it is possible to put down our ideas and images almost as fast as we conceive them. This quality of immediacy often brings a freshness to our work that is difficult to capture in slower mediums. This is also why pastels are the perfect medium for artistic self-discovery and personal insight.

An artist working in pastels is very much like a young child with a box of crayons: We can simply jump into a drawing without the hassles of opening and closing tubes of paint, mixing colors on a palette, or constantly cleaning off wet brushes. Instead we can proceed immediately to the real business of getting our paintings finished. Just open up a box of pastels, clip a piece of paper to a drawing board, and you're ready to go to work—and the work, once executed, may quite possibly be as complete and well rounded as an oil painting.

Despite the simplicity of pastels, many artists find them difficult to work with at first. Sometimes the artist simply needs more experience, but sometimes it's just a matter of finding the right technique or kind of pastel or tool to make pastels do what you want them to do. That's why this book has made every effort to explore a wide variety of techniques and materials: to help you find just what you're looking for, so that you can make your pastels do exactly what you want.

When you buy a box of pastels from the art supply store, it does not have a list of instructions printed on it. The assumption is that each artist should be the best judge of what to do with these wonderful, beautiful sticks of pure color. Nonetheless some guidelines are useful, especially to the artist new to pastels.

The techniques and procedures in this book demonstrate a variety of ways of working in each of the major pastel groupings: chalk pastels, oil pastels, and oil sticks. These methods are certainly not intended as strict rules; in fact, in many instances, the steps can be done in a different sequence from that shown here. Fortunately there are no rules to pastel painting—just possibilities to explore. I hope you will think of the methods and procedures presented in this book as a buffet from which you can sample a variety of ideas and techniques, experimenting with those you like and making them your own. Be my guest and help yourself!

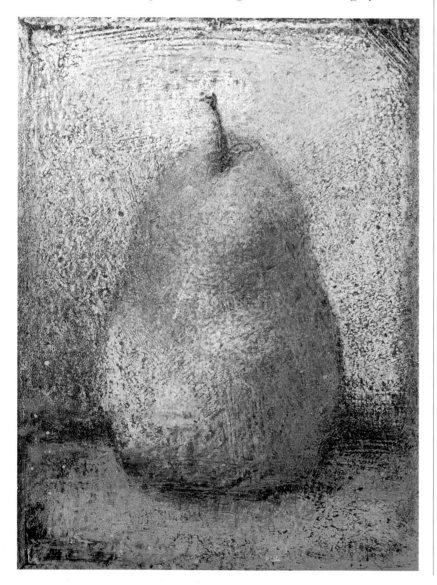

PEAR
Oil pastel on wood,
6 × 4 ½" (15 × 11 cm).
Collection of David
Mowery.

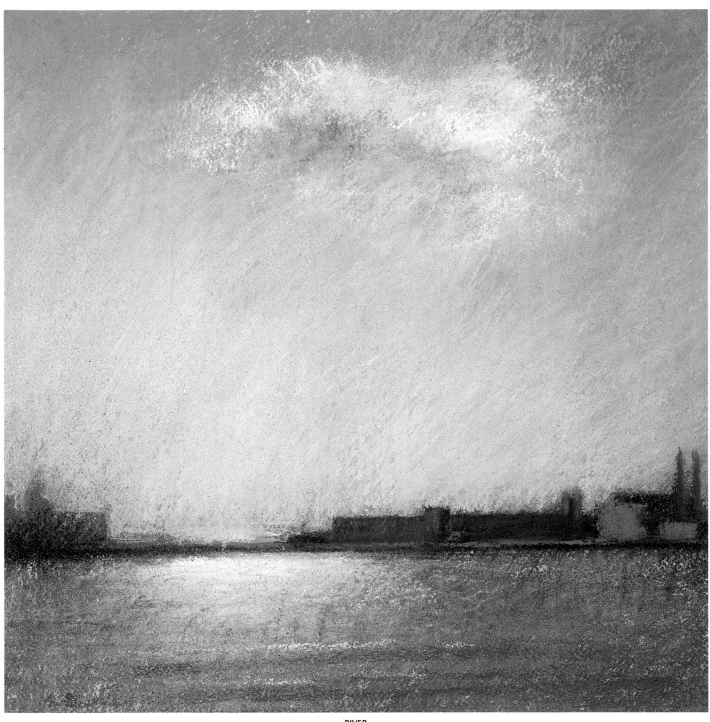

RIVER
Pastel on paper,
12 × 12" (30 × 30 cm).
Collection R. and
M. Kellner.

MATERIALS AND TOOLS

Today's pastelist has easy access to an overwhelming number of materials and tools. These include the pastel mediums themselves, the papers and other supports onto which they are drawn and painted, and the accessory tools needed to achieve a variety of textures and special effects with them. A basic familiarity with these pastel materials will be useful to you before we go on to discuss the many ways they can be used.

This chapter is an overview of the pastel world as it now exists. We will look into the more popular and respected brands that are readily available, as well as some that are brand-new and rare but of extremely high quality. This survey is by no means totally comprehensive, because the immense world of artist's materials is always changing and growing.

Pastels have evolved into three major groups: traditional or chalk pastels, which include both soft and hard pastels; oil pastels; and oil sticks. All three groups are basically color in a stick form, with which the artist can draw and paint simultaneously. Some artists define pastels in a stricter sense, to mean hard and soft chalk pastels only. But in this book I'm taking a broader approach, because I believe that the conventional and the experimental can happily coexist side by side.

I hope this chapter will acquaint you with some of your artistic options—and inspire you to continue exploring others on your own.

Soft Pastels

Soft pastels are pastels in their most basic form—what most people picture when they think of pastels. They are usually made with a combination of gum tragacanth, pigment, and precipitated chalk or clay. Soft pastels are generally thicker than hard pastels, varying in length from 2 to 6 inches (5 to 15 cm). Some brands are cylindrical, while others have square tips and flat edges.

Soft pastels are water-soluble, very soft in texture, generous in their application of color, and easily smeared. Commercially they are available in sets of hundreds of colors, more than any of the other pastel mediums discussed in this book.

Because of their fragility, soft pastels usually come in a paper wrapper that holds the pastel together and simultaneously identifies the brand of color.

Sennelier

If any pastel can be considered the Rolls Royce of the pastel world it would have to be Sennelier. In fact, Sennelier's logo representing the crowns of the kings of France is meant to represent a tradition of quality and excellence on the highest order. Sennelier pastels have been made in France by the same family for three generations. The Sennelier firm was founded in Paris by Gustave Sennelier in 1887, across the Seine from the Louvre and near the Ecole des Beaux-Arts de Paris. From its beginning the firm has devoted itself to the manufacture of high-quality products for the fine artist.

In the early 1920s Gustave Sennelier and his son Henri, a chemical engineer, undertook to develop a supreme line of high-quality soft pastels. After several years they developed a selection of 700 colors. Over time this original selection was whittled down to the current range of 525 colors, still the world's largest selection of pastels.

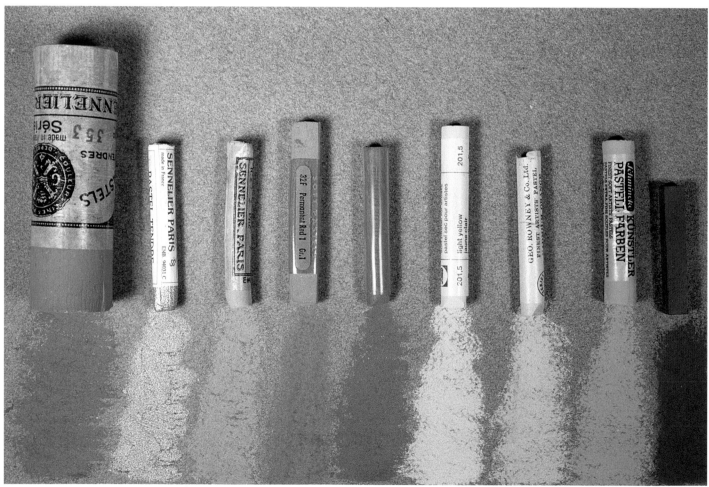

SOFT PASTELS. From left to right: giant Sennelier, iridescent Sennelier, standard Sennelier, Grumbacher, Quentin de la Tour (Girault), Rembrandt, Rowney, Schmincke, and Holbein.

SENNELIER SOFT PASTELS

Sennelier's approach to pastel making has always been the same: to use only natural products and to make pastels carefully and slowly, with most of the process done by hand, just as they did 70 years ago. The special molds designed by Sennelier do not compress the pastel paste too tightly but instead allow it to "breathe" or aerate. Afterward the individual pastels are allowed to dry slowly for a minimum of 15 days before being wrapped by hand in the distinctive paper sleeves.

Even though based on tradition, the Sennelier pastels have also steadily kept up with the changing times. The pigments and binders used, while never synthetic, have nonetheless recently been adjusted to conform to new legislation governing toxicity. The color selections of Sennelier's smaller sets of pastels are always made in collaboration with working pastelists

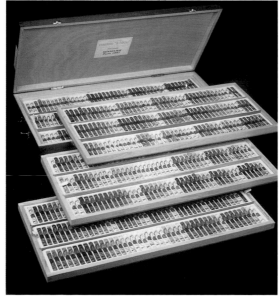

COMPLETE SENNELIER SET OF 525 SOFT PASTEL COLORS
(Photo courtesy of Sennelier)

who have indicated their preferences for certain colors. Thus today Sennelier has 13 individual boxed wooden sets of soft pastels, many keyed for specific types of work. For example, in addition to the usual sets for landscapes and portraiture, there are now selections for seascapes and florals. But the most impressive pastel set of all contains Sennelier's entire 525-color range. With several removable wooden trays of hues with their tints and shades, this handsome boxed set will impress anyone.

IRIDESCENT SENNELIER SOFT PASTELS

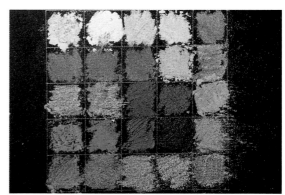

COLOR CHART OF IRIDESCENT SENNELIER SOFT PASTELS

New Products. As if this weren't enough, Sennelier is always adding new products to its pastel line. For example, one recent addition is a line of iridescent soft pastels. These new metallic and iridescent shades are much like Sennelier's famous set of iridescent oil pastels, which had been released several years earlier. Both kinds of iridescent pastels contain many of the same colors, but the oil pastels are more pearlescent, while the soft pastels are more metallic and more like earth colors. The iridescent pastels come in boxed wooden sets of 25 colors each (either soft pastels or oil pastels) and are more widely available than most other brands of iridescent and metallic pastels.

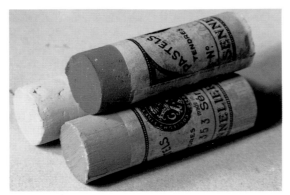

GIANT SENNELIER SOFT PASTELS

Since 1986 Sennelier has also developed a line of giant soft pastels designed to cover large areas. These come in 44 colors and are available in boxed sets of 16 colors. These unique large pastels will revolutionize the technique of pastel painting like nothing else before them. Although designed to cover large areas, they can also provide bold and luscious strokes of broken color when used in scumbling techniques on rough paper. The giant Sennelier pastels are soft and smooth to work with but not fragile or brittle. There is little opportunity to be fussy or picky while working with giant Senneliers. Their size, beauty, and weight lend themselves to a bolder, more painterly approach.

Painting with Senneliers, a pastelist can truly appreciate the meaning of the word "soft" in soft pastels. The pastels are so soft that the color goes down with almost no resistance. Even after many layers of color, you can still build up a smooth, even coat of pastel—especially with the giant pastels, which seem to have an almost endless supply of color. Sennelier soft pastels work best for cross-hatching, so that their soft tips are worked directly on the paper. Almost all the colors go down smooth and creamy.

Certain problems occur with Sennelier because of their softness. Some artists complain that Senneliers are *too* soft, so that they sometimes disintegrate as the paper sleeve is pulled away, and the small fragments are too soft to be used. Also, some artists find the standard Sennelier sticks too small to be used for broad side strokes or scumbling techniques. Both shortcomings are easily solved by using the giant pastels. These larger pastels seem somewhat stronger than the smaller ones; they certainly feel denser and do not easily disintegrate as one works with them.

Finally, it should be noted that Sennelier is truly a professional artist's material, and its price reflects its quality and attention to craftsmanship. For this reason Sennelier may not be the best choice for the beginning student. But on the other hand, because Sennelier offers 13 beautifully crafted pastel sets, there is a set to fit anyone's budget. Even a beginner can very quickly fall in love with pastel painting when working with such high-quality materials as Sennelier soft pastels.

QUENTIN DE LA TOUR (GIRAULT)

Girault is another famous handmade pastel that comes to us from France. Today Girault pastels are known as Quentin de la Tour, distributed by LeFranc and Bourgeois. But it is still the same pastel and is still handmade like the older Giraults: one stick at a time.

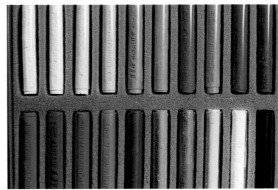

QUENTIN DE LA TOUR SOFT PASTELS

Girault has a full range of 320 colors, which makes it second only to Sennelier in the overall quantity of individual colors. All 320 colors are available in a deluxe wooden-boxed set. There are also four small sets of 20 colors each: one for bright colors, one for dark colors, one for landscape, and one for portraiture. Intermediate-size sets contain 80 or 120 colors.

Quentin de la Tour has a unique consistency somewhere between soft and hard: very firm but still soft. It is not as fragile and creamy as a Sennelier or a Schmincke, but not as hard as a Conté or a NuPastel. Quentin de la Tour pastels do not break easily; in fact, the older Giraults came unwrapped without a paper sleeve. Each color's number is embossed into the pastel itself rather than printed on the sleeve. Because these pastels are denser and firmer than most soft pastels, you can hold a bunch of them in your hand while you work without making a mess.

The new Quentin de la Tour pastels come encased in a firm, transparent plastic sleeve that helps reduce dust and acts as a very clean pastel

holder as well. The shape of the Quentin de la Tour is long and thin—excellent for linear strokes or cross-hatching. But the main attribute of these pastels still remains the density and purity of their colors. The combination of firm strength and a large selection of high-quality colors makes Quentin de la Tour a wonderful soft pastel for any artist.

ROWNEY

Rowney soft pastels are manufactured in England by Daler-Rowney and come in a full range of 144 beautiful colors. The Rowney pastel stick is exactly the same size as the Quentin de la Tour, but it is much softer in texture and handling (yet not quite as soft as a Sennelier). A Rowney soft pastel is also a touch smaller in diameter than a Sennelier, which gives it a cleaner, trimmer feel and look. Because of this, Rowney is the perfect soft pastel to use for a more controlled, precise approach to pastel drawing. But Rowney works equally well for techniques that require broad and generous amounts of color.

The overall feel of Rowney's colors is light and tinted; this is true of both its saturated colors and its earth tones and grays. Because of this high selection of tints I find the Rowneys almost indispensable for passages that require careful rendering and blending. The quality and permanence of the Rowney pastels are so high that the Victoria and Albert Museum in London chose Rowney pastels to restore the color of their large-scale tapestry cartoons by Raphael.

Rowneys come packaged in a variety of 14 different sets containing 12, 24, 36, or 72 colors, either assorted or keyed to landscape or portraiture. The full range of 144 colors comes in a deluxe wooden-boxed set. Because of the narrow diameter of the Rowney pastel stick, it is best used by drawing with the end or tip rather

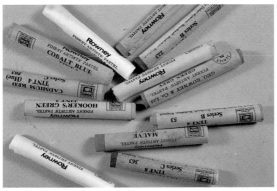

ROWNEY SOFT PASTELS

than the side. Side strokes are definitely easier with Rowney's set of 24 half-length broad sticks, which are wider and thicker.

REMBRANDT

Rembrandt soft pastels have been made in Holland since 1900 by Talens and are probably the best-selling brand of pastels today. This is not surprising since Rembrandts perfectly satisfy the needs of many pastelists on so many levels. First of all, the Rembrandt soft pastel is slightly larger than its European competitors, measuring $2^3/4$ inches (7 cm) in length and $3/8$ inch (1 cm) in diameter—exceeding Sennelier, Rowney, and Quentin de la Tour in length by $1/4$ inch (0.6 cm)—and perhaps equal only to Germany's Schmincke in volume. Many pastelists find

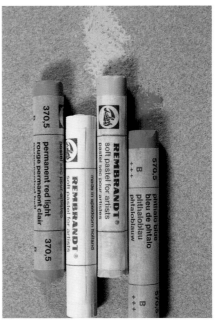

REMBRANDT SOFT PASTELS

this size ideal for drawing with the tips and ends, as well as for working the sides into significant broad strokes. There is a lot of mileage in the Rembrandt soft pastel.

The Rembrandt color range is another plus. It is suitable for many purposes, so that both professionals and students can satisfy their color needs somewhere within it. At the core of the Rembrandt system are 43 full-intensity hues with 41 additional shades heading toward black and 124 tints heading toward white. The total range is 208 colors, and it is available in a deluxe three-tiered wooden set of 225 sticks (which includes duplicates of a few colors most often used).

Rembrandt soft pastels are also very reasonably priced and available in 13 boxed sets, many keyed for portraiture or landscape. Some of these sets come in stiff cardboard boxes rather than wooden ones, which makes the Rembrandts even more affordable—especially for students or beginners who are looking for a starter set of pastels. Sets range in number from 15 pastels through 30, 45, 60, 90, 150, and 225. One particularly unique assortment of 30 half sticks is easy to carry and ideal for sketching or for beginning students. There is also an interesting set of 45 new colors that have recently been added to the Rembrandt range of soft pastels.

Rembrandts are extremely easy to work with. Their long, thick, round shape makes them excellent for drawing. When broken in half, their shape and the fine kaolin binder make for smooth, broad side strokes. Rembrandt soft pastels are strong and can take a lot of rough handling. They rarely arrive broken, and occasionally I have even seen one fall off the drawing table without breaking. They are also fine for dusting techniques that involve shaving off small particles of pastel with a razor blade.

For artists who like to work with soft pastels in a direct way without too many layers, or who don't want a large build-up of pigment, Rembrandt is an excellent choice. However, if you want to keep working layer upon layer, use fixative before applying the final layers.

GRUMBACHER

One distinctive thing about Grumbacher soft pastels is their shape. Grumbacher is one of the largest flat-edged soft pastels made in America today, measuring slightly under 3 inches (7.6 cm) long and almost 1/2 inch (1.3 cm) wide. This flat shape lends itself easily to working with very broad, open side strokes and filling in massive areas rather than line work and cross-hatching. Moreover, the hard-edged corners are ideal for those wonderfully unique pastel strokes that begin as lines and suddenly blossom into wide strokes with the flick of the wrist. Most artists who work with Grumbacher pastels like to build up large flat surfaces with side strokes and do linear work with the edges.

Grumbacher is also an extremely soft pastel and can therefore be worked up in many successive layers. Because of their extra soft texture and flat-edged design, Grumbacher pastels are excellent for scumbling and other

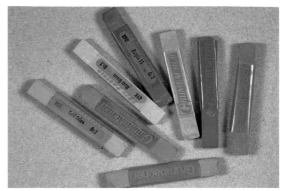

GRUMBACHER SOFT PASTELS

broken color techniques, especially on rough or sanded papers. They also work beautifully for dusting techniques that involve scraping off particles of pastel with a razor blade.

But the Grumbacher palette is perhaps the best reason for working with these pastels. Grumbacher's colors have a deep, rich, warm quality that seems unique to them. The lavenders, red-oranges, blue-grays, and indigos are particularly beautiful.

Grumbacher soft pastels come in a full professional range of over 300 colors, with smaller sets available.

SCHMINCKE

Schmincke pastels are large, round pastels that come to us from Germany and certainly rank very high as one of the leading brands of professional pastels in the world today. Schmincke pastels are very soft and come in the most gorgeous colors imaginable. These are the pastels to use when you are after thick, buttery coats of rich color and when no other brand quite seems to do the job. Schmincke never fails. Although I use many brands of soft pastel, Schmincke is probably my personal favorite.

SCHMINCKE SOFT PASTELS

At the core of the Schmincke color range is a selection of 54 hues plus white, black, and 11 neutral grays. Each basic hue has four variations: one darker shade and three successively lighter tints, so that each color is available in five shades. The entire range comes to 283 highly permanent colors, available in a deluxe wooden chest of drawers weighing over a hundred pounds. In this impressive pastel set there are three sticks each of the complete 283-color range, bringing the entire set up to 849 pastels. This is the largest pastel set in the world. Smaller sets of 15, 30, 45, 60, and 90 colors are also available. As with most pastel sets, many of Schmincke's are keyed to either portraiture or landscape.

Schmincke soft pastels are also slightly larger than most other brands. Approximately the same volume as Rembrandts, the round Schminckes have a wider diameter. This slightly chunkier weight makes Schmincke ideal for drawing wide, soft side strokes; this is what Schmincke does best. Of course Schmincke is not as big as the giant Sennelier soft pastel, or even the rare Arc-en-Ciel. But it offers a super-soft pastel at a great price and in 283 colors. Because of their softness, the individual Schmincke sticks do break very easily—but this is OK since the half-size sticks are easier to work with for most purposes anyway. Schmincke pastels do not readily disintegrate into powder, but hold together very well no matter how small they get.

The most significant quality of Schmincke soft pastels is their amazingly soft, even texture. Regardless of what color you're working with, Schmincke pastels sail across the paper with a velvety smoothness that makes it possible to build up many soft, opaque layers without getting the color muddy. They are also perfect for the final stages of a pastel painting with multiple layers preserved with fixative, or for rich and brilliant scumbling effects on rough paper. Only an extremely soft, buttery pastel such as Schmincke will do in these situations.

Unfortunately, in spite of their amazing beauty and high quality, Schmincke pastels are relatively hard to find. Fortunately the Daniel Smith catalog now offers the complete line of Schmincke pastels both individually and in sets, including the deluxe set. New York Central Art Supply also sells Schmincke pastels through its mail-order catalog in individual sticks only (no sets). See the List of Suppliers on page 172 for further information on these two distributors.

HOLBEIN

Holbein was already famous for its incredible line of oil pastels when it recently added soft pastels to its product list. These flat-edged pastels with square tips are made in Japan, and their quality is exceptionally high, thanks to Holbein's new technology and manufacturing techniques. Holbein's soft pastels are known for their permanence, beauty, and performance. The entire Holbein range is 144 colors, and full sets are available in either wooden or cardboard cases. There are also smaller sets of 12, 24, 36, 48, and 72 colors.

HOLBEIN SOFT PASTELS

Holbeins are slightly smaller than most soft pastels. All pigments are carefully selected, and each crayon is of equal hardness regardless of the pigment it contains. One unusual characteristic of Holbein soft pastels is that they come with no wrapper or markings of any sort. No sleeve is necessary because Holbeins are less likely to smear than most brands of soft pastels. Although they are not hard and they spread color smoothly and evenly, Holbeins somehow seem stronger, denser, and less breakable than most soft pastels. Their unique texture is not quite matched by any other brand.

The square shape of Holbein pastels makes them easy and fast to draw with. Working with the edges makes it possible to get very hard, crisp lines, while the tips and sides give smooth, even coverage for broader strokes. Even more importantly, Holbein soft pastels show an excellent choice of colors. What I find wonderful about Holbeins is the careful and accurate blending of shades and tints within a color's range. The even gradations of colors facilitate highly accurate blending and color mixing—a significant advantage for any pastelist, regardless of preferred subject matter.

HANDMADE SOFT PASTELS

Some pastelists are never quite satisfied with the commercially packaged brands of pastel. Maybe the colors are not exotic enough, the size is not right, or the consistency of the pastel sticks is too hard—or maybe the artist just wants something really novel and different. In such cases, handmade pastels are often the answer.

Although pastels are theoretically easy to make, many artists prefer not to bother with the trial and error necessary to get the right formulas for an entire palette of colors. Fortunately two wonderful brands of handmade pastels are commercially available in the United States: Arc-en-Ciel and Townsend. Both these kinds of handmade pastels are of such superb quality that once you try them you will probably find them indispensable.

ARC-EN-CIEL

Arc-en-Ciel (rainbow in French) is an extremely beautiful handmade soft pastel. The quality of its materials and its purity of rich color are perhaps the highest in the world. Arc-en-Ciel pastels are extremely soft, yet they do not easily crumble or break. Drawing with these buttery, smooth-textured pastels is like no other experience in pastel painting. The only problem with Arc-en-Ciel pastels is that they are extremely rare and somewhat expensive—certainly not the pastel for beginners. New York Central Art Supply is the exclusive distributor of these beautiful pastels.

Arc-en-Ciel pastels are slightly larger than most quality machine-made pastels, although still considerably smaller than the Sennelier giant pastels. Arc-en-Ciel comes in two sizes: extra large rectangular chunks that are approximately 1 1/2 × 1 × 3/4 inch (3.8 × 2.5 × 1.9 cm), or in long sticks that have a cylindrical shape and measure approximately 2 1/4 × 3/4 inch (5.7 × 1.9 cm). The larger rectangular Arc-en-Ciel pastels come in 164 colors (including shades and tints), while the long sticks come in 106 colors. Prices vary according to the pigments used; there are six price ranges, with cadmiums and phthalo green the most expensive.

There are no sets as such; the pastels are almost always sold individually. But it is also possible to commission an entire set to be made privately, since New York Central Art Supply is a world-class art supplier that prides itself on the quality of its materials and on satisfying the special needs of its artist customers.

ARC-EN-CIEL HANDMADE SOFT PASTELS

The best way to buy Arc-en-Ciel pastels is to go personally to New York Central Art Supply, see these amazing pastels, and pick the ones you want. But if you can't get to New York City, Arc-en-Ciel pastels can also be purchased through the company's mail-order catalog. (See the List of Suppliers on page 172.)

These handmade pastels are best suited for pastelists who like to work on a large scale or in a broad, generous manner rather than with thinly applied details. Arc-en-Ciels are rich to work with and spread their colors very thickly. Like Schmincke and Sennelier, Arc-en-Ciel pastels can be applied in many layers without getting muddy. Sometimes the action and control of these remarkable soft pastels feel almost like working with a paintbrush. And the extraordinarily rich surfaces you can create with these rare pastels are worth the money and the effort of tracking them down. Once you've had the experience of working with Arc-en-Ciel pastels, you may never be quite satisfied with anything else.

TOWNSEND

Townsend soft pastels are of very high quality and are individually handmade by New York artist Diane Townsend. These beautiful pastels are similar in shape and texture to the Arc-en-Ciel soft pastels. Like Arc-en-Ciel, Townsend pastels are exclusively available from New York Central Art Supply.

There is no regimented number of Townsend colors, and the quantity and choice of colors vary according to supply. But at any given time there are usually around 200 colors to choose from; colors will also be made on special request.

All colors cost the same no matter what pigment is used to make them. The cost of one Townsend pastel stick is a bit higher than the cost of a standard Sennelier, but it is a bargain nevertheless since the Townsends are slightly larger in size, and their quality of pigment and softness of texture is extremely high. There are also oversize Townsend pastels measuring 3 × 1 inch (7.6 × 2.5 cm).

The wonderful thing about the Townsend pastels is their wide range of unpredictable exotic colors. For example, there are countless metallic colors, some of them combined into shining mixtures that are almost opalescent. For a long time Townsends were the only metallic soft pastels available. Now Sennelier has a set of 25 metallic colors, but the Townsends are still larger and more individualistic—more like the kind of pastels you would want to make for yourself. But metallics aren't the only interesting colors available in the Townsend line. There are many fluorescent hues, as well as some very soft dark shades that are almost nonexistent in any other brand. These deep rich indigos and dark greens are very difficult to make, yet they are almost indispensable for creating glowing velvety dark passages.

Even though Townsend pastels are extremely rare, they are worth a visit to New York Central Art Supply just to see how marvelously luscious handmade soft pastels can be.

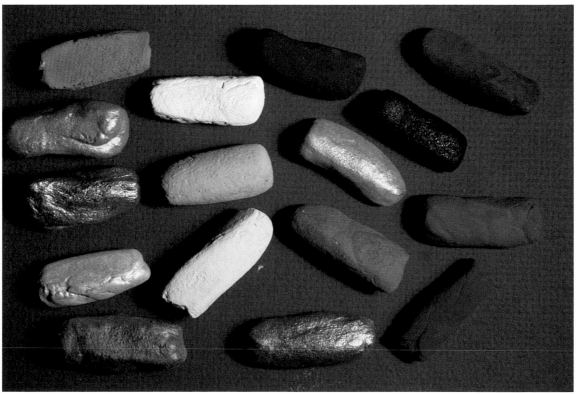

TOWNSEND HANDMADE SOFT PASTELS

HARD PASTELS AND PASTEL PENCILS

Hard pastels are another version of chalk (or water-soluble) pastels. They differ from soft pastels only in their density and hardness; hard pastels are just slightly harder than soft pastels. Because of their firmer texture, hard pastels are generally used for different purposes than soft pastels. While soft pastels are best for filling in broad areas of color, hard pastels are preferable for drawing and sketching, and for detailed or highly rendered techniques.

Hard pastels can be used alone or with soft pastels. They are often used as a drawing tool in the beginning stages of a painting to get down the essentials of color and composition; soft pastels can then be added on top to build up the final texture and color. In some instances hard pastels are used over a layer of soft pastels to make details and highlights. Hard pastels can also serve as a blending tool for soft pastels: Fine lines of hard pastel cross-hatching work well to blend and enhance large, flat shapes of soft pastel color.

Pastel pencils are actually hard pastels that have been rolled into thin rods and enclosed within a wooden holder, just like any ordinary pencil. Clearly the purpose of pastel pencils is exactly the same as that of hard pastel sticks: to draw and sketch and to add fine details. The pencils are very clean to work with and can be sharpened to quite a fine point.

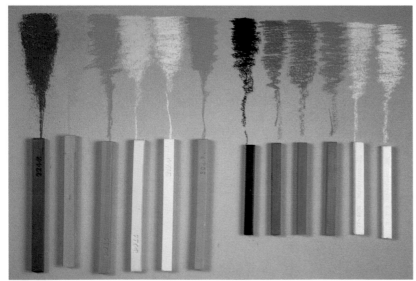

HARD PASTELS: NUPASTELS AT LEFT, CONTÉ AT RIGHT

Hard pastels—whether in stick or pencil form—play an essential role in pastel painting. Let's take a look at the major brands of hard pastel available to today's artist.

NUPASTEL

NuPastel hard pastel sticks are made in the United States by Eberhard Faber Inc., and they are probably among the most popular pastels ever made. NuPastels are everywhere; they are very affordable and easy to find—and they happen to be quite good. A set of NuPastels is the sort of tool that almost any pastelist will finally admit is indispensable. My very first set of pastels was a 24-color NuPastel set that somebody gave me in college, and almost 30 years later I'm still using it. I will probably always be using NuPastels as long as I'm doing pastel paintings.

The amazing thing about NuPastels is that they somehow manage to be both hard and soft at the same time. That is, NuPastel sticks are firm, dustless, and hard enough so that they do not need a paper sleeve, and many of them can be held in your hand without smearing their colors. Yet when you work them into a painting, they draw smoothly across the paper, and they are soft enough to be built up into several layers. NuPastels are square shaped with hard edges, and they measure a long $3\,5/8 \times 1/4$ inch (9.2×0.6 cm)—the longest pastel made. This long, thin, square-edged shape makes NuPastel an ideal drawing tool whose edges can be sharpened to a thin, pencil-like point with a razor or sanded to a chisel edge. The flat side of the NuPastel is effective for broad, flat strokes, and the tip is effective for cross-hatching.

Many sets of NuPastels are available. The full range of 96 colors comes in a large two-tiered cardboard box. The other sets range from 12 to 24, 36, 48, 60, and 72 colors. Only the 24-color set is keyed to portraiture; the rest are assorted colors.

CONTÉ HARD PASTELS

Conté is a name that has come to be associated with quality drawing tools since seventeenth-century French artist Jacques Conté made a thin rod of pigment mixed with French clay and put it between two pieces of wood, thus inventing the drawing pencil. For centuries Conté was famous for the earth-colored, black, gray, and white Conté crayons used by French artists ranging from Watteau to Degas and Picasso. Conté now has a wonderful line of 48 hard pastel colors.

SET OF CONTÉ HARD PASTELS

Conté does not specifically call its pastels hard, but in actual fact that is how they can be used. Conté pastels come in both round and square shapes. Both shapes come in sets of 12, 24, and 48 colors. Conté also has a new line of very thin pastels with square ends in the same 48 colors. These are called "carrés Conté" and are the same small size as the traditional sepia and sanguine Conté crayons. The "carrés Conté" pastels behave in the same way as hard pastels: They do not smear or break very easily but are soft and smooth when drawn onto paper, and are particularly good for work that is highly detailed or done on a small scale. They also work well for cross-hatching techniques and are extremely easy to blend with one another.

CONTÉ PASTEL PENCILS

Conté pastel pencils are simply pencil versions of the Conté pastel series. The pastel pencils come in a generously large size that makes them a comfortable drawing tool. The colored pastel "leads" are hard enough to survive a pencil sharpener, but I've experienced less breakage when I use a razor blade or knife to sharpen them. Conté pastel pencils are definitely the cleanest pastel in existence, with almost no dusting or smearing whatsoever. Like all hard pastels, they are designed primarily for drawing, sketching, and detailed work. Although these pencils can be sharpened to a fine point, they are not hard enough to hold a fine point for very long, so that it is necessary to sharpen them constantly if you want a truly fine line from them. This is why for drawing consistently with a very fine line, I would recommend the Othello pastel pencil by Schwan.

Conté pastel pencils come in 48 colors and are usually sold individually, but there are four sets available. The full set of 48 colors comes in a deluxe wooden box complete with two trays of pastel pencils, several extra drawing pencils, an eraser, and two stumps for blending it all together—truly everything the artist needs, with the exception of the paper!

OTHELLO PASTEL PENCILS

These pastel pencils are made of colored charcoal, and they are very water-soluble. Made in Germany by Schwan, Othellos come in 60 colors and are sold individually or in six sets ranging from 12 to 60 colors. These pastel pencils are slightly smaller than the Conté ones, more like regular pencils, and for this reason they are a lot easier to sharpen in a pencil sharpener. I find Othello pastel pencils the best for extremely fine and detailed work. I also like to use them to create an underpainting in the early stages of a piece, because Othello leaves thin lines with little build-up of pastel dust. This makes it easy to change the drawing as the ideas evolve. Because of these qualities and because of its large assortment of colors, Othello is a great pastel pencil to work with.

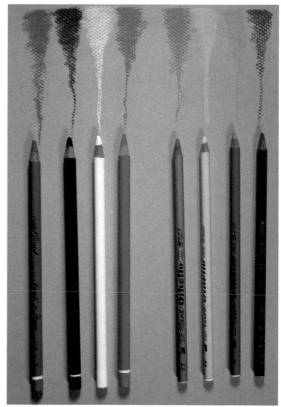

PASTEL PENCILS: CONTÉ AT LEFT, OTHELLO AT RIGHT

OIL PASTELS

The second major form in which pastels exist today is oil pastels. Oil pastels are a relatively new invention in the pastel world, coming into existence sometime after World War II and slowly gaining acceptance and popularity among artists starting in the 1960s. They are now appearing in an increasing diversity of forms. Most of the oil pastel brands in use today are made from the same high-quality pigments as their soft pastel cousins, and they occasionally exceed soft pastels with certain unusual colors such as fluorescent and metallic pigments.

Oil pastels are made by cooking raw pigments with an oil-soluble wax binder into a buttery paste, which is then molded into crayons. Unlike soft pastels, which are water-soluble, oil pastels are oil-soluble and water-resistant. Their waxlike consistency means that they can be handled in a somewhat different way from soft pastels. In fact, oil pastels are more paintlike; they are capable of producing a consistent film that can even be built up into impastos—not as thick as oil paint, but much thicker than any form of chalk pastel. Oil pastels can even be successfully combined with oil painting mediums for certain special effects, such as transparent glazing.

Oil pastels eventually dry to a hard finish the way paint does. This drying process may take many years to complete, but it does eventually happen. Because of this oil pastels do not have an infinite shelf life as soft pastels do. (The oil pastels that I still have from years ago are not as soft and flexible as the ones I bought last week.)

Perhaps one of oil pastel's greatest attributes is that it is free of one of chalk pastel's oldest problems—dust. Oil pastels are dustless. No tiny particles come loose as you work, so there is no need for fixative in the traditional sense. Oil pastels are also less fragile than soft pastels, less prone to shocks and accidents. Perhaps one reason oil pastels are growing in popularity is that they are more suited to working on a larger scale than chalk pastels are. The larger a chalk pastel painting becomes, the harder it is to control the dusting off of pastel particles. This is no problem at all with oil pastels.

The pastelist who wants to begin working in oil pastels can readily find high-quality professional brands almost everywhere. Here is a survey of the major commercial brands now available.

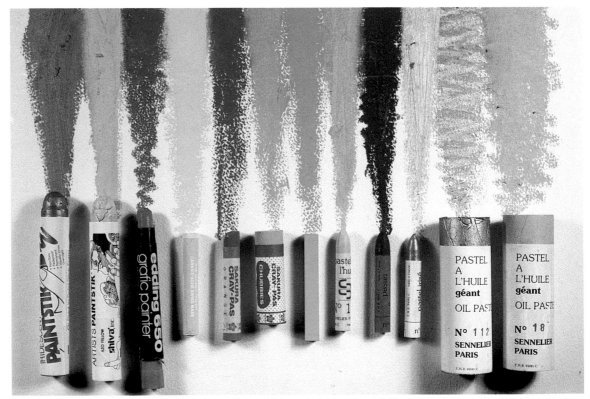

OIL PASTELS AND OIL STICKS. From left to right: iridescent Shiva Paintstik, standard Shiva Paintstik, Edding 650 Grafic Painter, Caran d'Ache, standard Cray-Pas, Cray-Pas Chubbies, Holbein, standard Sennelier, fluorescent Sennelier, iridescent Sennelier, giant iridescent Sennelier, and giant Sennelier.

SENNELIER STANDARD OIL PASTELS

SENNELIER

Sennelier remains unchallenged as the leading producer of quality oil pastels. Since Sennelier dominates the world of soft pastels, it is not surprising that this company should have led the field in developing oil pastels. In 1949 Henri Sennelier, Henri Goetz, and Pablo Picasso worked together to develop a new pastel medium that would have a consistency somewhere between a chalk pastel and a wax crayon.

Working closely with these artists, Sennelier developed an interesting and beautiful range of colors and refined the smooth, buttery texture that still characterizes the contemporary Sennelier oil pastel.

Sennelier oil pastels come in a range of 48 permanent, nontoxic colors. Since 1979 this basic palette has grown to include 21 metallic and iridescent colors, as well as six new fluorescent colors, bringing the full Sennelier palette to its present 75 colors. The addition of metallic and iridescent colors revolutionized the oil pastel palette. Golds, coppers, and silvers—as well as iridescent blues and pinks—opened the door to a new way of looking at color.

Sennelier now offers a set of 69 oil pastels in giant size, including a number of metallics and iridescents. The giant round oil pastel sticks measure 1 1/4 inches (3.2 cm) in diameter and are almost 4 inches (10 cm) long. Each one of the giant oil pastels is equal to 18 standard oil pastels, and they make it possible for artists to work with oil pastels on an immense scale equal to that of oil paintings.

Sennelier oil pastels are readily available in most large art supply stores and come in several sets. The standard oil pastels come in sets of 25 or 50 colors, both in wooden boxes. The metallic and iridescent colors can be purchased in a complete set of 25 colors or a more limited version of 10 colors; the fluorescent colors are sold individually or in sets of six. At this point the giant oil pastels are not available in a set but are sold individually. If you have difficulty finding them, get the Daniel Smith catalog or the New York Central Art Supply catalog; both carry the entire line. (See the List of Suppliers on page 172.)

HOLBEIN

Holbein is a relatively new brand of oil pastels, manufactured in Japan. I started seeing them and using them only in the last ten years—and I'm glad they're around. One of the best features of Holbein oil pastels is that they come in 225 different colors, the largest range of oil pastel colors to date. Before Holbein arrived on the scene, several other brands had soft pastel sets with ranges of a hundred or more colors, but no one offered anything comparable in oil pastels.

The Holbein set is based on 45 hues. Each hue is coordinated with a graduated range of four additional tints, bringing the total number of colors to 225. It is this perfectly graduated range

HOLBEIN OIL PASTELS

of pure hues and tints that makes the Holbein oil pastels such an extraordinarily useful tool for rendering subtle blends of tone and color.

Holbeins measure 2 3/4 × 3/8 inch (7.0 × 0.9 cm) and have flat edges. They come with no paper sleeve or wrapping of any sort, but instead are usually packaged with five sticks to a plastic box: the basic hue plus its four tints. This flat box with its lid on keeps the oil pastels fresh. Holbeins

slowly dry out if they are exposed to air for a long period of time. Although it would take years for an oil pastel to harden to the point where it can no longer be used, it is a good idea to store Holbeins in their plastic boxes to keep them fresh.

Holbeins are also sold individually and in sets. There is an introductory set of 25 colors, as well as professional sets of 50, 100, 150, and the complete 225 colors—all available in wooden cases.

CARAN D'ACHE

Caran d'Ache is an oil pastel of exceptional quality that is made in Switzerland. The full set contains 48 colors, and when you use them you wish there were more. Their wonderful consistency is ideal for anyone who needs a great deal of control over the blending of colors.

All the Caran d'Ache colors are equally soft without being gooey. These oil pastels are very smooth to draw with and to blend, but they are clean to handle and do not have a greasy or oily feel. This makes them excellent for sketching, illustrations, or any kind of detailed work.

Caran d'Ache oil pastels come in very slim metal boxes. Three sets are available: 12, 24, and the full 48 colors.

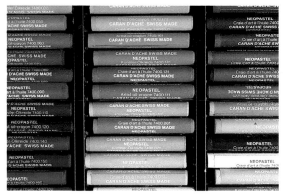

CARAN D'ACHE OIL PASTELS

CRAY-PAS

Cray-Pas is the most popular oil pastel anywhere in the world. In fact, to many people the name Cray-Pas is synonymous with oil pastel since it's the first brand they ever used. Cray-Pas are easy to find and inexpensive. In art supply stores and even stationery stores, I've seen various sets of Cray-Pas that only cost a few dollars.

Cray-Pas are made in Japan by Sakura and come in several distinct forms—and a wide range of boxed sets, to cover every artistic need. The most familiar size of Cray-Pas is called standard and measures $2 3/8 \times 5/16$ inch (6.0×0.8 cm).

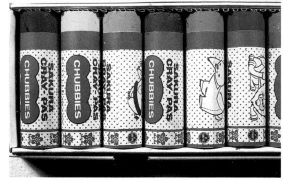

CRAY-PAS CHUBBIES

This is a little small by contemporary oil pastel standards, but it is nevertheless suitable for most oil pastel techniques, especially for details. The standard size comes in many small boxed sets, but the full palette is 48 colors, including silver and gold; 50 oil pastels come in a box (which includes two extra white sticks).

The jumbo Cray-Pas come in 25 colors and are similar in quality to the standard size. They are actually not that much bigger—$2 3/4 \times 3/8$ inch (7.0×0.9 cm)—but they are designed for working in larger areas with heavier strokes. Both the standard and jumbo Cray-Pas are nontoxic.

Hi-Cray-Pas is Sakura's highest-quality oil pastel, intended for the serious artist. It is the same size as the jumbo, with a similar range of 25 colors. But Hi-Cray-Pas oil pastels are generally softer and smoother to draw with, and the colors are denser and more consistent in texture. They have a look and feel similar to Caran d'Ache but go down in a stiffer, less oily fashion. Hi-Cray-Pas are not as commonplace as the standard or jumbo varieties, but they can be found in larger high-quality art supply stores. Both Pearl Paint and Daniel Smith carry them.

There is also a wonderful set of Cray-Pas that was originally intended for children but has more recently been adopted by artists: Cray-Pas Chubbies. Unfortunately Chubbies come in sets of only 12 colors. But they are very soft to work with and have a full, round shape that measures $2 3/8 \times 11/16$ inch (6.0×1.7 cm). Still another variety of Cray-Pas has square ends and flat sides, specifically designed for broad side strokes. It is very soft and oily and has no paper wrapper.

Cray-Pas is an excellent oil pastel for anyone to start out with. Its low price makes it perfect for beginners and students, and it is great for sketching and illustrations. Cray-Pas also makes a professional-grade oil pastel, but this kind is not as easy to find as the less expensive sets.

HANDMADE OIL PASTELS

Like chalk pastels, oil pastels are also available in two handmade varieties: R&F Pigment Sticks and Chardin. Both these kinds of handmade oil pastels are characterized by immense size, excellent pigment quality, and an extremely soft consistency. They provide a fine painting tool—especially for oil pastelists who need to work on a large scale. If you want to do an enormous oil pastel painting, R&F Pigment Sticks and Chardin are the kinds to experiment with first.

R&F PIGMENT STICKS

R&F Pigment Sticks is a brand-new line of handmade oil pastels that may ultimately prove to be the best ever made. These immense oil pastels, which measure 6 1/2 × 1 1/2 inches (16.5 × 3.8 cm), are the largest in existence, almost twice the size of the Sennelier oil pastels. They are also incredibly soft—enough so to be used on almost any surface. R&F Pigment Sticks are probably the best oil pastels to use on stretched canvas. Their inventor, New York artist Richard Frumess (who is also the manufacturer of the high-quality R&F Encaustics), intends for these huge new oil pastels to be so soft that they will be the crayon equivalent of a brush loaded with paint. This claim is no exaggeration. The R&F Pigment Sticks are the softest, smoothest oil pastel I've ever worked with.

This smoothness is no accident. Each color in the R&F Pigment Sticks is a careful combination of the three elements that go into making oil pastels: pure pigments, linseed oil, and natural waxes. These three elements must be carefully adjusted in order to get the right painterly consistency, since the best proportions vary from one pigment to another. R&F Pigment Sticks are intended to offer the most perfect balance of pigment to medium anywhere.

The line, which is still being developed, will offer approximately 50 colors, including eight metallic colors. There is also a large colorless wax blending stick. R&F Pigment Sticks are priced according to the pigments used and come in five series. Each stick contains pure pigment; Frumess has said that he plans for the pastels to be pure, unmixed pigments rather than the shades or tints common with many other brands. The best source for obtaining R&F Pigment Sticks is Pearl Paint in New York City. (See the List of Suppliers on page 172.)

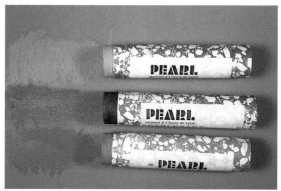

CHARDIN OIL PASTEL, MADE BY PEARL PAINT

CHARDIN BY PEARL PAINT

Pearl Paint in New York City is the world's largest art supply store, and it recently began to offer its own line of art supplies. One of the more unique and exciting new products available exclusively from Pearl Paint is a new handmade jumbo oil pastel called Chardin. These giant pastels are made in France and measure 4 1/2 × 1 inch (11.4 cm × 2.6 cm). The line is available in 44 colors, including ten iridescent and metallic colors.

Chardins are perfectly soft and are comparable to Sennelier in performance. Their longer shape makes them excellent for drawing as well as painting. Chardin has the cleanest wrapper of any oil pastel in use today: a stiff cardboard cylinder from which the artist pushes the oil pastel out from the back, almost like the lead in a mechanical pencil.

This stiff cardboard sleeve simultaneously keeps the oil pastel moist and keeps the artist's fingers relatively clean—something most oil pastelists really come to appreciate!

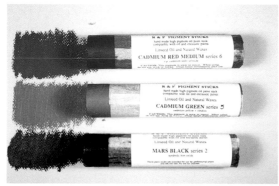

R&F PIGMENT STICKS

OIL STICKS

Oil sticks are the third major form of pastel used by today's artists. This medium contains ingredients much like those in oil paint, but made into a paste and then rolled into a large crayon or stick format. Although oil sticks have only recently become available as an artist's material, they have their origins in the mid-nineteenth century. Shortly after the Civil War, when the American lumber industry was beginning to flourish, a primitive kind of oil stick was used by lumberjacks to mark freshly cut logs with something that was portable as well as water-resistant. In those days the selection of colors was undoubtedly limited compared with the oil stick palette available to a twentieth-century artist.

Artists can use oil sticks much like oversize oil pastels—as a painting medium that can also be drawn with. With oil sticks, you can create graphic or painterly effects with the same tool, and without having to stop repeatedly to reload a brush with fresh paint. The growing popularity of oil sticks is an indication that they are here to stay.

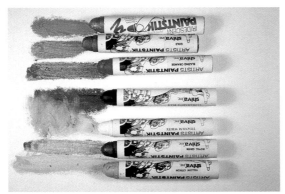

AN ASSORTMENT OF SHIVA PAINTSTIKS

ARTISTS PAINTSTIK

Artists Paintstik, made by Shiva, is clearly the leading brand of oil stick available today, and its popularity is growing. Paintstiks began to appear in the art supply stores in the late 1970s, and they appealed to artists as a single medium that combined both painting and drawing.

Originally there were only a few colors to work with. But today the complete palette has expanded to 55 colors, including two whites, several useful light grays, over a dozen metallics, six fluorescents, and most of the traditional colors that are found in the typical oil painting palette (cadmium red and yellow, ultramarine blue, phthalo blue and green, sap green, yellow ochre, and so on). With this large professional palette, almost any color mixture can easily be obtained. Paintstiks also come with a colorless wax blending stick, which can be used to spread and blend Paintstik colors or to make them more transparent. This wax blending stick can be used to blend and manipulate oil pastels as well.

Shiva Artists Paintstiks come in two sizes. The standard size is $4\frac{1}{2} \times \frac{5}{8}$ inch (11.4 × 1.6 cm). Some colors also come in Thinline sticks, which are as long as the standard Paintstik but about $\frac{1}{4}$ inch (0.6 cm) in diameter. Artists Paintstiks are usually sold individually, but many small sets of six colors are also available. The Professional Set contains 12 basic colors.

Since Paintstiks are actually oil paint rolled into a stick, they can be used on any surface that traditional oil paint can be used on: stretched canvas, heavy paper, gessoed wood panels, even plastic and vinyl. Paintstiks always dry with a thin film across their open surfaces. This paint film should be removed before the oil color is worked across the support. Often small bits of this dried film work their way into the wet color as it is being applied, which gives the Paintstik color a characteristic look and texture.

OILBAR

Oilbar is a brand-new, brilliant oil stick that has been formulated with high-quality pigments mixed with refined oil and wax, and rolled into a superior oil painting stick. Oilbar is significantly larger than Shiva Artists Paintstik, measuring $5\frac{3}{4} \times \frac{7}{8}$ inch (14.6 × 1.9 cm), and comes with a palette of 35 colors including two metallics: gold and silver. Prices are scaled according to pigments, with the cadmiums and cobalts the most expensive.

Oilbar also comes in a jumbo size called a stump, which is available in the same 35 colors as the original Oilbar. Clearly the Oilbar stump is designed to be impressive by anyone's standards. Over three times the size of an original Oilbar, the stump is the size of a flashlight and has the necessary hefty feel to really push oil color across a rough surface. Oilbars can be used on any surface that has been prepared for traditional oil paint, including canvas and paper. There is also a smooth, colorless Oilbar blender. Like Paintstiks, Oilbars accumulate a thin film on their outer surfaces that must be cleaned off before working.

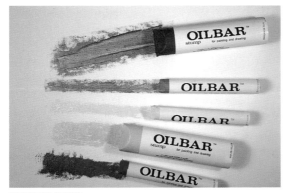

OILBAR OIL STICKS

Oilbars are made in the United States by Starline Art Products, Brooklyn, New York, 11211. They are also available at Pearl Paint and New York Central Art Supply, and can be ordered from the Daniel Smith catalog.

EDDING 650 GRAFIC PAINTER

The Edding 650 Grafic Painter is a truly unique oil stick. It is soluble in oil and alcohol, and it dries extremely fast. Most oil sticks take at least 24 hours to dry to the touch and several days to dry completely. But the Edding 650 Grafic Painter is dry to the touch in less than ten minutes, and within half an hour it dries into a rock-hard waterproof paint film.

Because the Edding 650 Grafic Painters dry so fast, they are useful to any pastelist who needs to keep working pastels in layers. Many layers can be built on top of each other even during one sitting. You can also draw right over Grafic Painters with other mediums, such as pen and ink, colored pencils, oil pastels, markers, and acrylics.

For this reason Edding 650 Grafic Painter is an interesting and versatile oil stick for a pastelist who likes to work with mixed media techniques.

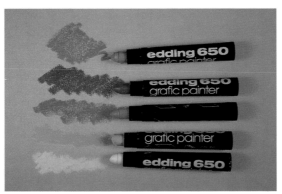

EDDING 650 GRAFIC PAINTERS

Grafic Painters come in a full range of 20 colors. All colors are totally opaque except white, which is slightly transparent and opalescent.

Edding 650 Grafic Painters are encased inside a hard plastic sleeve, which is designed to keep the oil stick from drying out too fast. Just as with Chardin oil pastels, this plastic sleeve also makes Grafic Painters extremely clean to work with. You can hold a bunch of them in your hand without any smearing. The oil stick is moved up within its sleeve by pushing it from the back with the blunt end of a pencil.

Unfortunately Edding 650 Grafic Painters are relatively hard to find in art supply stores. One chain that does sell them is the Sam Flax Art Supply Stores (see the List of Suppliers on page 172). If you can't find Grafic Painters with the pastels, look where graphic markers are sold.

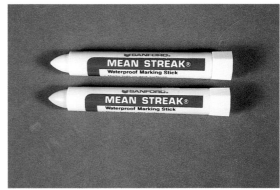

SANFORD MEAN STREAKS

MEAN STREAK

Mean Streak is another somewhat exotic oil stick that is similar to the Edding 650 Grafic Painter, except that it is much larger and comes only in red, blue, yellow, and white. Like the Grafic Painter, Mean Streak dries extremely fast into a hard, tough film.

Mean Streak's main use is in conjunction with other pastel mediums, especially since its palette is so limited. As we shall see later in this book, it is possible to use Mean Streak as a "binder" for working over soft pastels. Mean Streak also works well with oil pastels; I often use it for underpaintings over which oil pastels can be worked in later stages.

Mean Streak oil sticks can often be found in stationery stores as well as art supply stores, since they are intended to be used primarily as a water-resistant opaque marker. However, I have seen white Mean Streak oil sticks advertised in the Dick Blick Art Supply catalog.

Papers and Supports

More than any other painting medium, pastel truly mirrors the surface of the support onto which it is painted. The pastel pigment attaches itself to the upper surface of the support, clinging to its top ridges and accentuating its texture. This means that the paper, board, or canvas support that holds the pastels is an integral part of the final look of the finished painting. The choice of what kind of surface to work on is a creative decision for the pastelist who is interested in the beautiful interplay of pastels and paper.

Almost any paper can be used with pastels. Experimentation and experience will help you decide what paper is best for you and the type of work you do. But unless you are an absolute beginner, always work on high-quality art papers that have a neutral pH. You owe this to yourself and your art; too much is at stake to work on anything less. High-quality papers will improve your pastel paintings and make them last longer. It is definitely worth the extra expense.

The fine art papers discussed here are all of high quality—beautiful and interesting sheets in their own right. This is just a brief sampler of the kinds of papers that may help you make better pastels; you will probably want to consider many other brands as well. Some of the papers described here are easily obtainable anywhere, while others are extremely rare and often very expensive. Remember that expense and rarity do not necessarily equal quality or guarantee success.

Canson Mi-Teintes

Canson is one of the most popular pastel papers made and can be found almost anywhere. Canson Mi-Teintes is a medium-weight 65 percent rag paper that comes in 35 lightfast colors and has a neutral pH. Canson is machine-made in France and comes both in individual sheets and in rolls. Individual sheets are 19 1/2 × 25 1/2 inches (50 × 65 cm) and come with sharp cut edges that have no deckles. Each of the 35 colors, including black, is also available in rolls 51 inches × 11 yards (130.0 × 1,005.8 cm).

Canson Mi-Teintes paper is textured on both sides, but one side is rougher than the other. For me personally, the smoother side is by far the more interesting, being not too obvious in texture and yet rough enough to hold pastels easily. Canson is strong enough for most pastel techniques but will not hold up indefinitely to excessive abrasion or erasing. Too much scraping will cause Mi-Teintes to pucker, and if it gets wet it will also pucker and not really flatten out unless stretched and taped flat.

On the other hand, Canson Mi-Teintes paper is reasonably priced and easy to find. The unusually wide range of colors available makes Canson Mi-Teintes ideal for the pastelist who loves to exploit paper color and needs a variety of interesting colors to work on.

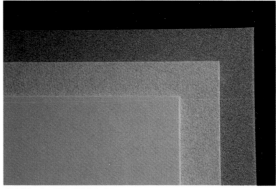

CANSON MI-TEINTES BOARD

Canson Mi-Teintes Boards

Several selected colors of the Canson range are also available mounted on a thicker board for extra support. These colored boards come two to a package and measure 16 × 20 inches (41 × 51 cm). The rougher side of the sheet is the working surface. The stronger backing support allows Mi-Teintes boards to be used for heavier scraping techniques and wash effects. Unfortunately, these boards come in only one size, and the range of colors is limited. But if you enjoy Canson paper, these boards are definitely worth a try as well.

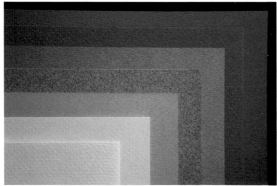

CANSON MI-TEINTES PAPER

STRATHMORE 500

Strathmore 500 is the most popular pastel paper available in America. It is a 64 lb. machine-made paper, 100 percent rag, with a neutral pH and a lightweight laid feeling to it on both sides. Made in the United States by Strathmore, it comes in 14 colors and is great for charcoal drawings as well as pastels. It measures 19 × 25 inches (48 × 64 cm) and is relatively inexpensive. Strathmore 500 is more delicate and fragile than Canson Mi-Teintes and is not recommended for scraping or excessive erasing. But the subtle laid texture is definitely visible and gives an appealing look to a drawing worked lightly in pastels or pastel pencils.

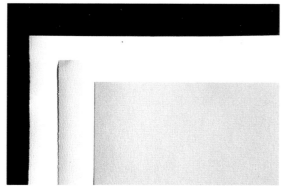

STRATHMORE 500 PAPER

STRATHMORE 400 GRANDEE

Strathmore 400 Grandee is a heavier colored sheet by Strathmore. This 100 percent rag paper measures 19 × 25 1/2 inches (48 × 65 cm) and comes in an 80 lb. cover weight. One side of the sheet is heavily textured and the other side is smoother. The heavily textured side may appear too mechanical and even for some people's taste, but it is nevertheless a strong colored sheet capable of withstanding a lot of hard drawing, scraping, and erasing without puckering.

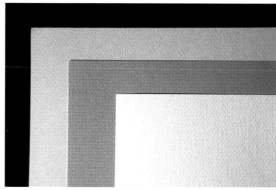

STRATHMORE 400 GRANDEE PAPER

FABRIANO INGRES PAPER

FABRIANO INGRES

Fabriano is an Italian paper mill that dates back to the late sixteenth century and is world-famous for the fine quality of its artist's papers. Fabriano has two papers that are specifically for pastels and drawing. Fabriano Ingres is a machine-made paper that comes in 19 colors and measures 19.5 × 27.5 inches (50 × 70 cm). This is not a rag sheet but rather is made from sulfite pulp with a neutral pH. It comes in two weights: regular, which is about the same as Canson Mi-Teintes, and heavyweight, which is about 80 lb. One side of the Ingres sheet is rough, and the other side is very smooth but still textured. The texture of Fabriano Ingres is a fine perpendicular pattern much like woven cloth, and so subtle that it does not dominate the pastel or charcoal drawings done on it. Heavyweight Fabriano Ingres is an excellent, moderately priced pastel paper that is both strong and subdued.

FABRIANO ROMA

Unlike Fabriano Ingres, Roma has a high profile; its laid texture is very pronounced and strong and will very much be a significant part of the look of the pastels done on it. These gorgeous handmade sheets come in eight colors, each color named after some famous Italian artist. (For example, the white sheet is called Michelangelo and the green Veronese.) Each sheet of Fabriano Roma is 100 percent rag with four deckled edges, and it measures 19 × 26 inches (48 × 66 cm). It also has an oversized watermark worthy of Imperial Rome, depicting the mythological Romulus and Remus being suckled by a she-wolf. Handsome as this watermark is, it does dominate the entire sheet of paper and will play a significant role in any drawing made on it. Nevertheless, the Roma sheet is a very strong paper because of its

FABRIANO ROMA PAPER

internal sizing. Fabriano Roma is moderately high-priced, as are many handmade sheets, but the price is clearly worth it for a sheet of paper whose quality is every bit as impressive as it looks.

INGRES ANTIQUE

Ingres Antique paper is made in Germany by Hahnemuhle—one of the oldest mills in Europe, dating back to 1598. Ingres Antique (sometimes called Dresden Ingres) is made from sulfite pulp and cold-pressed in a mold. Its slightly textured laid surface with 4 very slight deckles. It is a lightweight, soft paper with a slightly textured, laid surface that is unassuming and low-key: perfect for pastels and drawing. Ingres Antique comes in ten subdued colors and measures 18 3/4 × 24 3/4 inches (48 × 63 cm).

INGRES ANTIQUE PAPER

LARROQUE PASTEL PAPER

Larroque pastel paper is made in France at the Duchene paper mills and designed especially for pastels. This 100 percent rag paper has a neutral pH and comes in six different soft colors. Because this paper is truly handmade, no two sheets are quite alike, but they generally measure 20 × 26 inches (51 × 66 cm) and have four deckle edges. There is also a portfolio packet

of 18 smaller sheets (three sheets for each color) measuring 9 × 13 inches (23 × 33 cm). These are also handmade with four deckle edges.

The Larroque pastel paper has a great deal of character. Merely holding it tells you that it has a special quality for pastels. Larroque is soft and unsized and feels as if it is half paper and half fabric. Its feltlike surface has a soft, uneven texture that grabs pastels like magic. Soft pastels work especially well on Larroque; many layers can be laid on top of one another without fixative. Also, because Larroque holds pastels so well, very little pastel dust falls off. This is an excellent

LARROQUE PAPER

paper for the pastelist who works at achieving thickly built-up layers of pastels and whose approach to color is broad and massive rather than carefully blended.

Larroque papers have a slightly buckled, uneven texture common to many handmade papers. Some pastelists find this beautiful and attractive, while others find it disconcerting. And although Larroque is ideal for working with pastels in a direct way, it is not well suited to pastel techniques that involve turpentine or watercolor washes. (The lightly sized Larroque paper buckles terribly when wet and really never quite flattens out.) But if a soft, beautifully handmade paper designed to really hold great amounts of pastel is what you've been looking for, Larroque pastel paper should fit the bill.

FRENCH COLORS

French Colors, distributed by the famous French pastel firm of Sennelier, is another extremely beautiful handmade paper designed especially for pastels. This paper may remind you of Larroque pastel papers, but French Colors is slightly heavier and comes in ten subtle colors. Each sheet measures 20 × 26 inches (51 × 66 cm), is 100 percent cotton rag, and has four deckle

FRENCH COLORS PAPER

edges. The surface is similar to Larroque but even softer, with a slightly stronger tooth. French Colors is perfect for holding enormous amounts of soft pastel without fixing the individual layers. It is also very strong and capable of taking a lot of abrasive drawing and scraping techniques.

French Colors is loosely sized and shares the characteristic buckling qualities of the Larroque papers—but even more so. The curling and general undulating quality of this beautiful paper may not be suitable for artists who would like a flatter, smoother, or slicker quality.

MATIÈRE THICK RUSTIC

Matière is another paper made in France and distributed by Sennelier that is very similar to French Colors and Larroque. Made from recycled fibers, this heavy, gray, feltlike paper comes in a thick and thin weight. The thick weight is almost as thick as a board, yet very soft and pliable, more like a rug than a paper. It is an excellent surface for pastels because its loose, fibrous texture really holds a lot of pastel. However, it is effective only with extremely soft pastels such as Schmincke and Sennelier.

What is interesting about Matière is the way it responds to moisture. It does not buckle when

MATIÈRE PAPER

wet, but soaks up water like a sponge and then goes flat again. This is particularly useful if you are combining liquid acrylic mediums with soft pastels, or if you are using acrylic mediums as a sizing. If Matière is covered with acrylic medium on both sides, the sheet will dry perfectly flat with no warping or buckling. It will also be stronger and an ideal surface for many subsequent layers of pastels—or for oil pastels.

SANDED PASTEL PAPER

Pastels are the natural medium for this high-quality sandpaper from Germany. Sanded pastel paper is available in two grades, or grits. The extra-fine grade is so fine that it doesn't even feel like sandpaper; it is ideal for working in hard pastels or pastel pencils in highly finished techniques that do not require too much build-up of pastels. The other grade, called fine, actually feels like sandpaper and is probably more useful for the majority of pastel techniques.

Both fine and extra fine come in individual sheets measuring 21 1/4 × 27 inches (54 × 69 cm). The fine grade also comes in rolls that are 48 inches × 10 yards (122 cm × 9.1 m). These sanded sheets were once available mounted to

SANDED PASTEL PAPER

boards, and I wish they still were, because the sanded sheets tend to curl a lot. Fortunately the curl is concave—that is, the edges curl up higher than the center—so that the problem can be solved by simply fastening down the outer edges of the paper to something flat. Even so, the curl is an annoyance, and the sanded sheet must be either mounted or matted (with its edges held down by the mat) when framed.

Nevertheless sanded pastel sheets are excellent for pastel paintings that require a smooth, even texture. The extra-fine grade is perfect for subtle blending and highly refined modeling. Sanded pastel sheets will hold large amounts of

pastel chalk—especially the fine grade, which has a 500 grit texture. However, both grades do have a saturation point and lose their sanded quality when filled with too much pastel pigment. The pastelist can then either scrape off the excess pastel powder or resort to fixatives before adding more pastel color.

LA CARTE PASTEL

La Carte Pastel is a newly developed coated board, designed especially for soft pastels. Made in France and recommended by Sennelier, it comes in a range of 14 beautiful colors; each sheet measures 19 1/2 × 25 1/2 inches (50 × 65 cm). The

LA CARTE PASTEL

surface of each sheet of La Carte Pastel has a colored coating of finely ground vegetable fibers on a 200 lb. board. (Both the vegetable coating and the board underneath have a neutral pH.) The resulting surface has a slightly abrasive texture, similar to sandpaper, that really grabs and holds pastel. Fixative is almost never necessary. Very soft pastels, such as Sennelier, work best on La Carte Pastel; the colors go down in very smooth, even strokes that leave almost no build-up. La Carte Pastel is perfect for any pastelist who wants an archival-quality support in a range of colors, an abrasive finish, and the firm flat support of a stiff board.

La Carte Pastel is not suitable for pastel techniques that require water, because its fibrous vegetable coating is water-soluble and will completely dissolve and wash off when wet. This delicate coating is also sensitive to abrasion, so La Carte Pastel is not the best support for pastel techniques that require too much scraping or erasing. On the other hand, La Carte Pastel is unaffected by turpentine, and if wash effects are called for, turpentine or alcohol can be used as a solvent instead of water.

La Carte Pastel is distributed by Sennelier, and one source for it is New York Central Art Supply.

PASTELLE DELUXE

Pastelle Deluxe is a rare, highly specialized paper designed specifically to be used with pastels. This extremely beautiful paper was developed by the artist Winston Roeth and is available only from New York Central Art Supply. Basically Pastelle Deluxe is a sheet of paper (100 percent rag and neutral pH) that has been covered with a special fibrous, granular coating designed to hold down pastel particles so well that absolutely no fixative is necessary. The formula for the coating is a secret, but each sheet is individually hand-coated.

Pastelle Deluxe comes in eight beautiful colors including black. There are two sizes available: 30 × 44 inches (76 × 112 cm) and 22 × 30 inches (56 × 76 cm). Some colors are more expensive than others, but all Pastelle Deluxe sheets are expensive regardless of the color. This paper is designed for professionals, not for beginners or students who are just starting out. But one or two sheets wouldn't hurt anyone's budget. For the curious there is a sample packet of all the colors available.

The experience of working on Pastelle Deluxe is not to be missed. This paper takes pastel in a beautiful, even way, and it is especially suited for extremely soft handmade pastels (such as the rare Arc-en-Ceil and Townsend) as well as for

PASTELLE DELUXE PAPER

Schmincke and Sennelier. The claim that it holds pastels to its coated surface and will not dust is perfectly true, as long as there isn't a tremendous build-up. After many thick applications of soft pastels, the coated surface loses some of its grip, and fixative may be necessary. But for pastelists who tend to work lightly and without building up a lot of thick color—and especially

for those who can't stand using fixative in any form—Pastelle Deluxe is the ideal pastel paper.

VELOUR PAPER

Velour paper is a colored sheet with a treated surface that imitates velour or suede. This texture, as one would imagine, has a special affinity for pastels. Velour paper is made in Sweden and is available in 15 individually colored sheets, including a velvety black. All sheets are machine-made and measure 20 × 26 inches (51 × 66 cm).

Very soft pastels, such as Sennelier and Rowney, work extremely well on velour paper.

VELOUR PAPER

Pastels worked on velour paper go down evenly but with a somewhat diffused, blurred texture. It is as if the pastels blend themselves on this unusual paper. Hard, sharp lines are difficult to achieve, and heavily built-up textures are impossible. But soft, gradual blendings come naturally, which makes velour paper ideal for a hazy, out-of-focus look that many pastelists like.

PASTEL CLOTH

Available from Sennelier, pastel cloth is a new kind of drawing support for the pastel artist. This special cloth is an unwoven synthetic material specifically made to hold great quantities of pastel chalk. Its deep surface tooth is not so much rough as complex, and it is so receptive to holding pastel that fixative is unnecessary for the first several layers. Another advantage of pastel cloth is that it is almost indestructible. It cannot be torn and remains very strong when wet.

Pastel cloth is prepared on a roll, like canvas, and is sold by the yard instead of in sheets. It is excellent for working on a very large scale, and it can be stretched on stretcher frames. Pastel cloth is 48 inches (122 cm) wide and has a neutral pH. Because it comes in a roll it has a tendency

PASTEL CLOTH

to curl, so it is necessary to tape down the edges while working. Finished works on pastel cloth must be carefully matted with the edges firmly held down to prevent curling.

SABERTOOTH

St. Armand's Sabertooth pastel paper, made in Canada by the St. Armand paper mill, is designed as an all-purpose multimedia pastel paper. It is especially recommended for work in oil pastels. Sabertooth is a heavy bristol board that has been coated with a substance similar to gesso that gives it a slight tooth that is receptive to pastel. Sabertooth comes in four colors: white, buff, gray, and green. The individual sheets come in one size only: 24 × 36 inches (61 × 91 cm) and with either a coarse or a fine surface.

Sabertooth answers the need of all oil pastelists for a paper that is safe from the oxidizing effects of drying oils on uncoated paper. While working on Sabertooth, you can confidently use oil pastels—even dilute them with plenty of oil-soluble medium—without damaging the permanence of your support. Sabertooth is also strong, heavy, and capable of taking a great deal of abrasive drawing and scraping.

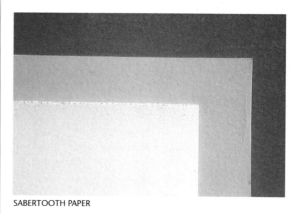

SABERTOOTH PAPER

MULTIMEDIA ARTBOARD

AHC's Multimedia Artboard is a new and exciting paper board designed to solve the problem of how to paint in oils on paper without sizing it first. (Daniel Smith Non-Buckling Painting Board is such a similar material that I'll discuss the two together, although Daniel Smith's product is slightly more absorbent.) Both are unique heavy papers specially treated with epoxy so that they are unaffected by paint solvents of any sort. For example, when the oil in oil paint begins to oxidize, it will slowly destroy paper fibers that have not been protected by gesso,

MULTIMEDIA ARTBOARD

acrylic gels, or sizings. Thus oil paints (and therefore oil pastels and oil sticks) may eventually have a destructive effect on untreated paper. Paper can be treated with a simple sizing of gesso to protect it, but the process is somewhat time-consuming, and the paper may buckle and warp because of the water and the glues of the sizings.

With Multimedia Artboard there are no preparations required. This board comes ready to work on in almost any medium imaginable. It is as useful for acrylics as it is for oil paints. It can even be used for pen and ink, egg tempera, or encaustic. It is immune to the chemical reactions of paint, and it will not warp or buckle if it becomes wet. So when working in water media or using water mixed with pastels, it will remain constantly flat—much like plastic.

The main advantage of working with Multimedia Artboard is that you can use it to work in oil pastels or oil sticks with absolute assurance that any oil solvents used will not affect the permanence of the support. Multimedia Artboard is strong enough to survive a lot of razor and palette knife scrapings. It is also extremely easy to draw on with soft pencils, charcoal, or soft pastels. Particles of soft pastel hold onto this

epoxy surface as if it were a sheet of heavy watercolor paper. Multimedia Artboard is also ideal for very heavy application of strong fixatives and varnishes, which sometimes damage the more delicate fibers in paper.

Although it is chemically indestructible and has amazing versatility and beauty, Multimedia Artboard is unique in one very unfortunate way: It is breakable. It will chip if mishandled, snap in two if rolled, and crack if something heavy falls on it. So care must be taken while using this amazing drawing material. Perhaps future versions of Multimedia Artboard will be unbreakable. But even though it is breakable, Multimedia Artboard is absolutely the best support available today for working in oil pastels or oil sticks.

Both Multimedia Artboard and Daniel Smith Non-Buckling Painting Board come in four sizes, the largest being 26 × 40 inches (66 × 102 cm). One side of the board is plate smooth, and the reverse side has a cold-pressed texture.

WATERCOLOR PAPERS AND ETCHING PAPERS

Although watercolor papers and etching papers are designed for other purposes, many pastelists are turning to these papers as alternatives to traditional pastel papers. Both these kinds of paper are extremely strong as well as beautiful. Contemporary pastel techniques rely increasingly on multiple layers and heavier, built-up colors—as well as more use of scraping and erasing—to get special effects. Sometimes conventional pastel papers are not strong enough to withstand all this abuse and wear and tear.

Another reason for using etching and watercolor papers is that they are amazingly strong when wet. Since many new techniques of working pastels require water or various water-soluble mediums such as acrylics or gouache,

WATERCOLOR PAPERS. From left to right: D'Arches 140 lb. rough, Lanaquarelle 140 lb. rough, and Strathmore Excaliber.

ETCHING PAPERS. From left to right: Murillo off-white, Rives BFK, Stonehenge natural, German, and American.

watercolor papers are quickly becoming the paper of choice among many pastelists.

Yet another reason for selecting watercolor or etching papers as a support for pastels is that pastel paintings are getting bigger. Pastel papers come in relatively small sizes and are also relatively lightweight; most of them are under 90 lbs. Watercolor papers, on the other hand, are easy to find in imperial sizes of 22 × 30 inches (56 × 76 cm) or larger, and they come in standard heavier weights of 90 lbs., 140 lbs., and 300 lbs., all of which are heavier than the heaviest pastel paper. And for truly elephantine works there are papers like the Arches 1114 lb. cold-pressed and rough sheets, which measure 40 × 60 inches (102 × 152 cm) and are as hefty as thin plywood. Pastelists who work on a large scale or who like a heavier, more resistant feel to their support often prefer etching or watercolor papers.

HANDMADE AND ORIENTAL PAPERS

More and more handmade papers are surfacing in the art supply stores, and they have an immense appeal to artists working in all mediums, pastelists included. Because paper texture is so intimately connected to the look of a finished pastel, artists who work with pastels become increasingly sensitive to the beauty of paper textures themselves. Today small paper mills abroad and in the United States are making extremely beautiful art papers by hand. These individually made sheets have a great deal of character, and no two sheets are ever quite alike. They are often so beautiful already that it seems almost a shame to work on them. Handmade papers are a natural choice for the artist who wants a truly different texture on which to work out new ideas, or a surface that gives form to an emotional or decorative sensibility.

Some of the best papers for working in pastels are handmade watercolor papers from India, such as Indian Village Handmade Rough. These sheets are extremely rough and crinkled, and each one has its own unique character and individuality. When working on Indian Village, you use up a lot of pastel by pushing it into the crevices of the paper to take full advantage of the rough texture. The paper is sufficiently sized to withstand the abrasion that accompanies most standard pastel techniques. Each sheet of Indian Village paper has large deckled edges and should be framed so that the entire character of the sheet can be seen.

HANDMADE WATERCOLOR PAPERS. From left to right: Indian Village rough, Lanaquarelle 300 lb. cold-pressed, and Arcworth 300 lb.

CLOSE-UP OF INDIAN VILLAGE ROUGH HANDMADE PAPER

By contrast, most oriental woodblock papers are too delicate to stand up to vigorous application of pastel. These lovely sheets with their softly textured surfaces might seem ideal for pastels, but in actual practice they are too fragile to be used effectively except for the gentlest of techniques. Only the very softest pastels, such as Schmincke or Sennelier—or, even better, the handmade Arc-en-Ceil and Townsend pastels—should be used on oriental woodblock papers. Anything harder would begin to disintegrate them.

MUSEUM MAT BOARD

MUSEUM MAT BOARDS

Perhaps one of the most versatile and durable supports for pastel painting is 100 percent rag museum boards. Museum boards are used primarily in archival matting and presentation of works of art done on paper. They come in two-ply, four-ply, and eight-ply (double-thick) sizes and in several colors. Because of its neutral pH, museum board is highly recommended for its archival qualities and as a support for all pastel mediums. This type of support has a soft, smooth, buffered finish with no texture whatsoever, but it does have a slight tooth that makes it a good surface for both hard and soft pastels.

One advantage of museum board is its durability. It is very strong and can easily withstand any technique that involves heavy scraping or the use of special abrasive tools, such as electric erasers or razor blades. Museum board also has the wonderful quality of not permanently warping when wet. It is very flexible and will flatten out again if simply left in a dry, flat place.

But perhaps museum board's most appealing quality for the pastelist is that it can be easily coated with a variety of materials. Acrylic gesso and various coated sizings are easy to apply, as are marble dust and sand (used to create heavier, grittier textures for pastels). Because museum board can be sized and coated so easily—and because it is available in heavy thicknesses and large dimensions (40 × 60 inches, or 102 × 152 cm, being the largest), museum mat board is an ideal support for oil pastels and oil sticks.

There are many ways of sizing a museum board for work in oil pastels or oil sticks. Acrylic matte medium can be used alone. My favorite sizing is a diluted solution of gesso and acrylic medium with an optional pinch of marble dust

or very fine quartz sand to add some tooth if desired. Another variation of this coating is three parts acrylic matte medium to one part acrylic modeling paste, mixed together in a wide bowl. Do not add any water to this mixture, since it may cause the board to expand and buckle too much.

To apply any sort of sizing to a museum board, mix enough of it to coat both sides of the board. Use a very soft nylon or acrylic brush to coat the back of the board first, and let this dry to the touch for about 20 to 30 minutes. Initially the museum board will bend convex but then as it dries it will go concave. Then coat the front side of the museum board, and allow the board to dry thoroughly overnight. Because both sides of the museum board have been coated equally, it will remain perfectly flat after it has dried. The sized museum board is now totally suitable for working in any oil pastel or oil stick medium.

CANVAS BOARDS AND PANELS

We said earlier that pastels can be used on just about any surface, so it should not come as a surprise that pastels work very well on canvas

MASONITE PANELS: GESSOED AT LEFT, UNPRIMED AT RIGHT

CANVAS PANELS

boards as well as on hardwood or Masonite panels. If pastels can stick to paper, they can adhere to a canvas support just as well. The trick to using pastels on panels or canvas boards is that the pastels must be the softest possible, and liberal amounts of fixative should be used to adhere the first layers. Working the pastels in layers becomes almost a necessity in working on canvas panels or boards. It's also worth noting that canvas must be firmly mounted, as in a panel; if simply stretched across a frame, canvas "bounces" too much and does not offer firm enough resistance to the pastel, and a great deal of the color will dust right off.

Masonite and wooden panels can be surprisingly effective supports for soft pastels. Again, the rule here is to use extra amounts of heavy fixative and build the pastels up in layers. If you use Masonite, it should be the untempered kind, which has sufficient tooth to hold soft pastels. Be prepared for a lot of pastel falling off the surface if the accumulation gets too heavy.

Wooden and Masonite panels and canvas boards are particularly good supports for oil pastels and oil sticks. Both these pastel mediums, especially oil sticks, harden slightly as they dry. To use them effectively, it is best to work against a very firm surface, and boards and panels give the maximum of resistance to these oil-soluble pastels. Moreover canvas and Masonite panels can be sized and gessoed to protect against the corrosive actions of the oil-soluble binders in oil pastels and oil sticks.

MAKING YOUR OWN CANVAS PANELS

Sometimes a canvas panel or board is too conventional or evenly textured for my taste, so I enjoy altering my canvas panels to make them thicker and more heavily textured than they originally were. To do this, I build up several layers of additional canvases and glue them to the original canvas board. I make the new canvas layers slightly smaller than the original because I want the edges to appear uneven and layered. I coat these new surfaces with a sanded acrylic modeling paste called Lascaux Plastik B for a rough, almost organic texture. The idea is to add a textural patina to the canvas support that will carry into the final pastel. Such a surface can give a pastel the unexpected look of a fresco or an ancient encaustic panel.

Materials for making a canvas panel. At left, from bottom to top: a commercially made canvas panel, a loosely cut piece of cotton duck smaller than the panel, and a loosely cut piece of linen even smaller. At right, from bottom to top: scissors, putty knife, palette knife, acrylic modeling paste, and spray adhesive.

I begin by spraying the surface of the commercially made canvas panel with a heavy coating of adhesive.

While the glue is still wet, I carefully place the piece of raw cotton duck over the original canvas panel. (Once it is in place, the fabric is not easy to slide around or adjust, although it can be pulled off and laid back down if necessary.) With a putty knife I work out the wrinkles.

After the piece of cotton duck dries, which takes about 10 to 15 minutes, I cover it with a second coat of the spray adhesive.

The frayed edges of the linen canvas are important to the final look of the panel, so I use my palette knife to press them down into the glue while it is still wet.

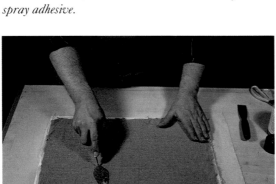

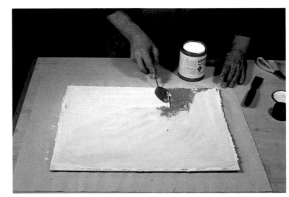

With the adhesive still tacky, I place the piece of hand-cut raw linen over the cotton duck. Next I press it down with the palms of my hands, and work out the ridges and creases with the putty knife. Any ridges accidentally left in at this stage will be evident in the finished panel.

After the panel has dried about half an hour, I cover the entire panel with acrylic modeling paste, using a wide palette knife to push the paste into the canvas. The edge of the knife works well for evening out the paste surface. I also catch the end of frayed linen with the modeling paste and work them together into a stiff texture.

Once the panel has dried overnight, it is ready to use. This close-up view of a corner shows the panel's heavy texture, which is an ideal support for certain mixed media techniques—pastels combined with acrylic, for example, or oil pastels combined with Oleopasto or Zec.

MEDIUMS AND FIXATIVES

Pastels can be altered and transformed by painting mediums as well as by fixatives. Certain special effects are best achieved by using them.

GUM TURPENTINE

Gum turpentine is the most common oil-soluble paint medium, and it can be used both with oil pastels and with chalk pastels. Turpentine spreads pastels into thin washes—a technique most useful in the early stages of a painting.

WINGEL

Wingel is a multipurpose oil and alkyd painting medium that can be used with oil pastels either to create a hard finish, to make the color more transparent, or to accelerate drying. Wingel can also make oil pastels and oil sticks thicker, so that they can be built up into a slight impasto. This versatile medium can even be used with chalk pastels to create transparent glazes over which more opaque layers can be drawn.

ACRYLIC MEDIUM

Because chalk pastels are water-soluble, they can be dissolved in acrylic medium to make them more paintlike. The acrylic medium also serves as a strong fixative, binding the pastels permanently to their support. Different kinds of medium can also be used to give pastels an impasto that they could never achieve on their own.

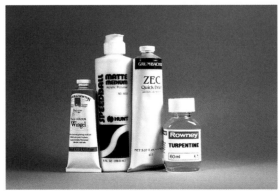

PASTEL MEDIUMS. From left to right: Wingel, an alkyd gel by Winsor & Newton; Speedball, an acrylic matte medium by Hunt; Zec, an oil medium by Grumbacher; and gum turpentine.

ZEC

Zec is an oil-based paint medium designed to add more body to oil paint and at the same time to accelerate its drying time. Zec can be used to create impasto and add body to oil sticks. It makes the paint strokes more dramatic and exaggerated.

FIXATIVES

Pastel fixative is a very weak solution of varnish that is sprayed onto the surface of a pastel painting in order to reinforce the adhesion of pastel particles to their support. There are two basic types of fixative: workable fixative and final fixative. The most common form of pastel fixative comes in an aerosol spray can. But fixative is also available in glass jars and can be applied to

FIXATIVES. From left to right: Blair workable fixative, Rowney Perfix final fixative, Krylon acrylic spray, and Blue Label raw fixative with mouth atomizer.

the surface of a pastel by the old-fashioned method of blowing it through a mouth atomizer. Raw fixatives can also be painted or splattered directly onto the pastel with a brush to create special textures in a painting.

Workable fixative is the weakest form of spray fixative available. It is meant to be used in passages where the pastel build-up is getting too thick, and fresh color can then be applied on top of it. Workable fixative has a matte finish that will not add an unnatural sheen to the pastel, even if it is oversprayed. Final fixative is meant to be applied after the pastel is finished to help hold the particles in place permanently. Both workable and final fixatives are strong enough to prevent smearing.

Acrylic spray is slightly stronger than either workable or final fixative and will really hold a layer of pastel in its place. Once a pastel is sprayed with acrylic spray, it is very difficult to remove the color. Unlike workable fixative, acrylic spray leaves a glossy shine if heavily sprayed. Acrylic spray is the most secure way to fix pastel to relatively smooth or hard supports. It is also the most reliable spray for pastel that has been built up in thick, heavy layers.

Tools

Much of the appeal of pastels lies in their simplicity; compared to many painting mediums, they require very little equipment. Even so, there are some tools that most pastelists find handy now and then. These include palette knives, razor blades, erasers, tortillons, and several others.

Palette Knives

Perhaps the most useful tool for working in pastels is a good smooth, flat palette knife. This tool is almost indispensable for both chalk and oil pastels. It can be used to scrape color off the painting—and, if desired, apply it to a different area instead. A palette knife is also ideal for pressing loosely applied pastel colors into the support to keep them from dusting off.

AN ASSORTMENT OF PASTELIST'S TOOLS: three sizes of sponge brushes, a plastic eraser and an eraser pencil, a blending stump and two blending tortillons, a palette knife, and a chamois.

Finally, palette knives are important for spreading solvents and mediums, especially with oil pastels and oil sticks.

RAZOR BLADES

Single-edged razor blades are another highly useful tool. They are indispensable for scraping off colors either to expose what is underneath or to make corrections for new colors. Razor blades are also useful for scraping powder off chalk pastels for dusting techniques, and for sharpening almost anything from pastel pencils to oil sticks.

CHAMOIS

A chamois is a soft, suedelike cloth used to blend and spread loosely applied pastel. Chamois are most effective in the early stages of a pastel painting, before the colors are heavily built up. A chamois can also be wrapped around your fingers for careful blending and control.

ERASERS

Erasers of various types should be kept handy when doing pastels. A kneaded eraser is extremely useful in making corrections in chalk pastel, since it removes unwanted pastel from its support. (First scrape away as much pastel as possible with a razor blade or palette knife.) A pencil eraser can also be used as a pastel blender, working the surface of a pastel in an interesting way by removing a little of the color as it blends.

TORTILLONS AND BLENDING STUMPS

A tortillon is a cylinder made of paper rolled into a long thin point. A blending stump is also made of rolled paper but has a much shorter point than a tortillon. Both kinds of tools are used for blending and spreading pastels. They are more precise blenders than your fingers because they are narrower and cleaner to work with. Both tortillons and blending stumps can be cleaned by wiping off excess pastel with a tissue or a soft rag. In oil pastel painting, tortillons and stumps can also be used as incising tools.

SPONGE BRUSHES

A sponge brush can be used as a blending tool for chalk pastels, as well as to apply water-soluble mediums such as acrylic gels. A moistened sponge brush can also be used to create wash effects with chalk pastels.

SPONGE PAINT ROLLERS

FOAM ROLLERS

Foam rollers are handy for spreading acrylic mediums over chalk pastels in mixed media techniques. A foam roller is more effective than a brush for this purpose because it picks up less of the loose pastel. Rollers also work very well for smoothing out any rough textures created by oil-base mediums with oil pastels or oil sticks. In fact, foam rollers may be the only way to achieve a smooth texture with oil pastels.

HOLDERS

Metal and plastic pastel holders are useful for several reasons. First of all, they help keep your hands clean of pastel dust. But more importantly, pastel holders can add a few more inches to broken pastel pieces, thus allowing you more flexibility and free wrist action while drawing. Certainly holders are not useful for all drawing techniques, but for cross-hatching or linear drawing the added few inches of a chalk holder can be a distinct advantage. Holders also give you more control for fine details. (You'll see me using them this way later on.)

PASTEL HOLDERS: for soft pastel above; Holbein's for oil pastel below

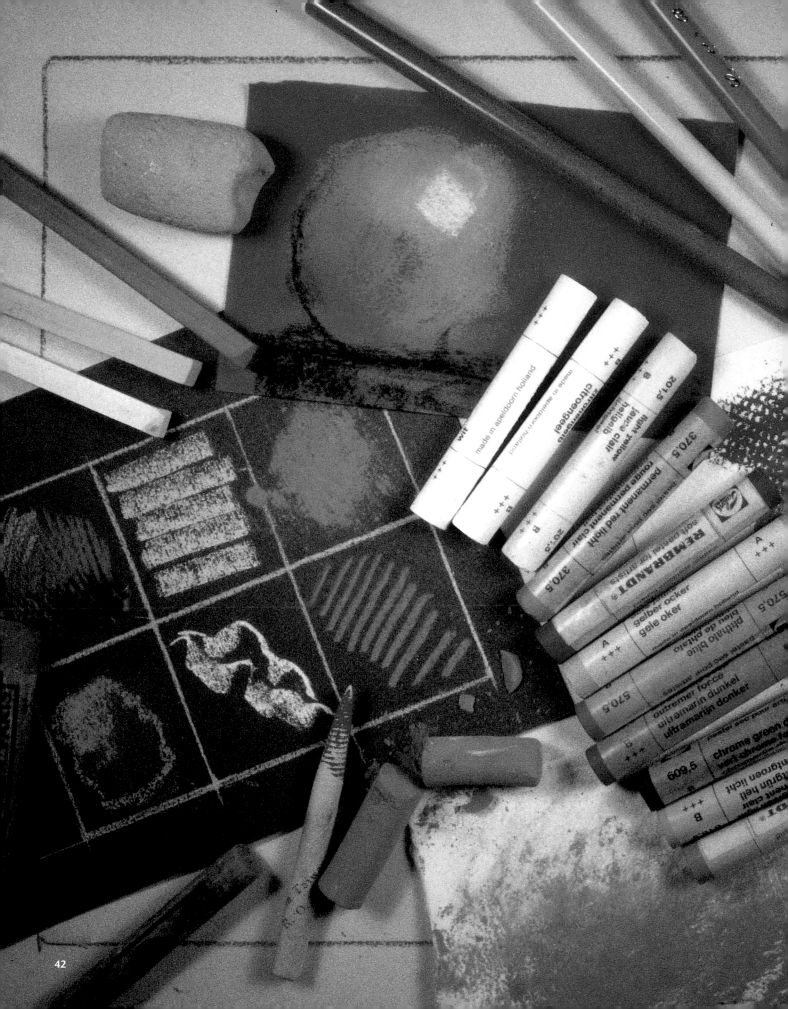

Basic Pastel Techniques

For me pastels have always been both a deceptively simple medium and a complicated one. Sometimes working in pastels seems as direct and natural to me as my own handwriting, while on other occasions a pastel painting becomes as complex and indirect as an oil painting, requiring many layers of glazes and scumbles to achieve a glowing color and sensuous texture.

Techniques for working in pastel all stem from the medium's dual nature: Pastels are simultaneously a drawing medium and a painting medium. In some ways it is a little artificial to distinguish pastel painting techniques from pastel drawing techniques, because with pastels painting and drawing become truly simultaneous activities. Still, if hard pastels are this medium's pencil points, soft pastels are its paintbrushes.

All artists who love pastels have a personal commitment to drawing. I know I do. I love to draw. Drawing is basic and fundamental to me, the key to everything I do as an artist. The way I draw is personal—the result of a long, complicated evolution of trial and error that finally resulted in a style that satisfies almost all of my needs as a creative artist.

Every artist who truly likes to draw has a unique, personal style. So it is not surprising to find that artists who are relaxed and at ease with a personal drawing style find in pastels a medium that allows them to be uninhibited and inspired as they work. To be relaxed and comfortable with drawing is the key to mastering pastels.

Hard Pastels for Pastel Sketching

This nude was drawn with hard pastels, and details were added with Conté pastel pencils.

The close relationship between drawing and pastels is especially clear in pastel sketching. Sketching is the most fundamental approach to drawing. When sketching I am just drawing for the fun of it, not worried about the final outcome. For this reason sketching is relaxing. Often I sketch with the TV on, or while listening to music under the headphones. Being relaxed is crucial in working

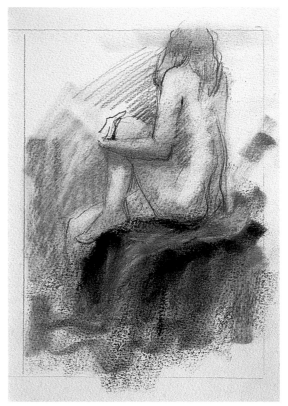

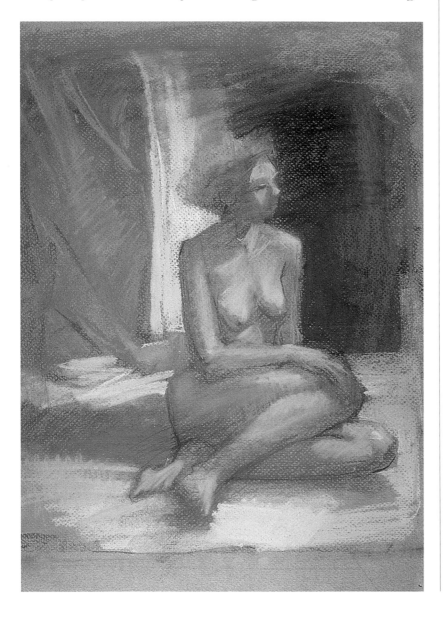

successfully with pastels, because a relaxed imagination makes free associations and surprising connections that spark off fresh, creative ideas.

Since sketching is a relaxing form of drawing, it provides the ideal setting for becoming familiar with pastels. I first started using pastels in a casual way, for small sketches and studies to work out problems I was having with larger oil paintings. By working on these small studies I quickly learned some of the basics of pastel painting, almost unconsciously. Before I knew it I was doing pastels that surpassed the oil paintings for which they were intended to be studies.

A pastel sketch should be small and done relatively quickly, without too much attention to details; it should not become finished prematurely. Keep your sketches as loose as possible and don't hesitate to smudge and erase either hard or soft pastels. Pastels are natural smudgers, and erasing into a smudged area can create a beautiful gestural effect. Always keep in mind that while you're sketching you're also drawing, so feel free to continue working with more familiar drawing materials such as pencils or pen and ink. Such

graphic mediums work very well with pastels. Keep your drawing style loose and open, flexible enough to mix mass and line together. In general, use hard pastels or pastel pencils for line and cross-hatching, and the broad side of soft pastels for masses of color.

Most hard pastels are long, thin, and rectangular with hard edges. The two most common brands are NuPastel by Eberhard Faber and Conté Pastels. Because hard pastels are made with their pigments pressed in tightly, they do not need a paper wrapper to prevent smudging or breaking. They also produce less dust than soft pastels, so that less pastel powder accumulates on the drawing's surface. You can also hold many hard pastels in your hand without smudging your fingers, which is a real advantage in a medium notorious for causing dirty hands. Hard pastels are best for line work and details. Their tips can

be cut with a razor or sharpened to a perfect point with a sanding block. But perhaps the best way to give hard pastels a sharp edge is to simply break them into smaller pieces. Freshly snapped hard pastels can give extremely fine, almost hairlike lines.

Pastel pencils are hard pastels in pencil form. They come in two styles: Conté à Paris and Othello. The Othello is about the same size as a regular drawing pencil. It has a hard pastel core and is easily sharpened with an electric pencil sharpener or a razor blade. Because Othellos are made of hard pastels, they are extremely useful for drawing very fine lines and cross-hatching. Conté à Paris, a larger pastel pencil, is capable of broader coverage. Conté pastel pencils can be sharpened either to a pencil point or a chisel edge. For best results, sharpen the point on a sanding block or shave it down with a razor blade.

Left and below: Here are two quick nude sketches done in hard pastels over soft drawing pencil. I blended the pastel colors with a paper tortillion.

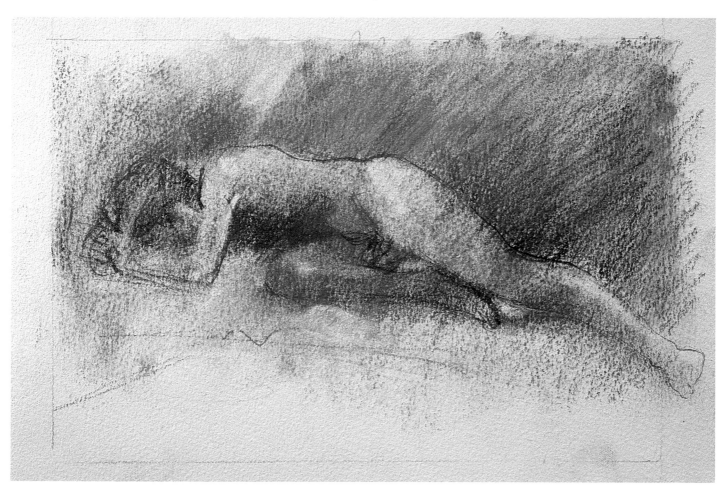

SOFT PASTELS FOR COLOR AND TEXTURE

Soft pastels are both larger and softer than hard pastels—softer meaning less dense and more paste-like in consistency. Soft pastels are also more powdery and leave behind thicker accumulations of color when they are applied to paper.

Most soft pastels come wrapped in a paper label that displays the manufacturer's name and the identity of the color. This wrapper also helps hold the soft pastel stick together. It is not unusual to find soft pastels broken into one or two pieces, even in the art supply store. But this is fine since you will probably end up breaking them yourself in order to apply their colors in soft, wide strokes as you build up your paintings.

Some of the better-known brands of soft pastels are Sennelier, Rembrandt, Schmincke, Grumbacher, Rowney, Girault, and Holbein. (Holbein soft pastels are unique in that they do not come wrapped in paper.) Every pastelist seems to have a favorite brand of soft pastel; some are so devoted to one brand that they use it exclusively and reject all others. I myself have found that no two pastel brands are alike, and since each has its own unique qualities and individual purpose, I use a variety of brands. I couldn't possibly say which ones are the best because they've all seduced me at one point or another. I recommend that you try different brands before settling into using just one exclusively.

Another difference between soft and hard pastels is that soft pastels come in many more colors (or, to be more accurate, more tints and shades). Most manufacturers have sets that exceed 200 colors. Sennelier even has a set of 525 colors. These large selections or "palettes" of soft pastels suggest that they are used to create subtle nuances of colors, whereas hard pastels are intended to lay out the structure and foundation of a drawing.

Soft pastels are made to be applied either in broad sweeps that generously block in color as a mass, or else in short, thick strokes. (In contrast, hard pastels lend themselves better to delicate, razor-sharp lines.) Strong, vibrant color is one characteristic of soft pastel painting. The other is texture because soft pastels, stroke per stroke, place more pigment on their supports than hard pastels do. This allows you to take maximum advantage of the surface variation of the paper support, and to build up textural effects with the generous layer of loose pigment that accumulates.

Pastels mirror the surface they are painted on. If you are working on a rough handmade paper, you will use a lot of pastel to fill in all the crevices. But you will also have a tremendous opportunity to exploit the velvety powdered colors of your soft pastels to create sensuous textures that complement the paper's beautiful surface.

Another way of using soft pastels to achieve texture is to alter the appearance of the pastel coating itself, usually by spraying excessive amounts of fixative or by breaking up the pastel surface with a variety of tools such as drawing pencils, palette knives, or razors. (You'll learn more about these techniques later on.) Soft pastels can also be manipulated like oil paints to create scumbles and glazes, only on a smaller scale. A heavy coat of fixative hardens the microscopic particles of pastel so that successive layers become more encrusted and thickly textured. They also adhere better to the paper.

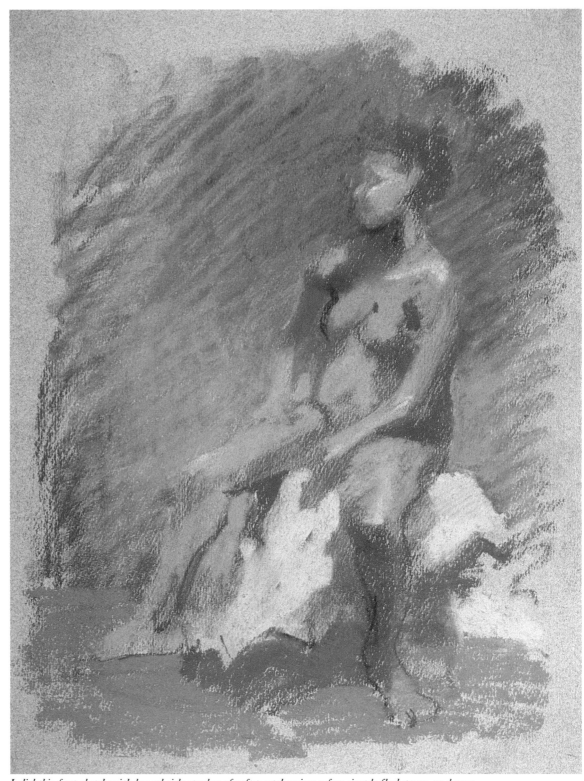

I did this fast sketch with broad side strokes of soft pastel, using a few simple flesh tones and gray.

BASIC APPROACHES TO PASTEL PAINTING

A pastel stick is a very simple and self-contained painting tool, yet it is amazingly versatile and can be manipulated in many different ways. As these illustrations show, pastel can be applied in broad side strokes or in delicate strokes with the tip or corner of the stick. Colors can be blended into any tone imaginable, or scumbled over each other for exciting broken textures. Pastels can also be dusted onto the paper as a powder, erased, or scraped off with a razor blade. They can even be transformed into a paint medium with solvents such as Wingel or Liquin. So many textures are possible!

Side strokes. The flat side of a pastel can create a variety of effects. This technique works best with a small chunk of pastel (half a stick or smaller) and with soft pastels such as Grumbacher, Schmincke, Rembrandt, and Holbein.

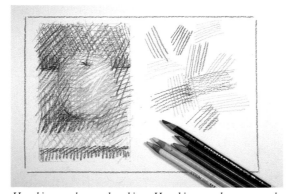

Hatching and cross-hatching. Hatching strokes are made with a series of parallel lines drawn close together to make a light tone; with cross-hatching the hatched lines intersect because they are drawn at varying angles. Pastel pencils, such as Othello or Conté, are best for this technique. Its advantage is that the images are loose and flexible and therefore easily changed as the painting develops.

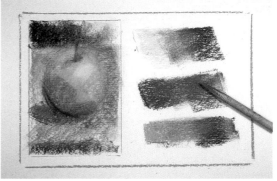

Blending colors. One of the most attractive qualities about pastel painting is the ease with which colors can be blended. Here are several bands of colors that have been blended together—in this instance with a soft tortillon.

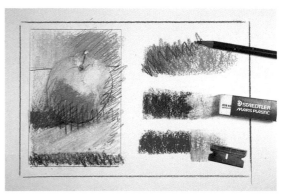

Ways of manipulating pastel. Top: A soft lead pencil or pastel pencil can be used to break up a consistent tone of soft pastel for a broken color effect. Middle: Pastel can be removed with a soft eraser, either to make corrections or to create special effects, such as highlights. Bottom: A single-edged razor can be used to scrape away pastel for an interesting look, especially on textured paper.

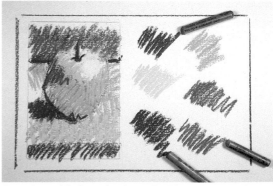

Drawing with the ends of pastels. The end or tip of a pastel stick—either hard or soft—creates a thick, soft line that beautifully conveys a sense of gesture and motion. The best pastels for this are Sennelier, Girault, Rowney, Conté, and NuPastels.

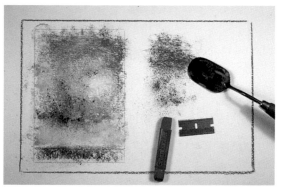

Dusting. For a soft, delicate haze of color, pastel dust can be shaved off the stick onto the paper, and then pressed into place with a flat palette knife. A clean knife has a smooth enough surface not to move the pastel around, even if you use a slight circular pressing motion.

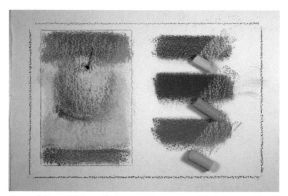

Scumbling. This technique relies on multiple layers for dazzling textures of broken color. One layer of color is applied, and often sprayed with fixative. Then the side of a soft pastel is lightly dragged across it, letting some of the first color show through. Scumbled colors have more texture and visual interest than blended ones.

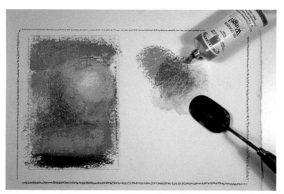

Working with paint mediums. Pastels are water-soluble, but they can also be liquefied with paint mediums and then worked with brushes and palette knives. Here I used Wingel, an alkyd-based oil painting medium; turpentine can also be used. Note that, like fixatives, paint mediums prevent pastel from dusting but also darken the colors.

Before we begin to examine a few general approaches to pastel painting, I would like to point out an important concept that is universal to all pastel techniques: working in layers. A pastel painting is made by working the picture up through several levels until it is completed. As you work on a pastel, you are continually adding more and more colored pigment and chalk onto your support. Sooner or later the tooth of the pastel paper becomes so filled with pastel dust that you can't add any more. If you do, the additional pastel chalk will not properly adhere to the paper, and you will have a situation called muddy color—the unpleasant combination of oversaturated pastel pigments.

There are two ways to avoid muddy color. You can keep scraping unwanted color off the pastel paper and replacing it with another fresher coat. Or you can keep applying varying strengths of pastel fixatives between the individual coats of hard and soft pastels, so that each new level of fresh pastel can be successfully applied over the previous one. You'll read more about these techniques later. But remember that whatever style or method you choose for your pastel paintings, multiple layers are the key to working with pastels successfully.

There are many ways to begin a pastel painting. The approach you prefer will depend on how you like to work in general. If you draw predominantly in line, you'll probably begin your pastel by first drawing in line and then filling in with color after you have finished your linear composition. My personal choice is to begin with undefined areas of cross-hatched color to create an extremely loose suggestion of the subject, and then develop the imagery and the form as I begin to add more pastel.

Here are three general ways of starting a pastel painting. These approaches are meant only as general guidelines, not as strict rules to be blindly obeyed. In actual practice many different styles and working methods overlap. Whatever your usual way of beginning a painting, you will find that pastels are adaptable to it.

BASIC APPROACHES TO PASTEL PAINTING

BLUE STILL LIFE
Pastel on museum board,
19 1/2 × 28" (50 × 71 cm).
Collection of Greene Art
Gallery & Sculptors' Guild,
Guilford, Connecticut.

*This large still life
illustrates how linear,
cross-hatching, and
blocking-in techniques
can be integrated
into one painting.
The basic approaches
described in this
section are not meant
to be rigid formulas,
but devices that you
can alter or combine
to achieve what you
want in a painting.*

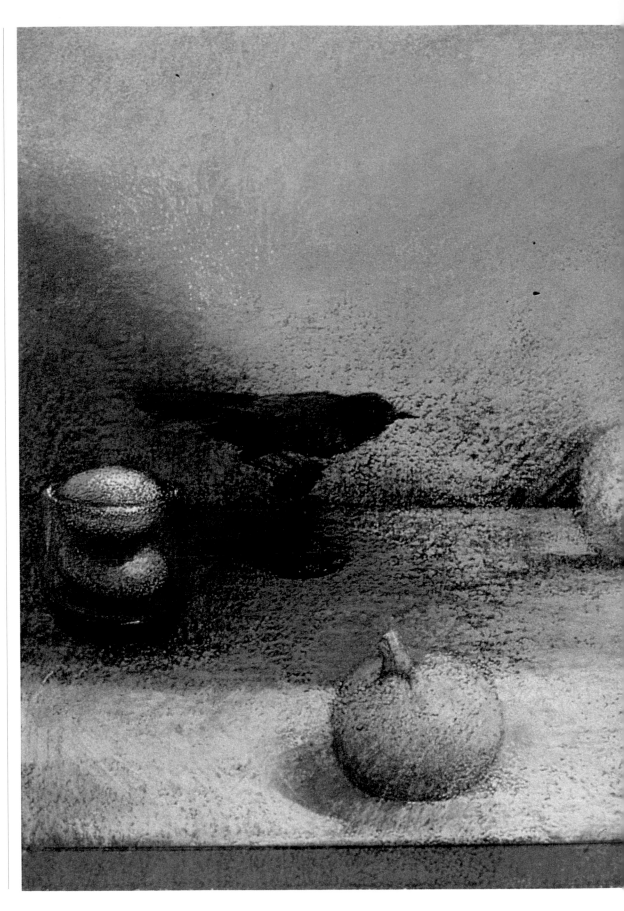

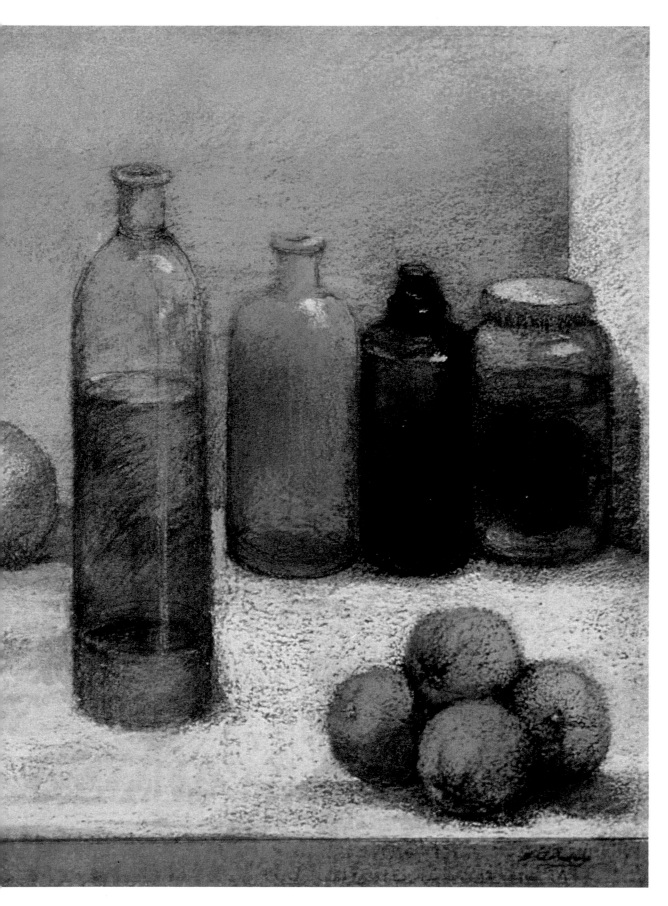

THE LINEAR APPROACH

In this method, the painting is started as a drawing, usually rendered in one color and in line only, that defines both form and outline. Lines can be both clear and very expressive. Even simple doodling can reveal pleasant surprises if you are relaxed and have a supple drawing hand. As long as the basic composition is in line, it is easy to make changes and corrections. Then, after rendering the entire composition as a line drawing, you proceed to finish the painting by filling in the outlines with broad strokes of pastel color.

Hard pastel or pastel pencils are ideal for making line drawings. Both pastel pencils and hard pastels leave a minimum of pastel on the support, so changes and corrections in the linear compositions can be made cleanly and fast.

Even at the early stages of a pastel drawing, try experimenting with a variety of linear pastel strokes. Vary the pressure on the edges of the hard pastels and see what subtle variations are possible. Relax and let the drawing emerge.

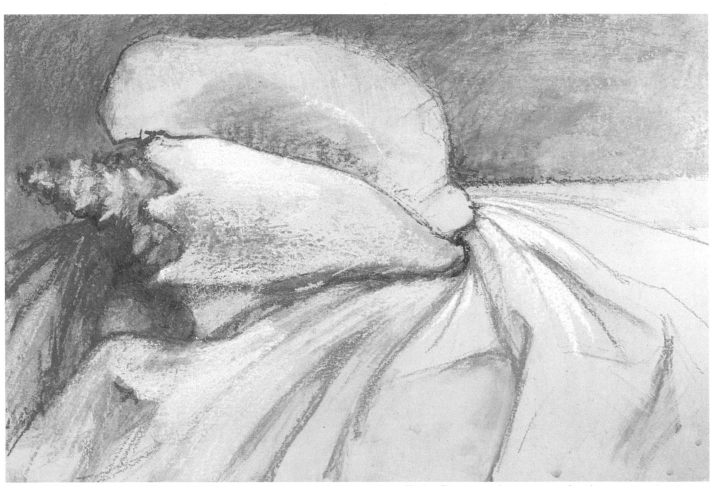

THE SHELL
Pastel on Multimedia Artboard coated with light blue gesso, 10 1/4 × 15" (26 × 38 cm). Collection of the artist.

This partially finished rendering of a shell shows how effective linear pastel passages can be when contrasted with more rendered or finished areas. The green lines of the unfinished drapery stand in strong contrast to the volumetric rendering of the shell itself, and the two opposing qualities of line and volume act as a foil to each other.

DEMONSTRATION

The linear approach involves rendering the subject in line first, usually with hard pastels. Then the painting is finished by supplementing the linear shapes with broader areas of color. Color can be filled in with hard pastels, soft pastels, or a combination of both. Details and refinements can also be worked in with pastel pencils.

If any corrections are needed, this is the best time to make them, before there is too much build-up of pastel color. A fresh kneaded eraser will easily remove the pastel pencil lines.

For this piece I've chosen black textured paper to create a dark finished tonality without a heavy build-up of pastel color. I begin by drawing a few simple compositional elements with a light blue Othello pastel pencil: an empty glass and the edge of the table. I use no shading or rendering at this point, just clean, simple lines. With a light yellow Othello pencil, I add the outline of the lemon wedge in the glass. Now I draw the entire lobster with a bright red Othello pastel pencil. I've made my drawing entirely with obviously local colors so that even in this early stage I can get some idea of what the entire picture will eventually look like.

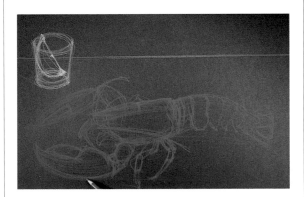

Using various colors of hard pastels, I begin to fill in the composition with more color. I use a hatching stroke for both modeling and rendering. The idea at this point is not to blend or smooth the color, but to work directly and let the pastel strokes show.

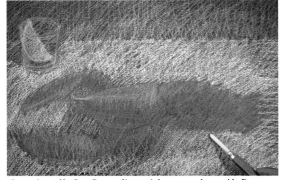

Occasionally I refine a line with a pastel pencil. By this time the simple local colors have become more subtle because several hues have been cross-hatched over one another. Here I am adding more hard pastel color. Notice that the pastel stick is in a holder, which extends the pastel's length and allows a more gestural stroke.

THE LINEAR APPROACH

Here is the completed layer of hard pastel. All the open forms have been filled in with cross-hatched color, the basic under-painting on which further refinements will be made. I coat the entire painting with a layer of workable fixative. This will provide stronger adhesion for the subsequent layers of pastel.

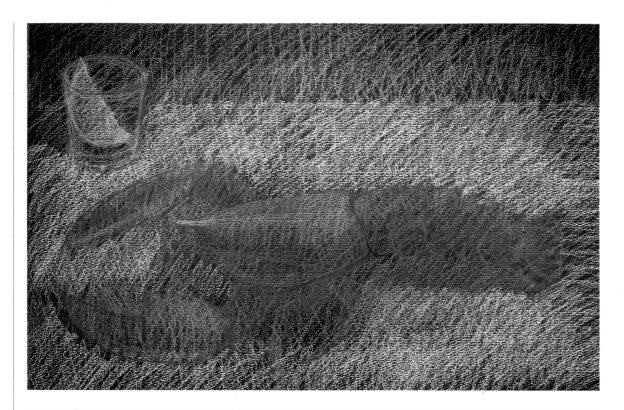

Next I use soft pastels to add details and refinements. The colors and texture have become denser and fuller, and the rendering is more direct.

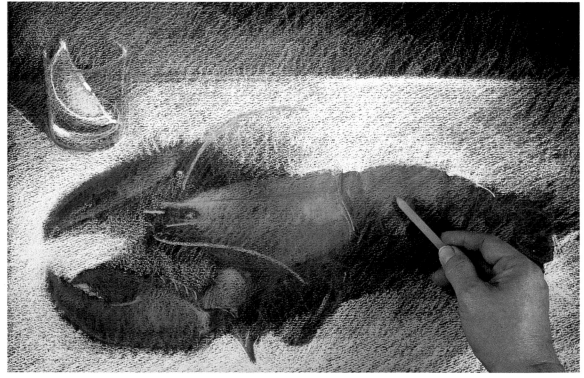

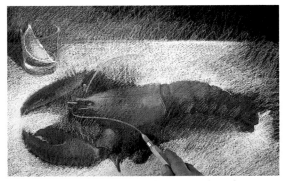

I still use hard pastels at this later stage, but almost exclusively for details.

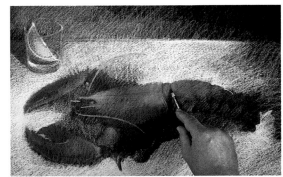

Toward the end of the painting process I also use pastel pencils for outlining shadows and details.

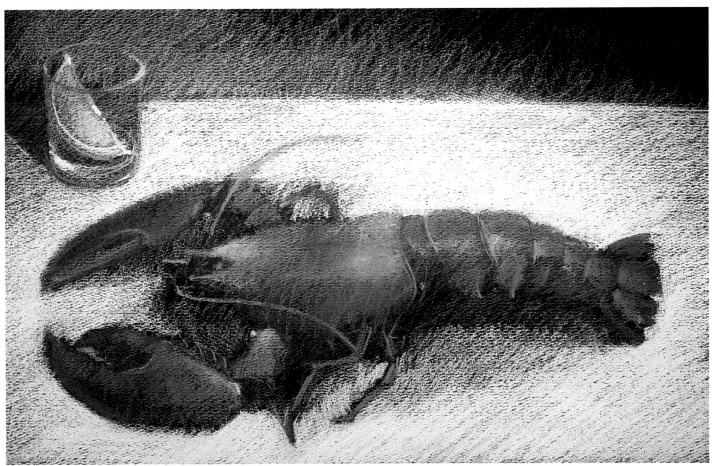

LOBSTER WITH LEMON
Pastel on black pastel paper,
14 × 22" (36 × 56 cm).
Collection of the artist.

The finished painting is a highly rendered still life and a good example of the linear approach. I've exploited the black paper here and there to add depth and mystery to the shadows.

THE MASSIVE OR BLOCKING-IN APPROACH

In the massive approach, you block in the composition with broad masses of pastel color, freely executed with the broad side of a soft pastel stick. In the early stages, give almost no consideration to the edges of the objects rendered. It is as if the elements of the painting are being molded in colors from the inside out, much like a piece of sculpture made of clay. As the painting develops, these blocks of color are slowly built up and molded into a more or less finished picture. Line work, while not used to create the composition or the larger elements of the painting, can be employed to help define and emphasize contours and to add details.

Soft pastels are best for applying the broad strokes that block in the major forms of the composition. Pressing the sides of the soft pastels against the paper in bold strokes creates not only mass and form but texture as well. By varying the pressure of the strokes, it is easy to create many interesting broken textures that seem to glisten with light and bring out the surface texture of the paper. But be careful to vary the strokes, and not to apply too much pressure. Forcing too many pastel particles into the tooth of paper results in an overloaded surface and muddy color.

BACKYARD
Pastel on rough watercolor paper, 9 × 12" (23 × 30 cm). Collection of Carol Schmidt.

This is the house next door to where I was raised in New Orleans. I drew this pastel directly on the spot, using large shapes of light and dark colors to block out the entire composition. Each layer of pastel was heavily fixed as I worked, and more details were added only at the final stages. To catch the afternoon light, I had to work very fast—and working in pastel helped me do this.

DEMONSTRATION

In the massive approach to pastel painting, color and form are built up simultaneously by blocking in large areas of color. Large sticks of soft pastel work best for this approach because their broad sides can fill in a wide space quickly. Lines and details are added only near the end of the drawing if at all.

This close-up view of one of the apples shows how loose the drawing is at this early stage.

I begin by blocking in the largest forms of the composition, using the broad side of soft pastel sticks in order to keep the shapes big and free of detail. I draw lightly, leaving the color open and floating on top of the paper, because I do not want much build-up of pigment this early in the composition. The paper will almost certainly fill with pastel as the work progresses, maybe almost to the point of saturation. But I feel confident that the excellent paper I'm working with (French Colors) will be capable of holding enormous amounts of raw pastel.

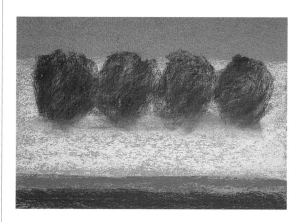

Now I begin to give dimension to the apples. The underpainting is dark, so I use lighter colors to model the forms. I also use a more or less analogous color scheme in order to keep the color under control. (See pages 94-95 for more about analogous color.)

THE MASSIVE OR BLOCKING-IN APPROACH

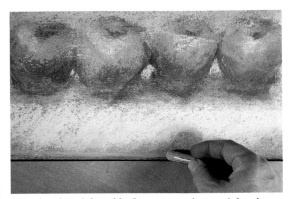

For the edge of the table, I use a wooden straight edge to draw a straight pastel line.

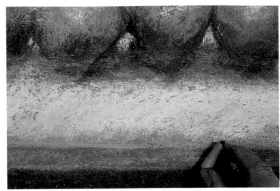

Then I soften the edge and create a reflective scumble by dragging a soft pastel over the underlying colors.

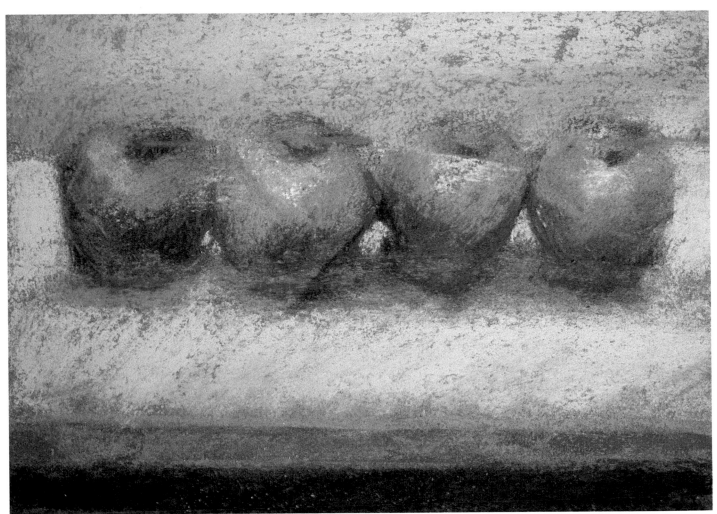

The painting is still very loose at this stage, but the apples now have volume. Although the texture remains rough, the scumbled colors create a delicate atmospheric light, a quality I want to keep. Except for the table edge, there are still no lines in the painting.

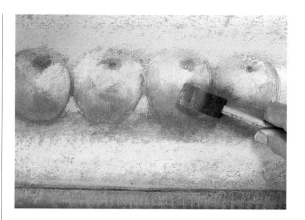

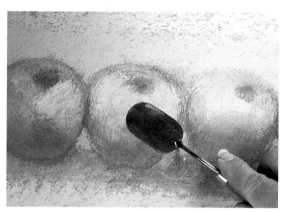

A close-up of one of the apples shows that even though the rendering is now becoming more volumetric, the actual application of pastel is still very loose and nonlinear.

Here I am using a dry sponge brush to blend the colors of the apples, then a flat palette knife to press the colors down into the paper. (It is important that the palette knife be clean and smooth for this.) Next I reinforce the edge of the tabletop with a dark Conté crayon, guided by as plastic straight edge.

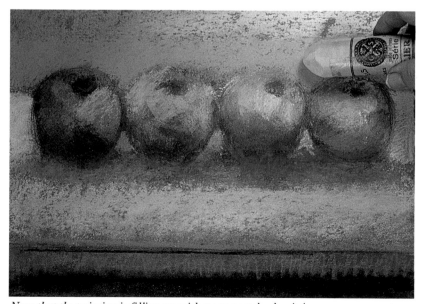

Now that the painting is filling up with more pastel color, it becomes necessary to use larger and softer pastels, such as this giant soft pastel by Sennelier. These rich, smooth pastels keep the colors free and open.

THE MASSIVE OR BLOCKING-IN APPROACH

I also use an ordinary soft lead pencil to reinforce dark areas and outlines. A pencil eraser makes an excellent blending tool, especially when a painting is nearing completion. It blends the color without removing too much pastel.

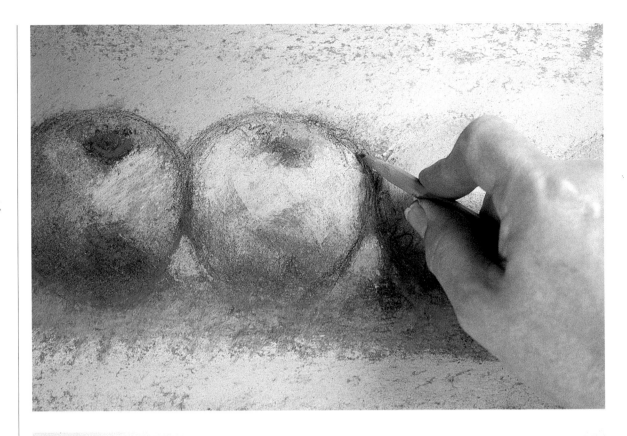

By this time the paper has become quite saturated with pastel. Since I'm far from finished, I decide to give the painting a layer of fixative before completing it.

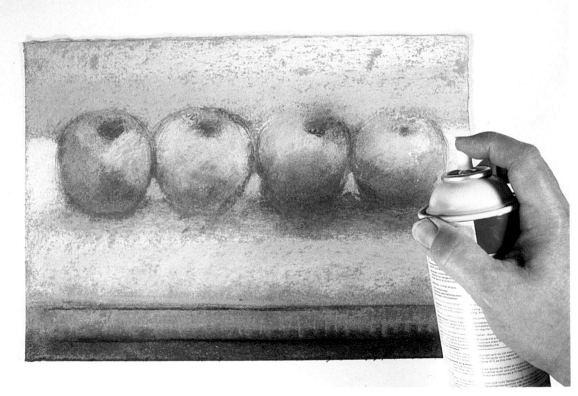

Using extremely soft pastels, I complete the final rendering of the apples. Here you see a warm white Sennelier.

I use a pastel pencil to reestablish local color for the brown stems. Soft pastel easily smudges over details, so that they must be redefined at the very end.

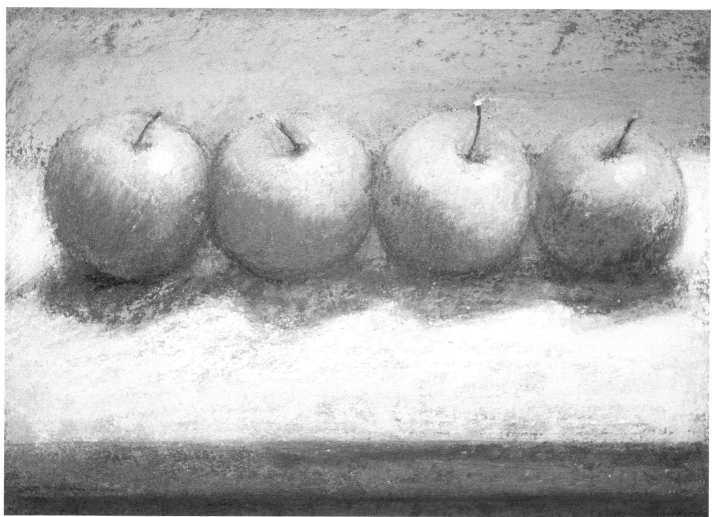

FOUR APPLES
Pastel on French Colors paper,
10 × 14" (25 × 36 cm).
Collection of Candace Raney.

Here is the finished painting. In this example of the blocking-in approach, the forms of the apples are clearly rendered, yet the pastel surface has a rough and interesting texture that emits a creamy yellow-green light.

THE ATMOSPHERIC APPROACH

The atmospheric approach is a form of cross-hatch drawing that employs both line and mass to build a composition. Many criss-crossed lines of color converge in the viewer's eye to create a range of shimmering tones, which are more interesting than a single area of flat color. (Pointillism uses a similar principle, but with adjacent dots rather than lines.) Cross-hatching techniques let you use your pastels to draw hazy patterns from which your composition gradually becomes clearer and more defined as it emerges from a glow of color. The effect is more atmospheric than solid or opaque.

Almost no attention to detail is necessary, because the idea is to create webs of broken color that leave open the option of making many changes as the painting develops. This approach to pastel painting is recommended for artists who like to keep their wrists loose and imaginations free, and who (like me) may not know exactly what direction they want to go in when they begin to start a painting, but take advantage of "happy accidents" along the way.

PEAR AND EGG
Pastel on Canson paper,
9 × 12" (23 × 30 cm).
Collection of the artist.

This atmospheric still life was drawn in a series of cross-hatched layers using both hard and soft pastels. This approach suggests forms rather than crisply outlining or defining them.

DEMONSTRATION

The atmospheric approach involves starting a pastel much as if it were a cross-hatched drawing. The picture is started with thin pastel pencils and is further developed with hard pastels; finishing touches can be added with soft pastels where desired. The idea is to keep the images loose, atmospheric, and painterly, and to use line only for clarifying details as the painting nears completion. The image gradually emerges from a hazy web consisting of overlapping lines of many different colors, and eventually gives the finished painting an exciting texture, far more interesting to the eye than areas of pure, flat color.

Using various colors of pastel pencils, I draw the objects within a maze of cross-hatched lines. None of the colors are blended together.

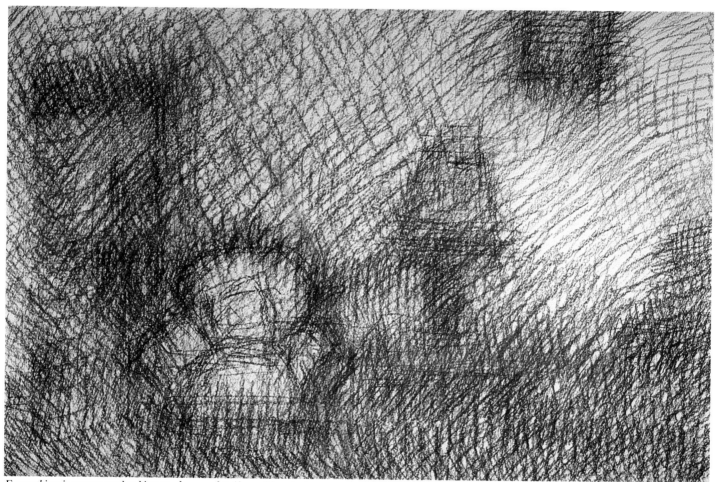

Everything is vague and subject to change; details and hard edges are nonexistent at this point. The important thing is to create a sense of atmosphere, or a mist of color from which specifics can later emerge.

THE ATMOSPHERIC APPROACH

After completing the first layer of the composition with pastel pencils, I switch to NuPastels to add more color. It is important to continue the cross-hatching drawing style with the hard pastels as well to keep the line quality broken.

Now that the hard pastel layer is completed, the effect is a simultaneous combination of pastel strokes that seem almost woven together to create the forms. Enough cross-hatching will still show through to create a richly vibrant texture in the finished painting.

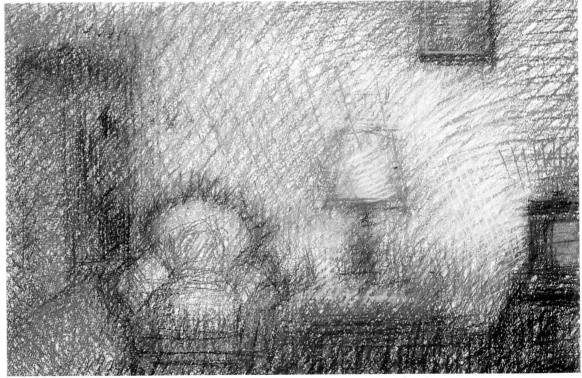

I complete the painting by spraying it lightly with workable fixative and scumbling soft pastels over the hard pastel layer.

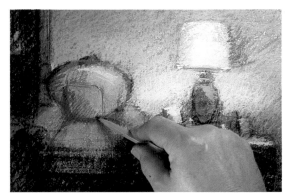

Using a soft lead pencil, I add a few darks and emphasize selected contours.

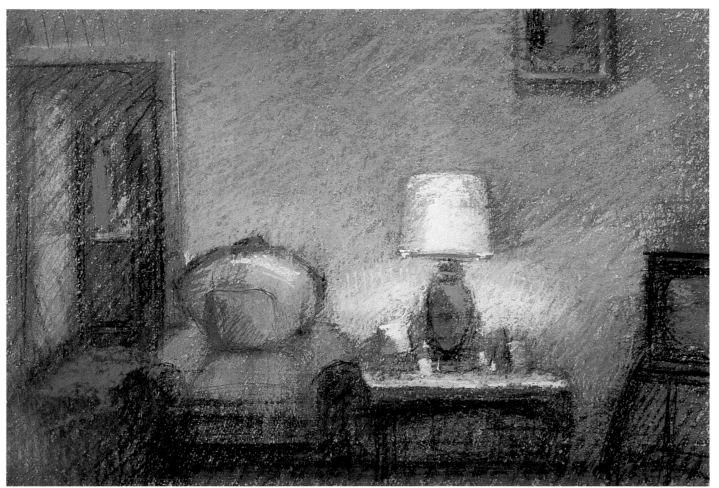

INTERIOR
Pastel on T.H. Saunders cold-pressed
watercolor paper, 12 × 16" (30 × 41 cm).
Private collection.

Here is the finished atmospheric painting. The soft pastel scumbled over the hard cross-hatching creates a scintillating broken texture full of light and subtle colors.

MAKING CORRECTIONS

Very often it becomes necessary to make corrections in a painting. One of the major advantages of working in pastel is that you can rework your drawing as fast as your ideas change, as long as you take a few precautions.

In the early stages of a pastel painting, corrections usually mean correcting the basic drawing. Lightly tap the paper to shake off any loose particles of pastels. Then either erase the original drawing with a soft kneaded eraser, or—as many artists do—simply start drawing the new corrections over the original version. Unlike oil paints, pastels are extremely opaque. This quality is very helpful for correcting a drawing in progress.

Corrections in later stages are more difficult because of the build-up of pastel on the paper surface. New layers of pastel will not adhere well and are in danger of muddying the color. However, if you carefully scrape off as much pastel as possible with a razor or other tool, you can then apply a fresh layer of pastel. Be careful not to damage or dull the nibs of the paper fibers with the razor blade, and to prevent the scraped-off accumulations of pastel dust from falling onto other areas of the painting.

If used cautiously, this scraping technique is very useful, not only for corrections but also for deliberately creating highlights or unusual textures. Scraping techniques—also called sgraffito, which is Italian for incised marks—are particularly effective with oil pastel. (See page 138 for more about this.) Even with chalk pastels, the scraping away of colors can lead to an interesting variety of textures.

Another alternative is *not* to scrape off the area you wish to change, but instead to fix it heavily and then cover it with fresh pastel. (The color change caused by the heavy spraying is unimportant because it will be covered anyway.) However, the disadvantage of this method is that you risk pentimento—the reappearance of an earlier image. Because fixative tends to meld particles of pastel together—including those from different layers—you may find that an unscraped error you had completely covered shows up again when you fix the finished pastel. This is especially true if the correction is lighter than the old version. For this reason you are safer scraping off the error before making your correction.

DEMONSTRATION

Making corrections with pastels almost always means removing pastel dust from the unwanted area and then redrawing over it with fresh pastels. The best time to do this is early on, before there is too much of a build-up of pastel dust. However, because pastel has no paint film, it is always possible to scrape away large portions of pastel dust from a painting.

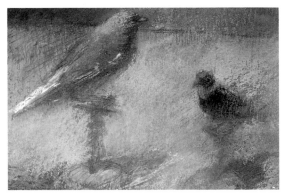

In this still life of two stuffed birds, I'm going to remove the small dark one on the right.

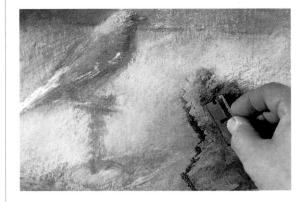

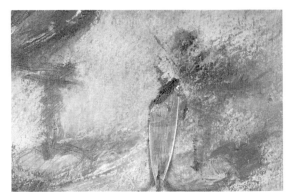

I begin by scraping away as much pastel as possible with a razor blade, then remove the scrapings with a palette knife to prevent them from dirtying other parts of the painting.

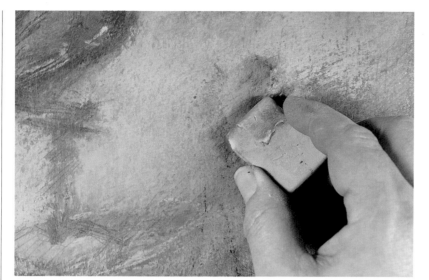

Next I use several kinds of erasers to continue removing the unwanted pastel. A kneaded eraser removes pastel dust very cleanly and is gentle on the paper support. For getting down to the paper surface in a hurry or for erasing large areas, I recommend a Magic Rub vinyl eraser, which is also harmless to the paper and leaves no "ghost mark." Kneaded erasers absorb pastel dust, while vinyl erasers simply rub it off.

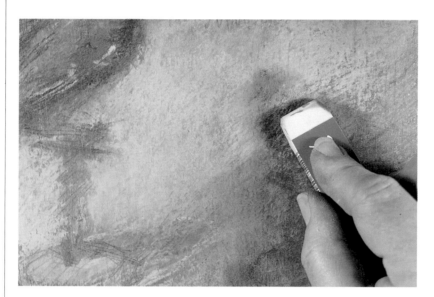

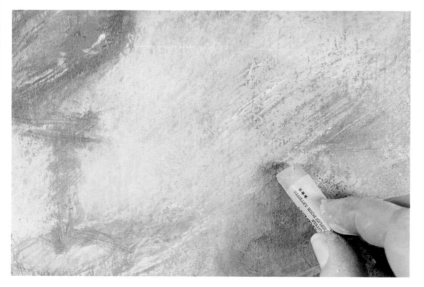

With an extremely soft pastel, I draw over the corrected area. The new color doesn't quite match the gray of the original background. I therefore apply workable fixative to the freshly covered area, so that another coat of fresh soft pastel will adhere better.

MAKING CORRECTIONS

Now I rework the entire background in order to unify the tones and color.

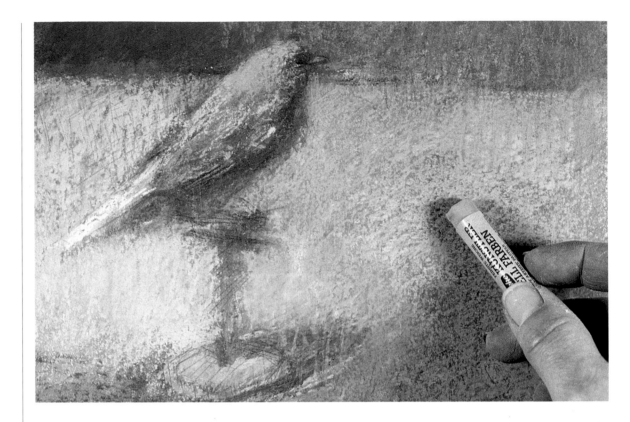

Here is the finished result. The second bird has been completely removed and covered with fresh pastel. Soft pastel is a very forgiving medium for making corrections because it is quite opaque, far more so than oil paint. Carefully corrected mistakes rarely show through.

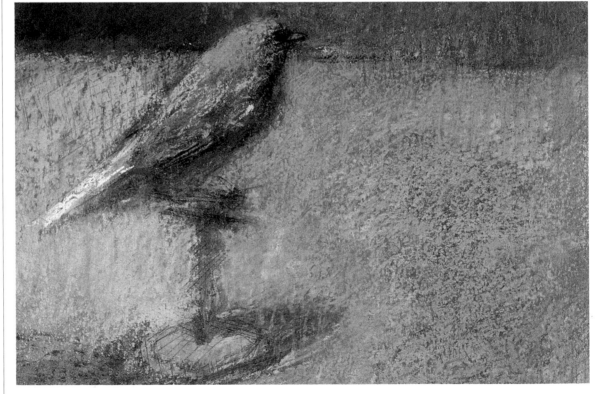

THE ROLE OF FIXATIVES

Fixative is a weak varnish, usually a highly diluted solution of damar crystals and alcohol. Its primary function is to fix, or hold down, the small particles of pastel color onto the fibers of their support so that they do not dust off. Two types of fixatives are commonly used in pastel painting: workable fixative and final fixative. Blair Spray-Fix Workable Matte Fixative and Krylon Workable Fixative are excellent workable fixatives, and Rowney Perfix Colourless Low Odor Fixative is a final fixative of very high quality.

Workable fixative. Workable fixative is very light and intended for work in progress. When the tooth of the paper is filled with pastel dust, it becomes necessary to lightly fix the surface before applying a fresh layer. Workable fixative makes it possible to create a pastel painting in multiple layers without the risk of too much heavy build-up of pastel chalk. This is important, because (as discussed earlier) the concept of working in layers is basic to many pastel techniques. Without occasional sprays of workable fixative, it would be impossible to build up rich impastos or to create beautiful scumbled textures.

Workable fixative can be applied either to small, isolated areas of a painting or as an overall general coating. For a heavy localized application, you can hold the can of fixative as close as 6 inches (15 cm) away from the painting. For a lighter coat, spray from about 18 to 24 inches (46 to 61 cm) away. The closer the fixative, the more focused the cone of the spray, and therefore the stronger the effect of the fixative. You can also use a template to mask off any sections of the painting you do not want to spray.

Both workable and final fixative dry rapidly. The alcohol in them evaporates almost instantly, and it is possible to resume working on a pastel almost immediately after spraying. However, it is a good idea to avoid breathing fixative, and the vapors hover around a painting for a while after it has been fixed. I suggest physically moving away from a freshly fixed pastel and leaving it to air in a separate, well-ventilated place for at least 30 minutes until most of the vapors have dissipated.

Final fixative. Pastel will remain in its original condition as long as its support survives. However, pastel is vulnerable to friction and must be protected against any rubbing or scraping across the surface. Final fixative helps to protect a finished pastel painting. Even so, every pastelist should realize that no amount of fixative is enough to protect a finished work completely. Only placing a pastel in a frame under glass can really guarantee its safety from damage caused by accidental brushing against the surface.

I spray all my finished pastel paintings with at least two coats of final fixative. After propping up the painting at a 45 degree angle, I spray the entire surface lightly from a distance of 18 to 24 inches. Half an hour to an hour later, I apply the second coat. Remember that two light coats are better than one heavy coat and far less likely to run or create unwanted splotches.

How fixatives affect color. The use of fixatives is highly controversial among pastelists because it tends to darken the colors of a pastel painting. This can be a problem, but the darkening effect can also be controlled or even used deliberately to create special effects.

Excessive amounts of fixative will not only darken a pastel but also harden its surface into a crust. This crust is not as hard as the thin film that develops on the surface of a fully dry oil painting, but it still adheres the pastel color very firmly to its support. It also alters the overall look of the painting more than many pastelists would wish. However, light sprays of fixative may change the color and appearance very subtly or even imperceptibly. Many pastelists are willing to accept this risk in return for the increased adhesion between pastel and support, which allows them to work in multiple layers.

Darkening pastel colors by deliberately overspraying with fixative is called heavy fixing. This technique often results in rich, translucent colors that cannot be obtained in any other way. A firmly fixed, darkened underpainting provides a marvelous foundation for many textures. For example, scumbling a lighter color on top works best when the layer below is fixed firmly enough not to lift up when fresh color is applied over it. (See pages 82-85 for more details about special uses of fixative.)

Every pastelist should become familiar with the many uses of fixative. Experiment with it to discover how to achieve various effects, and then incorporate the techniques that work best for you into your artistic repertoire.

PASTEL
TEXTURES

Few mediums can rival pastel for its effortless ability to create a variety of gorgeous textures. If seductive textures seem to come easily when you work with pastel, don't resist them! Sensuous texture is what pastel is all about.

The textural possibilities of this medium are almost limitless. Pastel will mirror the physical surface of all kinds of supports. Colors can be gently blended into seamless perfection, or they can be ground and pushed into the paper with palette knives and razors. Droplets of fixative can be spattered onto thick mounds of soft pastel to produce intriguing dappled textures. Ordinary soft lead drawing pencils can activate a flat plane of color and make it shimmer. Buttery mounds of soft pastel can be scumbled over one another to create broken colors that retain their own identity yet combine optically from a distance.

A pastel stick is an intimate painting and drawing tool, worked very directly with the artist's hand. This means that it responds to the subtle nuances of your touch in a gratifyingly immediate way. The longer you work with pastel, the more ways you will discover to build up expressive textures, and to use texture and color together to bring a painting to life.

BLENDED VERSUS BROKEN COLOR

Blended color is rendered to a smooth, even finish; broken color has a rough, textured finish. Pastel lends itself well to either kind of texture, and the choice of style is largely a matter of taste or artistic intent. Smooth or sanded paper works best for blended color and rough paper or canvas works best for broken color. But there is also a difference in the way color is handled. Blended color mixes colors together directly and then is smoothed out to a fine finish; in broken color the individual pastel colors are worked in separate and distinct layers. Broken color depends on optical blending of separate colors closely juxtaposed.

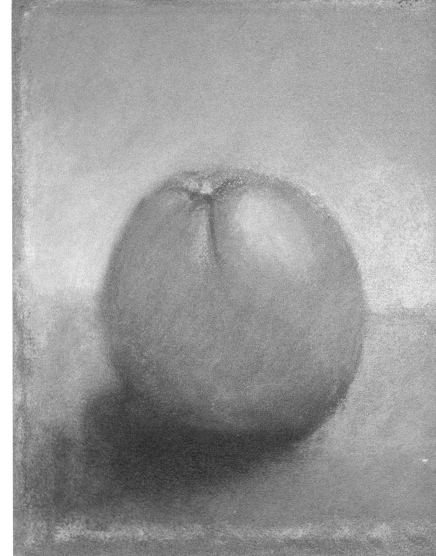

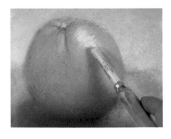

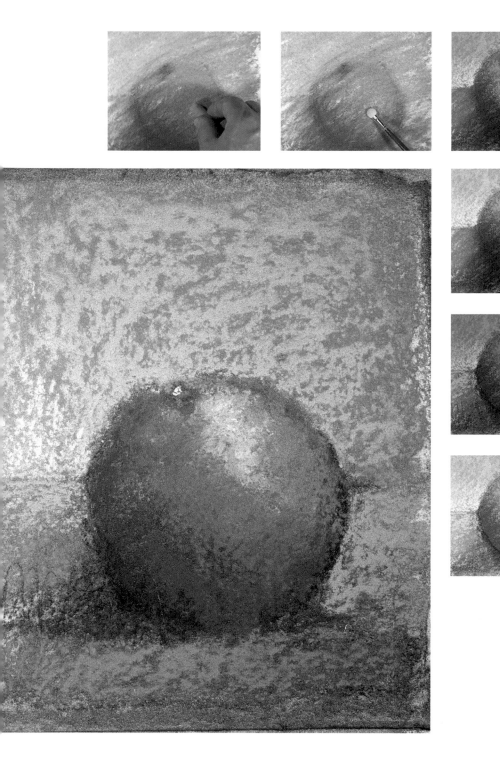

BLENDED VERSUS BROKEN COLOR

Blended color technique. One of the chief advantages of pastels is that they can be blended very easily. A tremendous range of subtle effects can be achieved by blending pastels together. Some of the most common tools used for blending pastels are fingertips, rags, tissues, brushes, chamois, stumps and tortillions, and erasers. Tools such as rags and chamois are used to blend very large areas of color, while fingers and paper tortillions work best for smaller, more detailed areas of the painting. Brushes can also blend very fine details.

In many ways your fingers are among the best blending tools ever invented. They're extremely sensitive and always available, and—forgive my reminding you of the obvious—they come in five different sizes. Fingertips move pastels around without removing them from the paper.

But be aware that too much pastel dust is not good for your skin, and the friction of constantly rubbing pastels into the paper will dehydrate your fingertips. For this reason it is best to become acquainted with a variety of blending tools.

Blending is often used to soften the edge between two adjacent colors. In nature some edges are harder than others, and pastelists have a great deal of choice about how much gradation to give each edge in a painting, what to blend and what to leave hard and distinct. Most paintings contain a variety of edges for maximum contrast and visual interest.

Blending is most effective with the first coat of pastel on fresh paper. A heavy build-up of many layers of pastel is hard to control, and the resulting colors are often dull and muddy.

HOLLAND TUNNEL VENTS
Pastel on Fabriano
140 lb. watercolor paper,
12 × 12" (30 × 30 cm).
Collection of Kathie Brown.
Photo by D. James Dee.

This landscape is an example of blended, even-textured pastel color. Compare its texture with that of the painting on the opposite page.

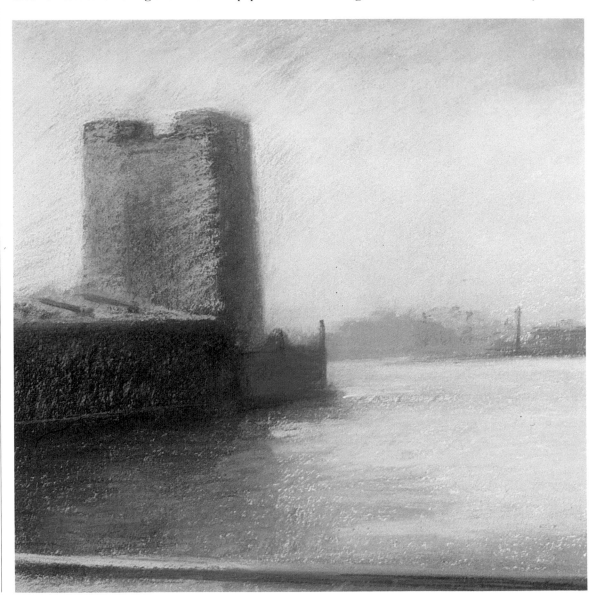

Pastels blend together so easily and smoothly that some artists are seduced into doing too much blending. Soft-focus effects are very appealing when used sparingly, but relying too heavily on them will weaken the overall impact of a painting.

Broken color technique. Unless pastel is deliberately blended, its color is not smooth and flat. Instead it remains separated, unevenly distributed across the surface of the paper. This is called broken color, and it can be strikingly beautiful. Broken color is one of the greatest strengths of the pastel medium. If you can master broken color, you have truly mastered pastels.

There are several techniques for achieving broken color. The texture of the paper is an important factor because, as mentioned earlier, pastel mirrors the texture of its support. Pastel lightly dragged over rough paper leaves the tiny depressions of the paper untouched for a broken look—in fact, this combination is ideal for broken color. A similar technique can be used to scumble one color over another that has been adhered to the paper with fixative.

Of all pastel techniques, broken color comes closest to the impressionist approach to oil painting. Pastel can be applied in small dabs of pure color that retain their individual identity but form a scintillating texture and merge in the viewer's eye from a distance. Such pastels often resemble miniature impressionist paintings.

Because broken color is so important to pastel technique, let's look more closely at some specific ways to achieve it.

THE SHIP
Pastel on Fabriano 140 lb. watercolor paper, 12 × 12" (30 × 30 cm). Collection of Municipal Assistance Corporation for the City of New York. Photo by Municipal Assistance Corporation for the City of New York.

This is an excellent example of broken color. The rough texture of this pastel was created by cross-hatching with a soft pencil through soft pastels to create an atmospheric feeling.

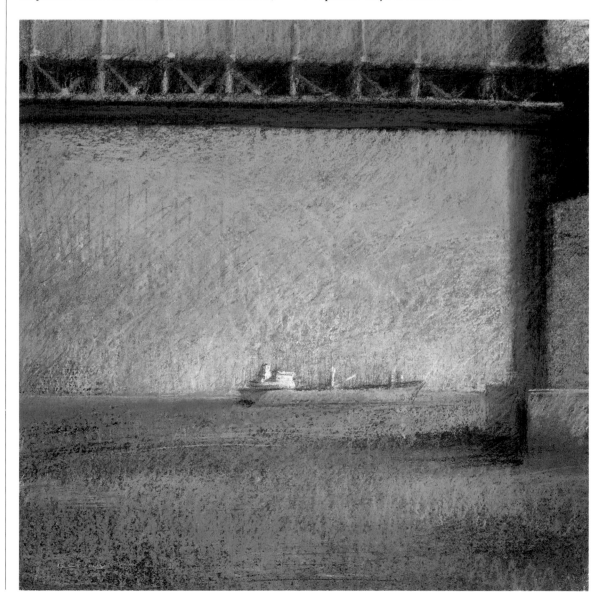

BLENDED VERSUS BROKEN COLOR

For the blended version of this landscape, I've chosen a matte, low-textured watercolor paper softer than a plate finish. At this point the basic composition has been established, and I am putting in a layer of very soft, light gray-blue to lighten the sky.

With a soft, long-hair watercolor brush, I spread the color across the sky, blending it into the other colors as I work. The soft brush has the advantage of spreading the pastels without leaving any texture or heavily built-up areas.

Next I use a flat palette knife to press this freshly blended color into the paper. The pressure of the palette knife also blends the color slightly.

DEMONSTRATION

The paintings in this demonstration are two renderings of the same landscape, designed to show the difference between broken color and blended color as well as some of the techniques used in achieving each style. As it happens, the blended color version has a deliberately subdued, almost achromatic palette, while the broken color is more brilliant. These color choices are merely subjective and have nothing to do with the surface qualities of either broken color or blended color.

I rework the details of the lamppost by working the pastels with the tip of a tortillon. The tip of this blending tool will easily remove pastel from its support, and its side can be used to gently blend the loose pastel dust where needed.

BATTERY PARK CITY VIEW
Pastel on Fabriano 140 lb. hot-pressed watercolor paper, 12 × 12" (30 × 30 cm). Collection of Mr. and Mrs. Craig D. Ripley.

The finished pastel is a landscape of subdued color and muted tones. I added more touches of soft pastel to bring more color to the water, and blended them with my finger. Almost all the colors were softly blended into each other.

For the broken color version, I use a very rough watercolor paper. This detail shows the rough surface after several layers of color have been worked up into a loose rendering of the landscape view. Note how much the texture already contrasts with the smooth, blended look of the preceding demonstration.

Using a giant Sennelier soft pastel, I add more color, skimming it across the rough surface of the painting to create a loose scumble.

Here I am scumbling on more color with a large, handmade green pastel. After stabilizing this area with fixative, I add more soft pastel color over it. The combination of many colors and heavy fixing makes this section of the painting very rough.

Moving around the painting, I dab and scumble various soft pastels onto the surface to build up more color and texture. I do not blend any of these colors.

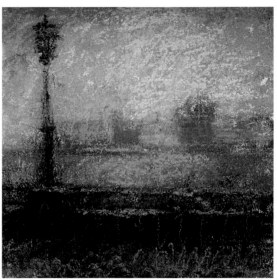

The painting is almost finished, but there are still some rough parts. The lower area needs to be brightened, and some details (such as the lamppost and railings) need clarification.

BATTERY PARK CITY VIEW
Pastel on 300 lb. rough watercolor paper, coated with sand, textured with modeling paste, and mounted on museum board; 12 × 12" (30 × 30 cm). Collection of Mr. and Mrs. Craig D. Ripley.

The finished painting successfully illustrates the broken color texture that I tried to preserve from the beginning. Several factors helped me to achieve this: very rough paper, direct application of soft pastels, liberal use of fixative, and unblended colors.

FEATHERING

Many pastelists use both blended and broken color in the same painting. One way to combine them is a technique called feathering. Feathering somewhat resembles cross-hatching but uses thin, parallel lines of one color drawn diagonally on top of another. The thin feathered strokes modify the base color and cast a subtle veil of texture over it. Feathering is best used over a flat or overly blended area of color and can restore vitality to an otherwise dulled section of a pastel.

This detail clearly shows the parallel feathered strokes. Either soft or hard pastels can be used for this technique. The important thing is to keep the pastel strokes parallel and to blend colors together only with the ends of the pastel sticks.

NIGHT STILL LIFE
Pastel on Fabriano 140 lb. cold-pressed watercolor paper, 12 × 17 ¹/₂" (30 × 44 cm). Collection of the artist.

This pastel is a fine example of the feathering technique. Interwoven parallel strokes blend gradually from one color to the next, enhancing the surface texture. The colors blend in the viewer's eye rather than on the surface of the painting; this is called optical blending.

SCUMBLING

Scumbling is a painting term that means lightly dragging one color over another one without totally covering it. In pastel painting, scumbling is achieved by applying very light strokes with the side of a soft pastel. This technique can create sensuous passages that combine texture with dazzling color combinations.

The secret of scumbling is to select a rough-textured paper, because an uneven surface helps separate the individual layers of color from one another. The rougher the paper, the more exaggerated the effect of the scumble. Many fine handmade art papers are ideal supports for scumbled pastels, as is coarse, heavy watercolor paper. It is important to remember not to push too much color onto the paper at the start of a painting because the paper fibers will become oversaturated with pastel chalk and will not accept additional layers of color.

Scumbling can be done either with light colors over dark or dark colors over light. In normal practice, no more than one or two colors can be scumbled over the first coat without the risk of making an unpleasant, overworked, smudged effect. When it becomes necessary to make changes or to continue building up color on top of color, apply a coat of workable fixative in order to prevent smudging. Fixed pastel layers have a tendency to grab and hold any fresh new colors that are applied over them. Any slight color change that may result from the fixative is preferable to a muddy overworking of the original colors. Many artists intentionally apply generous amounts of workable fixative to achieve a darker underpainting before scumbling lighter colors over it.

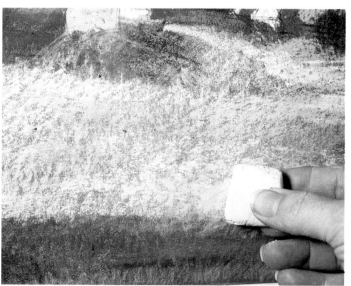

The foreground of this landscape was built up with several layers of fixed pastels that have fresher colors scumbled across them. Here I am scumbling a very soft pastel of light Naples yellow over the rough surface of the red earth underpainting. The resulting rich broken color establishes a strong foreground space, which acts as a stage setting for the landscape as a whole and creates a rich and varied texture that resembles the look of high grass. The finished painting that I am working on here appears on page 109.

DUSTING

Dusting is a special method that is unique to pastels. The artist shaves pastel particles from the stick onto the painting and presses them in place to leave a haze of color over certain areas. Both hard and soft pastels can be used, but hard pastels are more effective; soft pastels are more likely to disintegrate into large chunks rather than fine particles.

The basic procedure for dusting is very simple. Lay the painting flat, preferably in a place where there is no draft. Holding a pastel stick close to the painting's surface, use a razor blade or sharp palette knife to shave off small amounts of pastel onto the desired area of the painting. Dusting can be used to create effects ranging from an almost invisible veil of color to a completely opaque layer, depending on how much pastel you shave

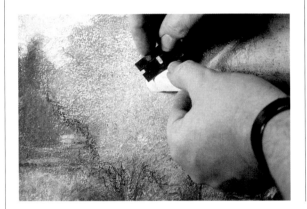

off. After practicing this technique for a while, you will know how much pastel to sprinkle on for various effects, but it is wise to start by dusting very small amounts of pastel and then build up the color in gradual layers.

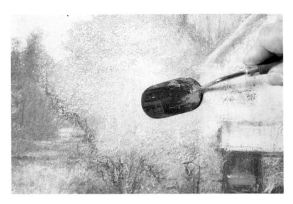

As the tiny particles fall into place, press them into the paper with a very clean palette knife, using straight downward pressure or a slight circular motion. (A dirty knife is not perfectly smooth and is therefore more likely to catch and move bits of pastel instead of simply flattening them.) As the pastel pieces are crushed into place, the small bursts of color widen and become more apparent. You can then decide whether to dust on more.

Dusting is a gentle way to soften your pastels. The gorgeous color effects that can be achieved with this technique are as varied as they are unpredictable.

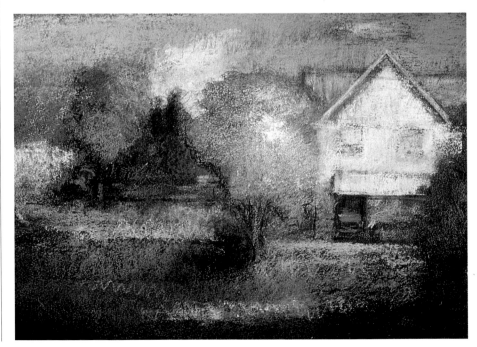

WALTER'S PLACE
Pastel on paper,
14 × 20" (36 × 51 cm).
Collection of Harriet
and Milton Rosen.

Dusting is a delicate technique for creating wonderful soft effects in a pastel painting. The powder-puff texture of the budding tree in this painting would have been difficult to achieve in any other way.

CREATING PASTEL TEXTURES WITH PENCIL

Another way to achieve broken color is to break up a flat surface of pastel with a soft drawing pencil or some other pointed tool. Drawing with a pencil through pastels lets you break out of the pastel mode for a change of pace. Yet at the same time it keeps your hands moving across the picture to search for an image or correct the composition. Constantly moving hands help an artist find ideas and keep the painting in a state of flux. This is a gesture drawing technique that prevents the mind from getting stuck partway through the drawing process, before the drawing is really finished.

Moving a pointed instrument through an unfinished pastel also breaks up the coating of pastel into smaller planes of color, which can then be sprayed and hardened with fixative. Dark cross-hatching with a soft lead pencil creates a soft, scintillating haze over the pastel painting. If this broken pastel-and-pencil surface is lightly fixed now and then and thereby hardened, it serves as a very interesting foundation over which fresh color can be added—a perfect opportunity for scumbling.

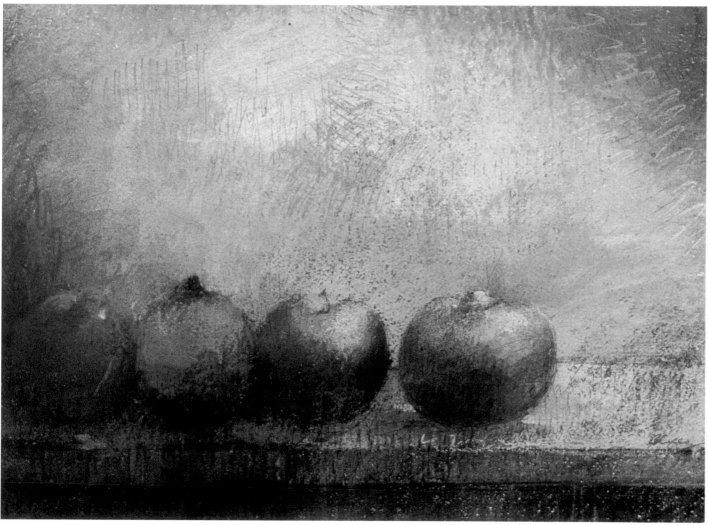

FRUIT
Pastel on paper, 11 × 13"
(28 × 33 cm). Private collection.
Photo by Aldo Mauro.

This painting was built up in several layers. By cross-hatching with pencils through the soft pastel, I established an interesting broken texture. The resulting mood is dark and settled.

CREATING PASTEL TEXTURES WITH FIXATIVE

Fixative serves many purposes for the pastelist beyond its obvious one of holding the pastel dust to its support. As mentioned earlier, fixative is a versatile tool whose side effects can be deliberately exploited. Either workable or final fixative can be used for most of these techniques, but workable fixative is preferable because it is stronger and changes color more.

Modeling form. Even though heavy fixing darkens pastels considerably, there are limits. For example, no matter how heavily you fix an area of pure white pastel, it will not turn black; the tone is only slightly darker than before. Because of this, fixative can be used to model three-dimensional forms and render tones from light to dark. Modeling by heavy fixing has the double advantage of being very fast and not causing unnecessary build-up of extra pastel.

This illustration shows how pastel fixative can be used to graduate tone. One color of pastel was applied to the entire panel, gradually intensifying toward the bottom, and a brush was used to blend the lower two-thirds. Then the right side was covered while the left side was sprayed with fixative. The amount of the sprayed fixative was increased toward the bottom, thereby making the color noticeably darker on the lower left than the lower right.

Creating transparent shadows. There are some interesting variations on the basic technique of heavy fixing. By spraying excessively in one spot and gradually lightening the spray toward the edges, you can achieve a sunburst effect. Templates and masks are also very helpful for spraying into one specific area of a painting. I often lay down a hard-edged mask, such as a large index card or a sheet of mat board, along the line that marks the edge of a plane. Then I spray fixative heavily into the shadows, where it provides just the subtle degree of darkness I want. Shadows in nature have a transparency that is hard to portray by just drawing flat dark tones; heavy fixing is a far more convincing way to bring them out.

Achieving splattered or broken textures. The aerosol can itself is a tool capable of achieving many special effects if you know how to use it. By varying the pressure you exert on the nozzle, you can adjust the consistency of the spray. Normal pressure yields a fine, even mist; just barely pressing down on the nozzle produces an uneven mist of larger, heavier drops. Such a spray often causes interesting spotted patterns and broken textures. In fact, one of the most useful tools for creating splattered effects is a defective nozzle. When a can of fixative runs low, tiny particles of dried fixative sometimes start to clog the nozzle's small openings. The spray from such a defective can is unpredictable and can impart new textural interest to a dull, lifeless section of a painting. After achieving beautiful textures in this way several times, you may find yourself deliberately saving nearly empty cans of fixative just for this purpose.

Creating special effects with raw fixative. Fixatives are available not only in the familiar aerosol cans, but also the old-fashioned way: in jars with removable caps. Blue Label Fixatif by Martin F. Weber is both strong and inexpensive; I find that Rowney's Perfix Colourless Fixative and Sennelier's Fixatif "Latour" change color the least. You can spray raw fixative with a mouth atomizer, or apply it in less conventional ways. Try pouring a small amount of raw fixative into a clear jar and using a soft brush to paint it across a pastel, pushing it into the low spots of

Fixative can be used for several special effects, as illustrated by this sheet of paper that was originally covered with an even coat of pastel. Top band: Sprayed fixative can create a gradual darkening of tone, shown here from upper left to lower right of the band; the rectangular insert was drawn on afterward and is an unfixed version of the same color. Middle band: Raw fixative was spattered over the pastel with a brush. Bottom band: Raw fixative was painted directly over the pastel with a brush.

the paper's surface. This is similar to using turpentine washes to spread your pastel colors, except that the fixative evaporates faster than turpentine and leaves more of a tooth to hold new layers of pastel. Painting with raw fixative works best in the early stages with light to moderate amounts of pastel. Remember to work quickly, because the fixative evaporates very fast! Clean the brush with rubbing alcohol or turpentine after you are finished.

There are even more drastic ways to use raw fixative. Spread it with a palette knife to get sharp, jagged edges, or use a bristle brush or toothbrush to spatter it across a painting for very large splotches and stains. Another interesting technique is to shave a small amount of pastel pigment into a jar of fixative and shake it well. After the pigment has dissolved, attach the jar to a spray atomizer and use it almost like an airbrush, spraying thin veils of color and fixing the pastel simultaneously. This method works well for subtle tone or mood changes in a painting that is nearly finished. Clean the atomizer afterward with rubbing alcohol.

DEMONSTRATION

This simple demonstration shows some of the special effects attainable with fixative in a pastel painting. Whether sprayed on over a template, splattered on with a brush, or sprayed from close up as a way to spread color, fixative is a very useful and versatile tool for the pastelist.

This simple still life of an orange is very loosely drawn in soft pastels and has not been fixed.

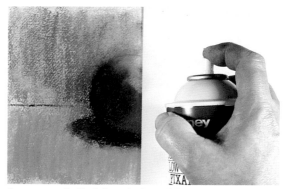

I cover one half of the painting with a sheet of paper and spray the exposed half heavily with fixative.

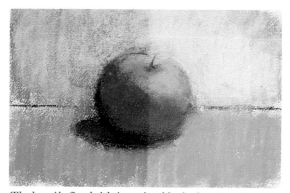

The heavily fixed side is noticeably darker than the unfixed side, but the color is not completely obscured.

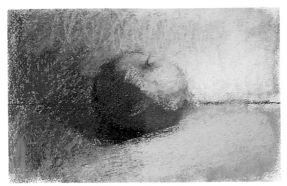

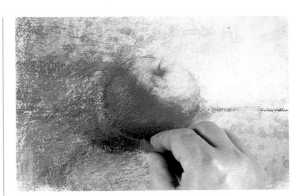

Once a second layer of soft pastel has been scumbled across the fixed layers, the abrupt vertical line between light and shade is no longer so conspicuous.

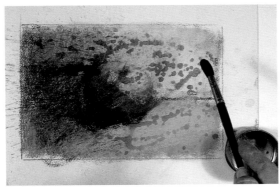

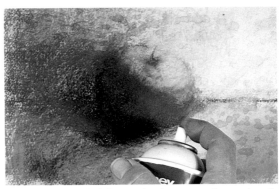

With a soft sable brush, I now spatter raw undiluted fixative across the pastel. This animates the surface by creating an uneven, spotted texture that will harden as it dries, so that fresh pastel will cling to it.

Now I apply a thick layer of red-orange soft pastel and spray it with fixative from an aerosol can, holding it just a few inches away. This powerfully direct shot of fixative spreads the fresh color to other parts of the painting, much like an airbrush. I use the same technique to add a dark indigo shadow and disperse its color into the background.

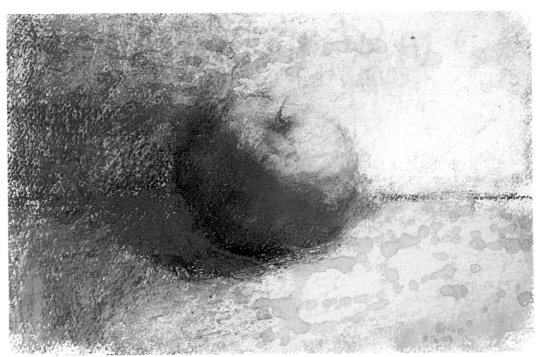

The finished painting displays a rich, vibrantly textured range of darks and lights. The heavily sprayed shadows have a luminous quality because of the diffusing action of the heavy sprays of fixative.

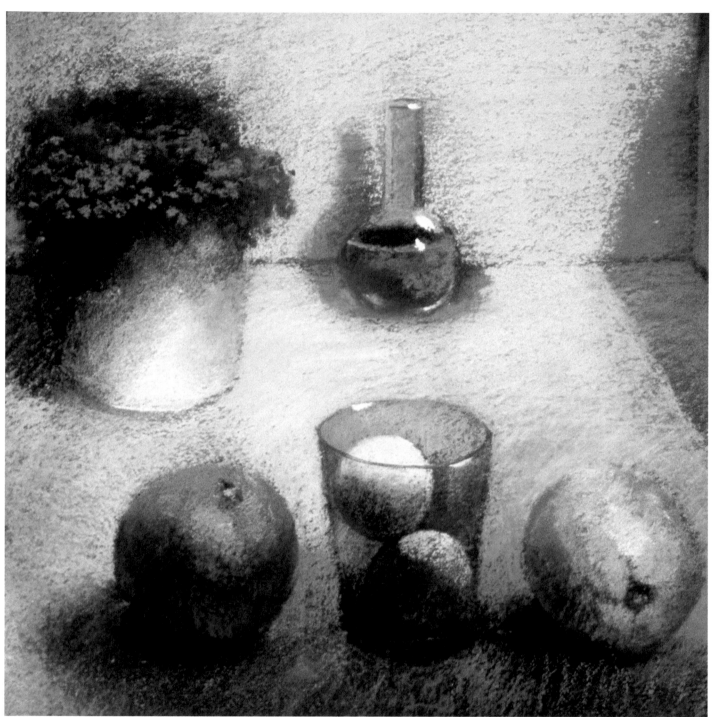

EGGS AND ORANGES
Pastel on heavy
watercolor paper,
12 × 12" (30 × 30 cm).
Collection of Walter and
Emily Luertzing. Photo by
Alexandra Timchula.

This still life is an example of how fixatives can influence the final look of a pastel painting, and how broken color can soften the edges of shadows. The dark tones of the eggs in the glass, and of the potted fern in the background, were made with layers of heavy fixing until the proper contrasts were achieved. Note how the dark underlayer of the fern's foliage still shows through the chrome green leaves to suggest a rich, soft texture. I also made the small vase darker in order to create more of an illusion of liquid and reflected light. The edges and surfaces of both glass objects have subtle highlights added, which contrast with the other textures.

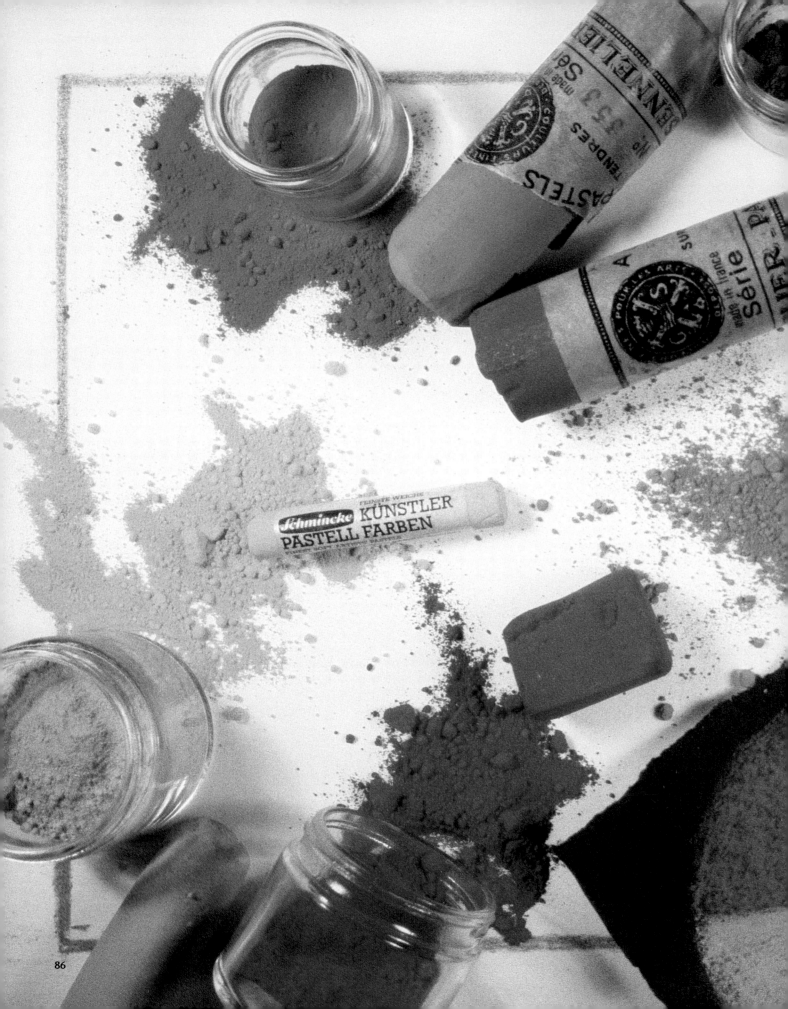

COLOR AND PASTELS

One of the truly wonderful qualities of pastel is the absolute purity of its colors. Pastel painting is as close as an artist can come to painting with pure color. No other medium succeeds so well at matching the freshness or intensity of the pigments themselves, because pastel is little more than a stick of finely ground pure pigment held together by a very weak binder. The photograph at left shows pastel sticks placed next to jars of raw pigments, and you can see that the colors are almost identical.

Think of your boxed set of pastels as a palette of pure pigments, each rolled into its own individual stick. Every stroke of pastel you apply leaves actual deposits of pigment clinging loosely to the fibers of their support. And pastels today come in every color imaginable, including dazzling metallic and iridescent hues.

Pastel color is opaque, matte, and nonreflective. These qualities make the hues appear crisper and purer, the whites appear more sparkling, and the dark colors and blacks glow like velvet. Pastels are also consistent in opacity from one pigment to another, which is not true with many paint mediums. For example, in oil paint most yellows are relatively transparent because of the way they react with linseed oil, but in pastels they are no more or less transparent than any other color. This reliability gives pastels an evenness of color that is not so easily obtainable in other mediums.

MAKING COLOR
WORK FOR YOU

Pastelists are constantly blending colors together to get new ones—either accidentally or intentionally—so a good working knowledge of color theory is extremely important. It is true that every artist's interpretation of color is a subjective and personal thing, and this is one reason why many artists resist a theoretical approach to color. But color theory doesn't dictate how artists should use color; it simply clarifies how colors interact and thus helps artists create whatever color effects they are seeking.

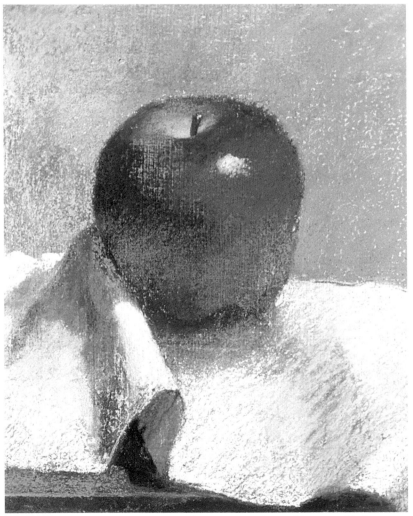

APPLE
Pastel on gessoed paper,
8 × 5" (20 × 13 cm).
Private collection.
Photo by D. James Dee.

This small still life successfully combines scumbled texture with naturalistic color. Notice the subtle complementary color relationship between the red apple and the gray-green background.

Let's face it: Color is one of the most difficult aspects of painting to master in any medium. (A frequent frustration of many beginning painters is knowing that a color doesn't quite look right but not knowing how to adjust it.) For this reason, I think a quick summary of the basics of color theory is appropriate for this book.

All colors can be classified according to their hue, value, and intensity. The interaction of these three qualities determines the precise identity of every color imaginable.

Hue is what we commonly think of as the color's name, and it describes where the color appears on the spectrum or color wheel. Red, orange, and blue-violet are all names of hues.

Value refers to the relative lightness or darkness of a color. White is the highest value, black is the lowest, and all other colors fall somewhere between them. For example, yellow is a lighter color than violet and therefore has a higher value. Bright red and bright green are similar in value even though they are very different hues. And pale blue is higher in value than dark blue because it contains more white.

Intensity refers to how bright a color is, how close to the radiant version that appears in the spectrum. Colors are at their purest and most brilliant in the spectrum; they become less intense as they become more neutral. There are three ways to neutralize a color: by adding white, by adding black, or by adding the color's complement (its opposite on the color wheel). Adding white or black changes the value but does not change the hue. Adding the complement changes the hue and may or may not change the value, depending on how similar the values of the two complements are. (For example, adding violet to yellow lowers its value far more than adding red to green.)

Hue, value, and intensity are also the three factors we can alter about a color—and pastelists are constantly changing the colors of their paintings. If you add a bright yellow to a bright blue, you have changed its hue to bright green. The intensity remains the same because the green is still bright, but the value is higher because the green contains a yellow lighter than the original blue. If you then add pure white to this bright green, you have mixed a lighter green, higher in value but less intense.

Adjusting colors in this way requires a lot of practice, but eventually you will develop an intuitive sense of color.

THE COLOR WHEEL

When white light is refracted through a prism, it is spread out into a band of brilliant colors known as the spectrum, the familiar colors of the rainbow. A common device to help artists work with spectral-intensity colors is to bend the spectrum into a circle, known as the color wheel. Because the color wheel makes it possible to visualize the abstract relationships among colors, it can help you keep your pastel colors as bright and intense as possible.

All other colors can be obtained by mixing the three primaries: red, yellow, and blue. The secondary colors fall between the primaries on the color wheel and are the result of combining them: Blue and yellow make green, red and yellow make orange, red and blue make violet.

The remaining hues on the color wheel, the six tertiary colors, are derived by mixing the primaries and secondaries. Yellow-orange, blue-green, and so on are tertiary colors.

As mentioned earlier, any two colors directly opposite each other on the color wheel are complements. Blue and orange, red and green, and yellow-green and red-violet are examples of complementary pairs. (See pages 96-99 for more about the many uses of complementary colors in pastel painting.)

Analogous colors are families of colors that share the same primary, so that they are adjacent to each other on the color wheel. For example, orange, red-orange, red, and red-violet all have red in common and therefore make a harmonious warm color combination. This type of color scheme is discussed further on pages 94-95.

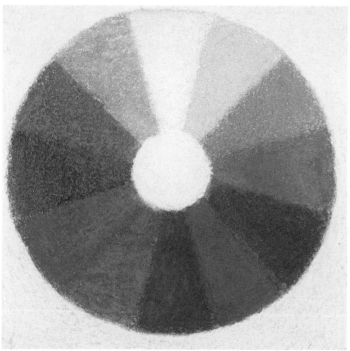

Here is a basic color wheel rendered in soft pastels. These 12 colors are the primaries (yellow, red, and blue), secondaries (orange, violet, and green), and tertiaries (yellow-orange, red-orange, red-violet, blue-violet, blue-green, and yellow-green).

This chart shows the effects of combining primary colors with their complements. Each band of color has a primary on the left side: yellow, blue, and red. These colors have been gradually blended with their complements, which appear in pure form on the right edge: violet, orange, and green. Each band has neutral colors in the center, where the pairs of complements blend.

VALUE AND THE ILLUSION OF VOLUME

Physically a painting or drawing is a flat, two-dimensional surface with length and width but no depth. Yet the artist is constantly called upon to create the illusion of three dimensions, to make objects look as if they have weight and volume and exist in a believable space. This is called modeling form, and it is accomplished by adjusting light and dark tones. Value, not color, is the artist's chief tool for establishing the illusion of volume. Because pastelists draw with color, they must concentrate on rendering colors in their correct values if they are to model form convincingly. It is the *interaction* of value and color that creates a truly illusionistic sense of light, color, and form.

Volume is easiest to convey when a steady, one-directional light source strikes the surfaces of an object. The surfaces of the object closest to the light source appear as highlights and are rendered in high values. The parts furthest away are perceived as shadows and rendered in dark tones, until they gradually become illuminated again by another light source. Between light and shadow is the gradual modeling of light to dark value as the object's surfaces turn away from the light. The same general principles still apply with diffuse light or multiple light sources, but they are less clear-cut and more difficult to render accurately.

Many artists find it helpful to practice modeling form in monochromatic paintings first before trying to combine value with color. The drawings and etchings of Rembrandt are magnificent examples of works rendered in value alone; the artist used no color but manipulated his lights and darks so skillfully that the forms glow in a very painterly light.

Because of their exceptional ability to blend with each other, pastels are an excellent medium for modeling form and volume. With pastels it is relatively easy to establish smooth, gradual transitions between light and dark tones for a convincing illusion of volume. And the clarity of the pastel palette allows forms to appear in a scintillating light.

This still life was rendered only in gray pastel, but the three-dimensional form is still absolutely clear because of the distribution of lights and darks.

HIGH-VALUE PASTEL TINTS

Most pastels that look almost white are not really white, but very high-value tints of colors. In any medium, what we often think of as white is actually a very light tint. The oil painter can mix a tiny dab of blue with a generous amount of white on his palette, and apply it to his painting in delicate lines with a fine brush. But because pastels are blended directly on the painting, it is much more difficult to blend a small area of a highly tinted color. High-value tinted sticks are very important to the pastelist because it is much easier to draw with ready-made pastel tints than to mix the basic hues with white chalk in the drawing.

When pastel sets are made, the idea is to take a basic pigment, such as cobalt blue, and mix it as the basic hue for a suite of tints and shades. The manufacturer then adds white to the basic color for increasingly lighter tints, until finally the values are so pale that they appear to be almost pure white. I find these high-value pastel sticks indispensable. Having access to a wide selection of high-value pastel tints as a very good reason for investing in a very large set of pastels. The subtle use of high-value colors is one of the hallmarks of a great pastelist's technique.

HUDSON RIVER
Pastel on Fabriano
140 lb. watercolor paper,
12 × 12" (30 × 30 cm).
Private collection.
Photo by D. James Dee.

Except for two or three contrasting cast shadows and the silhouetted water tower, this pastel painting is rendered in consistently high values—minor variations on a single tone. The drawing and composition were worked out with very subtle color adjustments. In this painting I wanted to convey the impression of a large stretch of water on a hot, humid summer day— weather conditions that blanch out any contrasts in a landscape and often make water identical in color and value with the sky. The texture of the surface was achieved with cross-hatching in soft pastels.

ACHROMATIC AND MONOCHROMATIC COLOR

One of the best ways to unify your paintings is to restrict your palette to a limited color range. Achromatic, monochromatic, and consistent-value color schemes are several options for doing this.

Achromatic colors are those with no color (or chroma)—in other words, grays. Middle gray is equal amounts of white and black mixed together. Colors can vary somewhat from strict grays and still give an achromatic impression; for example, muted blue-grays, green-grays, yellow-grays, and brown-grays would give a painting a suggestion of color, yet still convey a subdued, almost achromatic feeling. In such a painting, value and form play more important roles than color.

Here is an achromatic value scale, showing several gradations of values running from white to black. Theoretically there is an infinite number of gradations between the two extremes, but in practical terms it is difficult to convey more than ten or so. A similar value scale could be rendered for any hue—for example, running from very light pink to a deep red-black.

For a monochromatic color scheme, choose one color, and vary its value by adding white or black to create a range of tints and shades. By eliminating the distraction of a varied palette, this approach helps the pastelist focus on values instead for building structure and form into a composition. Many pastelists work monochromatically in the early stages of a painting, and then develop the colors once the basic foundation has been laid.

A monochromatic color scheme is also very effective for setting the emotional tone of a painting. (Think of Picasso's blue and rose periods, in which one color establishes a very definite mood.) If you have trouble orchestrating a whole spectrum of colors in a pastel, start with one color until you find the mood or tone you are after. Let one color dominate your feelings for a while, and see what happens. Individual responses to particular colors are subjective, and this personal reaction often guides the artist toward the right direction for a painting.

A variation on this approach is to work with more than one color, but to keep the value range consistent. A painting done only in dark shades or only in light tints conveys a very definite mood.

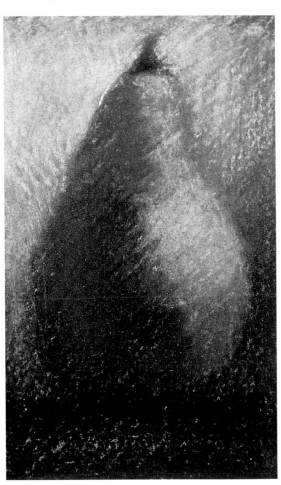

This monochromatic sketch uses red, black, white, and multiple gradations between. Such sketches are good practice in using value to establish form, while at the same time conveying a definite mood through color.

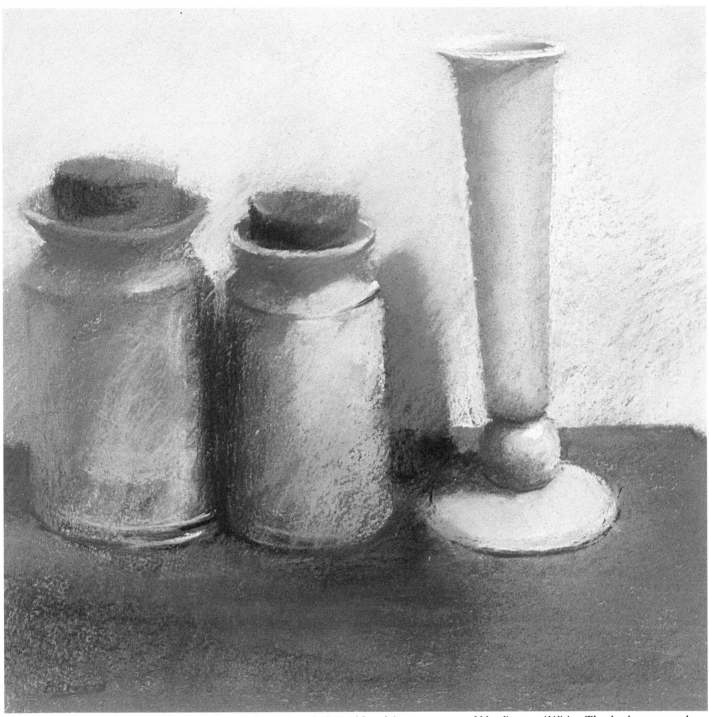

JARS
Pastel on Fabriano
watercolor paper,
12 × 12" (30 × 30 cm).
Private collection.
Photo by D. James Dee.

This is essentially an achromatic painting. Although it contains subdued blues, browns, and ochres, they all lean toward the neutral range. Form and value are more important than color here. This pastel also shows a wide range of blending possibilities. The slender vase on the left is rendered to a smooth and finely modeled finish, while the two jars illustrate a looser, almost atmospheric application of color.

ANALOGOUS COLORS

Working with a strictly monochromatic color scheme is rarely done in practice, because pure shades and tints of just one color are often too severe or artificial for the desired effect. Using analogous colors is another way of maintaining control and consistency of color with your pastels.

The broad definition of analogous colors is a family of colors that share the same primary. By this guideline, all colors that contain any blue (ranging all the way from yellow-green to red-violet) are analogous to blue and will work harmoniously together, even though they span over half the color wheel. (See the illustrations on the facing page.) In practice, a simple, more limited range of three adjacent analogous colors (such as blue-green, blue, and blue-violet) is a more manageable intermediate step after working monochromatically, and can yield a surprising variety of color. For example, a monochromatic painting done entirely in tints and shades of ultramarine blue may seem too icy. The addition of analogous phthalo blue-greens and cobalt blue-violets will still keep the feeling of the blue color scheme, but temper its severity and offer more interest and variety.

NEAR BEAR MOUNTAIN
Pastel on paper,
5 × 5" (13 × 13 cm).
Private collection.
Photo by D. James Dee.

THE ISLAND
Pastel on paper,
5 × 5" (13 × 13 cm).
Private collection.
Photo by D. James Dee.

These two small pastels were sketched the same day on the heights of the banks of the Hudson River near Bear Mountain, New York. I rendered them in a very limited analogous range, using only a few colors. Both hard and soft pastels were used to create large masses of atmospheric light and color, and I added accents and details here and there with a soft lead pencil. In spite of their small size, the overall effect of both these pastel sketches is of vast space, diffused light, and humid mountains mists—much like a Chinese landscape painting. Notice how the warm green of the foreground foliage establishes a clear separation of space from the cool blue-green mountain in the distance.

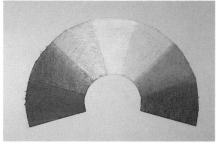

This fragment of the color wheel shows all the colors that are analogous to yellow, ranging from blue-green to red-orange. The study of a cat is based on this color scheme.

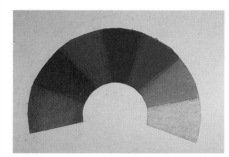

Here are the colors analogous to red, ranging from blue-violet to yellow-orange. The study of a monkey uses this color scheme, which actually has quite a broad range despite sharing the same primary.

Photo by Aldo Mauro.

The colors in the baboon study are analogous to blue, ranging from red-violet to yellow-green. Note how much cooler this color scheme is than either the yellow or red one shown above.

Photo by D. James Dee.

COMPLEMENTARY COLORS

As mentioned earlier, complementary colors are opposite on the color wheel. Complements have two important characteristics. First, if mixed together in equal proportions, they theoretically yield a middle gray; certainly they neutralize each other's intensity. Second, when placed next to each other but not mixed together, they intensify each other because of the vivid contrast between them. Thus green and red mixed together produce a neutral red or greenish brown, but if the same green and red are juxtaposed side by side, each will look intensely vibrant.

In the hands of the pastelist, this dual nature of complementary colors provides a myriad of opportunities to bring out the true beauty of pure colors and to add life to color mixtures. Here are a few of the ways complementary colors can be used to enhance a pastel painting.

For underpaintings. One way to approach rendering an object is to work in corresponding layers of complementary hues. Let's say you want to paint a red apple. You can do this by using tints and shades of red only, or by working within an analogous color scheme. Either of these methods will allow you to render a red apple with little danger of muddy color. Or you can try something different: Begin the apple with a layer of red's complement, green. Also use green for the shadows of your composition. Then, by fixing the first layer, you can begin to build red on top of the green underpainting, using a broken color technique so that some of the green still shows through.

This technique will give you a more brilliant, realistic-looking apple than either of the first two, because the traces of green will intensify the red and create a visually pleasing dark for the shadows. One of the primary rules of painting is that multiple colors working together give a greater sense of reality than does one flat color alone. Complementary colors are one of the artist's chief tools for accomplishing this.

For accents and brilliance. Try planning a composition in which you deliberately juxtapose complements where you want the most vibrant contrast. This can be done either with large areas of a painting or with tiny accents. Because complements bring out each other's brilliance, they tend to attract the viewer's eye.

To neutralize color. A pastelist often needs to reduce the intensity of a color. This is particularly true in landscape painting, where most of nature's colors are brownish greens rather than the pure, intense greens found on the color wheel. One excellent way to subdue a color is to introduce a feathered pattern of closely hatched lines in that color's complement. This calms down the color without changing its identity. The more of the complement you add, the more neutral the final color will be.

For believable shadows. Complementary colors in shadows give a painting a harmonious yet vibrant duality that approximates the look and feel of the real world. As opposites on the color wheel, complements are opposite in temperature as well, so that they broaden the tonal range of a painting and enrich its contrasts. For these reasons I nearly always use either the direct complement or a color adjacent to it for shadows in my pastels. Using blue-green or yellow-green for the shadow of a red apple, for example, gives a softer contrast than pure green and reduces the intensity of the color relationship, while still enriching the painting's range of tones and temperatures.

For compositional balance. Perhaps the most common way in which I use complementary color relationships is to set up a scheme of color checks and balances as a compositional device to establish a color balance and harmony. I try to respect the integrity of an object's local color but not become a slave to it. My color philosophy is that colors should be heightened, but that the exaggerations must appear believable.

To achieve this illusion, I need a great deal of control over my color schemes. I find that complementary colors act as natural compositional balancers to keep a painting in tow. Complements make it possible to exaggerate pastel color and yet simultaneously hold a painting's composition together with several large areas of contrasting but controlled tone.

On pages 97-99 are several examples of paintings in which I used simple combinations of complementary colors to keep pictorial compositions moving—alive, yet still under control. Working with complements can be a tricky balancing act, but because pastel is so flexible and lends itself beautifully to broken color techniques, it is the ideal medium for handling complements to their best advantage.

This series of still lifes shows how complementary colors can be used together in a composition. Each still life is the same, except that the colors have been changed to show a different set of complementary color relationships (blue with orange, red with green, and yellow with violet).

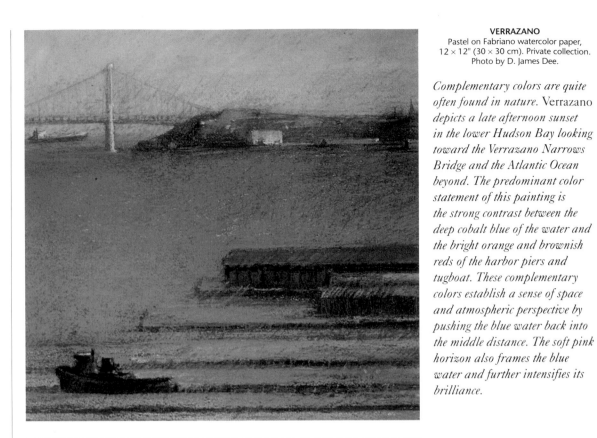

VERRAZANO
Pastel on Fabriano watercolor paper,
12 × 12" (30 × 30 cm). Private collection.
Photo by D. James Dee.

Complementary colors are quite often found in nature. Verrazano depicts a late afternoon sunset in the lower Hudson Bay looking toward the Verrazano Narrows Bridge and the Atlantic Ocean beyond. The predominant color statement of this painting is the strong contrast between the deep cobalt blue of the water and the bright orange and brownish reds of the harbor piers and tugboat. These complementary colors establish a sense of space and atmospheric perspective by pushing the blue water back into the middle distance. The soft pink horizon also frames the blue water and further intensifies its brilliance.

POWER PLANT
Pastel on Fabriano watercolor paper,
12 × 12" (30 × 30 cm). Collection of Jane
Raskin. Photo by D. James Dee.

At the Arthur Kill coal-burning power plant in Staten Island, New York, an enormous mound of black coal contrasts against the bright red of the power plant. The direct light coming in from the upper left further isolates the red facade of the building. In reality the entire view is permeated by the hazy, smoke-filled atmosphere. To achieve this effect, I had to create a neutral sky and soften the contrasts. I tinted the light gray highlights of the coal pile with a red related to the building, and rendered the sky in a deliberately complementary warm green. The greenish-red sky is a perfect example of broken color technique achieved by cross-hatching complementary soft pastels.

DARK RIVER
Pastel on watercolor paper,
12 × 12" (30 × 30 cm).
Collection of Kathie Brown.
Photo by Alexandra Timchula.

This brooding piece depicts a cold day in late November along the piers of the lower Hudson River. The pastel was executed directly on location, and its mood is an accurate documentation of that particular day. Because of the gloomy light, the colors of this pastel are muted grays and earth tones—but the subdued warm and cool colors work against each other to create a beautiful harmony. The dark red earthen colors of the building and highway railing complement the light greenish blue of the sky and water. Highlights along the wet ledges indicate the presence of an overhead light source even though the sun itself is not visible in the painting.

COMPOSING WITH COLOR

Pastel colors are so rich and vibrant that it is easy to be seduced into using them for their own sake. But the most skillful pastelists also know how to use color as an effective compositional device.

One of the most important aspects to consider when beginning a painting is the distribution of lights and darks. This basic pattern should be established during the early stages and will serve as the foundation for the rest of the painting's composition and color. For example, if you are painting a landscape whose predominant colors are an infinite variety of greens and blues, you could start working with a dark blue or green and then later build up your more intense colors.

Another useful compositional tool is color temperature, because cool colors tend to recede while warm colors tend to advance. If you carefully study the temperature of your subject, you are likely to find that most of the cooler colors are in the shadows, while the highlights and the planes closest to you are the warmest. You can choose to exaggerate these temperature contrasts for an illusion of deep space, or to work with subdued warm and cool colors for a more intimate mood. Either way, you are introducing a powerful compositional element.

Finally, one of the simplest and strongest ways to use color is to restrict your palette. A few well-chosen colors that interact to enhance each other will do far more for your composition than dabbling with every color in your pastel box.

TOWNHOUSES
Pastel on Fabriano watercolor paper, 12 × 12" (30 × 30 cm). Collection of Municipal Assistance Corporation for the City of New York. Photo by Municipal Assistance Corporation for the City of New York.

This view of urban townhouses stands as an example of value contrast between light and shade, as well as the appearance of complementary colors in the shadows of illuminated surfaces. The sunlight is striking the side of the buildings and the stone walls. These are rendered in light, warm colors, while the shadowed areas are rendered in dark greens and blues—the complements of the highlighted surfaces.

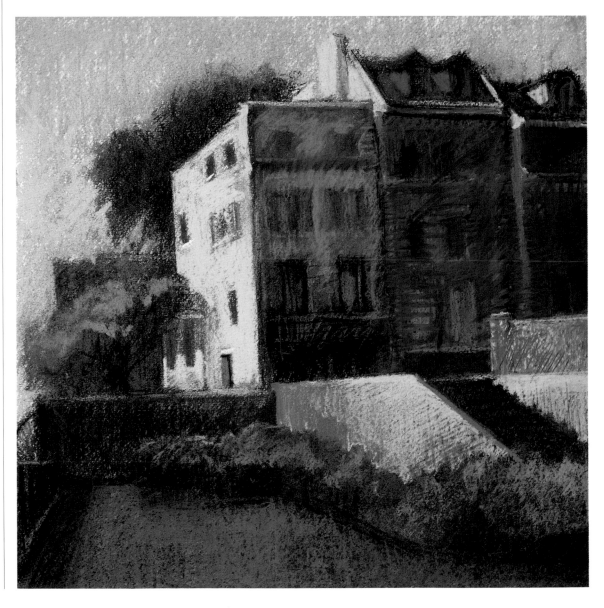

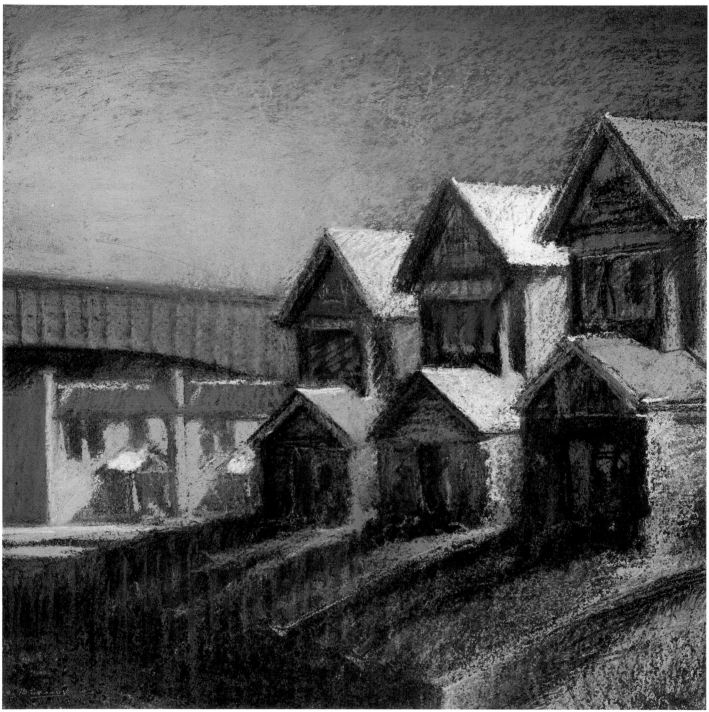

REGO PARK TOWNHOUSES
Pastel on Fabriano watercolor paper,
12 × 12" (30 × 30 cm). Collection of Municipal
Assistance Corporation for the City of New York.
Photo by Municipal Assistance Corporation for
the City of New York.

Here is another example of warm colors in direct sunlight and cool blue-green cast shadows. The dark blue windows are complemented by the bright orange rooftops of the row houses beyond, and the suggestion of orange at the top of the bridge complements the sky. Note also how the vertical blue lines in the left foreground echo the texture of the green bridge above.

LOCAL COLOR AND NATURAL LIGHT

Color is everywhere we look in the world. If you are drawn to pastel, chances are you are enthralled by color and want to re-create your impressions of it. And remember that your impressions are always subjective, as personal and unique as your drawing style or the subjects you choose to portray. Pastels are the perfect medium for recording your responses to color in a very direct, immediate way.

It is not surprising that some of the great nineteenth-century impressionists—such as Edgar Degas, Mary Cassatt, and William Merritt Chase—were among the finest exponents of pastel painting. Pastels are particularly well suited to an impressionist approach to color. The impressionists conceptualized color as a flexible and ever-changing quality, influenced by two constantly interacting factors: local color and atmospheric light. They found that the colors they observed in nature and were trying to reproduce in their paintings were not absolute, but had to be adjusted along with changes in light.

Local color is the intrinsic color of an object regardless of the momentary way natural light is affecting that object. For example, a child would say that lemons are yellow and trees are green—and draw them accordingly. This can be translated to mean that yellow is the local color of lemons and green is the local color of trees.

Atmospheric light is whatever kind of light exists in a particular place at a particular time. It is fickle, shifting constantly according to the time of day, the weather, the light source, and so on. Even something as transient as a cloud passing over the sun or a breeze ruffling the leaves overhead will alter the atmospheric light. And atmospheric light has a considerable effect on color. A bowl of lemons will be a different yellow on a bright sandy beach than on a cool, shaded back porch.

Pastels are the ideal medium for quickly trying to capture this kind of rapidly changing interplay of color and light. The convenience and speed of having so many colors immediately available allows the pastelist to make the necessary adjustments in tone, color, and value as the light changes. Also, many pastel techniques (blending, creating broken textures) lend themselves to adjusting for subtle color nuances.

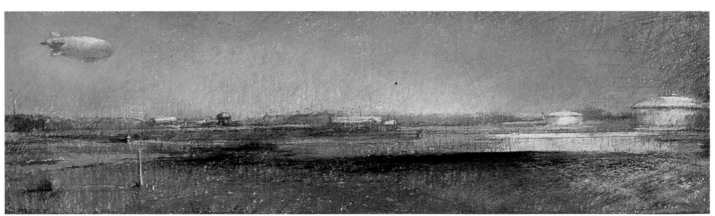

RESTRICTED ZONE
Pastel on watercolor paper,
7 1/2 × 28" (19 × 71 cm).
Collection of Bellevue Hospital.
Photo by D. James Dee.

The atmosphere has a definite effect on color. We look through the thickest layer of air when we look toward the horizon, and the more air we look through, the more it changes the color of what we are seeing. This is why the temperature of the sky becomes warmer as it approaches the horizon, and the values of the colors become lighter.

In this panoramic pastel painting the sky near the horizon has a rosy, golden tone. Even on the clearest blue days, the color of the sky is warmer and lighter as it approaches the horizon. Such a warm atmospheric color should be exaggerated by the landscape painter in order to create a more natural illusion of light.

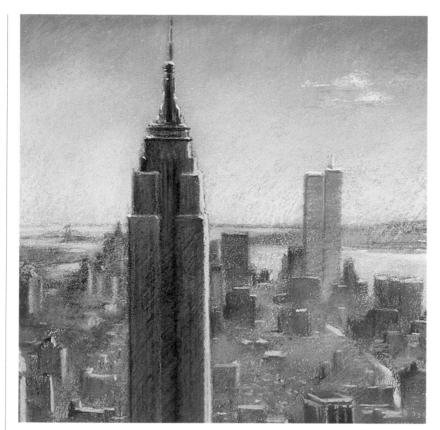

THE CITY
Pastel on Fabriano watercolor paper,
12 × 12" (30 × 30 cm). Private
collection. Photo by D. James Dee.

*The City is a study in types
of light. A strong direct light
is coming in from the upper
right; one side of the Empire
State Building faces directly
into the sun and is brilliantly
lit. The adjacent side, which is
in shadow, glows with a cooler
reflected light. The contrast
between these two sides of the
famous skyscraper is very
strong in value.*

*The World Trade Center
in the distance is also in
direct sunlight, but there the
differences between light
and dark are more diffused
because of atmospheric light.*

DOWNTOWN
Pastel on watercolor paper,
12 × 12" (30 × 30 cm). Collection
of Municipal Assistance Corporation
for the City of New York.
Photo by Municipal Assistance
Corporation for the City of New York.

*The buildings in this view
of lower Manhattan have
been reduced almost to basic
geometric blocks. Form has
been simplified drastically
in order to depict the quality
of light coming directly
from the late afternoon sun.*

ACHIEVING TRANSPARENT EFFECTS

I enjoy making transparent effects in my pastel paintings. Glass vessels, beautiful colored bottles, jars containing strange objects and heavy liquids—these bring a sense of mystery to still life painting. Creating the illusion of transparency has a special magic about it, much like a conjurer's trick, and when perfected becomes an indispensable tool for illusionistic and trompe l'oeil painting.

I think part of the pleasure of rendering transparent objects with pastels comes from the irony that pastels themselves are so nontransparent. As mentioned before, chalk pastels are absolutely opaque and known for their ability to cover anything completely. So how can an artist paint something as colorless and transparent as glass with an opaque medium so saturated with color?

The first step is not to be intimidated by the object's transparency, but to observe very closely what you actually see. When you look at a transparent glass, you do in fact see color—some of it reflected off the smooth surface, some of it passing through the glass and refracted by it. The colors to look for and depict are the colors that surround the object (from above, below, behind, and beside it). Also try to think of the object itself as a kind of clear frame or outline that surrounds these colors. The lines used to outline a clear object are rarely consistent in value. One side of the object will have a dark outline, while the opposite side will be lighter. Careful observation will show you how to adjust these line and tone variations.

Clear objects are three-dimensional in spite of their transparency, so adding highlights, reflections, and very lightly illuminated shadows will help make them look more convincing. But the most important thing is to observe very carefully how the clear objects themselves actually look in a given light. Remember that transparency is not a lack of color, as most people think of it, but rather a variation of the adjacent colors and the light.

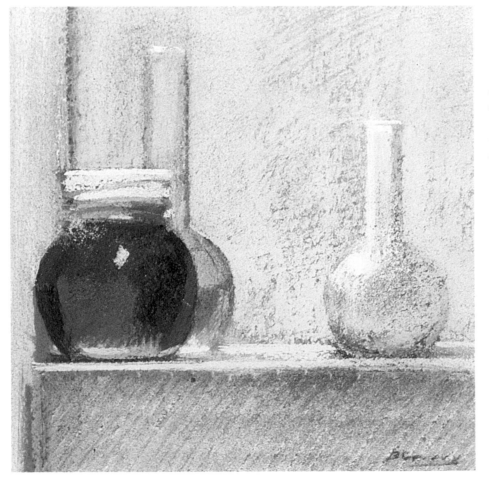

GLASS STILL LIFE
Pastel on watercolor paper,
8 × 8" (20 × 20 cm).
Collection of John and Gail Duncan.
Photo by D. James Dee.

This painting, based on a warm analogous color scheme, shows how to use transparent effects. The background color is visible through the clear glass. The light striking the honey jar is reflected back through the thick liquid to illuminate the bottom of the jar. Because the light is coming from above the objects, there are highlights on the tops of the glass surfaces, and the tabletop has opaque highlights rendered in very light raw sienna.

Notice that the yellow seen through the single vase is slightly brighter than the background. Colors seen through a transparent object often appear brighter and clearer. Also notice the blue shadows, which are intended to complement the predominantly warm colors.

DEMONSTRATION

It is easier to render the illusion of transparency if you select clear containers that have something in them—in this case, an egg. Try painting an object that is made of colored glass or contains a colored liquid.

I never hesitate to exaggerate color within the transparent object; colors seen through glass or liquids become electrified and more startling. (This may be why the impressionists were so fond of depicting water and the inside of bars.) I also concentrate on reflections and limited, well-placed highlights. Remember that glass is a highly polished surface characterized by bright, clean highlights and reflections, so use them well to enhance the illusion you are after.

Here I am using a giant Sennelier soft pastel to lay in the initial colors of the egg.

I start with a sketch in blue pastel pencil, and then spread the color with a large blending stump. The early stage of the painting is nearly monochromatic, but now I am ready to add more color.

After adding other soft pastel colors, I press them into the surface of the paper with a large, flat palette knife. I then fix the entire painting with a layer of workable fixative.

ACHIEVING TRANSPARENT EFFECTS

Now I start focusing on the glass. I lighten the portion of the jar over the egg, and I outline the jar's edges with an aqua NuPastel to help create the illusion of reflection. Then I create a highlight on the right side of the glass jar with a very soft white Sennelier pastel, and modulate it with a blending stump.

A little inside the right edge, I add another white stroke across the glass. This time I deliberately cover a large portion of the egg with the white highlight. This detail is critical in establishing the texture of the glass and creating the illusion of transparency. (Glass simultaneously reflects light—the highlight—and allows it to pass through— to reveal whatever is on the other side.)

Here I am adding other white highlights along the outside of the glass, which further add to the transparent illusion.

EGG AND JAR
Pastel on watercolor paper,
14 × 8" (36 × 20 cm).
Collection of the artist.

The final version of the painting shows a believable transparent jar containing an egg. Successfully creating a transparent illusion requires careful placement of reflective shadows and highlights.
It is much easier to render transparent containers if they appear to have something inside them.

EARTH COLORS

As we have seen, colors are at their brightest when they are of spectral intensity. In contrast to these intense hues are the more neutral colors we call achromatics and earth tones. As mentioned earlier, grays are combinations of black and white with no other color present; earth colors are duller versions of more intense colors, obtained either by mixing complements or by using naturally neutral pigments. Although they are not achromatic, earth colors are similar to grays in that their value is an extremely important aspect of their nature and a secret to the way they should be handled.

Because pastels so closely match the color of the pigments from which they are made, earth tones are particularly rich and vibrant in their pastel form. The rich yellow ochres, deep red earths, and dark umbers that are sometimes disappointing in their oil and acrylic versions sing with an inner clarity as pastels.

This color chart, rendered in soft pastel on an Indian paper made of sugar cane fiber, shows a typical assortment of earth colors. Each color was darkened with fixative, then scumbled over itself. From left to right, they are Naples yellow, yellow ochre, gold ochre, Indian red, raw umber, burnt umber, terra verte, English red, and Vandyke brown. There are many other earth colors that could not fit in this illustration! Also be aware that pigments may vary slightly from batch to batch.

Earth colors are extremely important to any pastelist who is concerned with achieving a balanced, believable sense of light and color. Most of nature does not come in colors as bright as the rainbow—and therefore too much pure, spectral-intensity pastel color destroys the illusion of reality. I find earth colors very valuable as a foil to modify the overwhelming brightness of chromatic colors for a more convincing overall color balance. They strengthen feeling and mood, while simultaneously giving the eye a resting place within a brighter color scheme.

The color of an earth tone is subordinate to its value, which means that earth colors make wonderful drawing tools. Most of my work begins with a drawing in an earth color such as burnt sienna or earth green. These tones let me get down to the essentials in a hurry without worrying too much about color. Yet they still provide enough of a hint of color and temperature to establish some sort of color notation even at the beginning.

Finally, earth colors are equally useful in the final layers of my pastels. The rich purity of their tones, especially in the soft pastel version, allows me to drag and scumble with them over more vivid colors, thus adding a rich patina of earth and mineral tones that glow with a vivid, sensuous light.

DEMONSTRATION

Earth colors are used in all forms of naturalistic painting, but particularly in landscapes, where they have the starring role. The very name "earth color" conjures up the image of a landscape.

The procedure for working with earth colors in pastel landscape painting is parallel in many ways to the same procedure used in oil painting. Both oil painters and pastelists use a simple palette of several earth colors—such as burnt umber, terra rosa, and raw sienna—to block in the main elements of a landscape. After the basic composition is established, then the brighter and more vibrant chromatic colors are added. Starting with earth colors gives the artist total control over the temperature and value of the colors.

Keep the foreground colors warm and the background colors cool, so that the appropriate areas of the painting appear to advance or recede. This is particularly crucial in a landscape, because landscapes normally encompass a considerable depth of space from the foreground to the horizon (perhaps several miles) whereas a portrait or still life may encompass only a few feet. You need all the depth you can get.

Another function of earth colors in landscape painting is to provide a warm underpainting that will add life to cooler colors scumbled over it. Greens are more vibrant when scumbled over a red underpainting, and atmospheric blues are more effective over a yellow ochre or rose-colored underpainting. The neutral intensity of earth colors provides an excellent foundation for the brighter, more intense colors of the final version.

Large areas of earth colors block out the essentials of the landscape. I try to keep the colors warm; even in the sky the colors are keyed in to the earth-toned palette. Details are kept to a minimum.

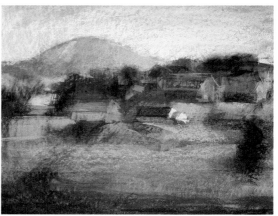

Now I further define the shapes of the landscape—but the forms are still indicated by short, solid blocks, and there are no real details. I introduce some cool colors at this point; blues and greens dominate the middle ground, in contrast to the warmer background and foreground.

CIVIA'S FARM
Pastel on sanded paper,
16 × 20" (41 × 51 cm).
Collection of Dr. Charles
Goodsell.

In the finished painting the architecture and foliage are as detailed as they will ever be. Earth colors still dominate the painting, but there is now a balance of warm and cool colors. The parallel bands of light and dark help create a horizontal sense of space from foreground through to the middle ground of farmhouses and onward to the distant hills.

METALLIC AND IRIDESCENT COLORS

Among the pastelist's more exotic options are metallic and iridescent colors. Metallic pastels were once almost impossible to obtain unless an artist knew how to make them himself. But now the French manufacturer Sennelier has sets of 25 metallic and iridescent colors, available in both oil pastel and chalk pastel, making these colors readily available to everyone. The metallic pastel sticks resemble small shining bars of gold, silver, and copper. Iridescent pastels have a hue but also a pearlescent sheen. The unusual glint of these pastels is making them increasingly popular with contemporary artists.

Metallic and iridescent pastels have such a seductive glow that it is tempting to use them to excess. I prefer them as an exotic seasoning to more traditional colors. They can be blended with more ordinary colors to make them more mysterious and exciting, and the resulting color mixtures are often almost impossible to define. Golds, silvers, and many of the iridescent colors are actually very close to earth colors in hue and in the way they are used.

These special pastels are more transparent than other pastel colors. This means that they work very well as "glazes" that enhance the richness of a dark color or bring an ethereal brightness to an otherwise flat color.

See pages 144-146 for a demonstration done with metallic and iridescent colors in both chalk pastels and oil pastels.

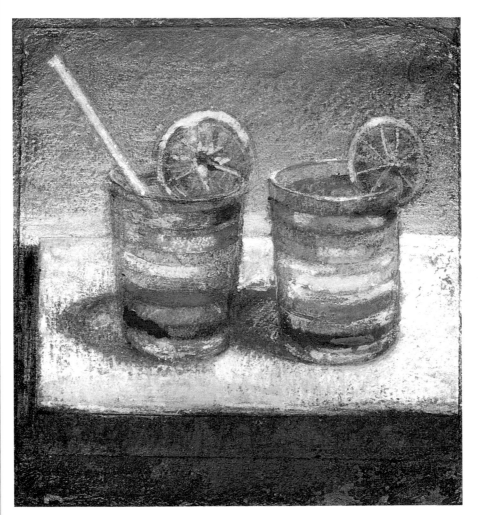

COCKTAILS
Soft pastel and iridescent soft pastel on Multimedia Artboard, 14 × 12 ½" (36 × 32 cm). Collection of the artist.

I heightened the color scheme of this still life by using iridescent and metallic colors. The background was rendered in three varieties of gold, worked up in layers to create a texture resembling tarnished gold leaf. The glow of the tabletop is a combination of iridescent colors and white, and a dark metallic pewter was mixed into the dark blues of the table base. Silver and copper accents glint along the edges of the glasses and tabletop.

PASTELS AND PAPER COLOR

One final factor to consider when planning the color of a pastel painting is the color of the paper itself. Pastels and colored papers have traditionally gone together. It isn't necessary to do a pastel on colored art paper, but so many pastelists work on colored sheets that the tradition has become more the rule than the exception. Certainly colored paper can determine and enhance the entire color scheme of a pastel. It is best used for pastels left in a partially unfinished state, such as rough sketches or works using a loose, painterly technique, so that a fair amount of the raw paper still shows. Also note that pastel lightly scumbled over colored paper creates a broken texture much as it would over a fixed pastel underpainting. (It goes without saying that if the paper is covered with multiple layers of pastel so that none of the original paper color shows through, it doesn't matter what color the paper is!)

DEMONSTRATION

Here is a series of small paintings that illustrate how dramatically paper color affects the finished look of a pastel. I did each of these paintings with the same technique, using the same colors, but on different paper. In each instance I applied the pastel color rather lightly, allowing the paper to influence the look of the finished painting substantially.

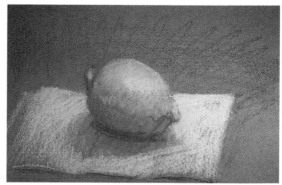

Rose pink paper gives a harmonious, analogous color combination.

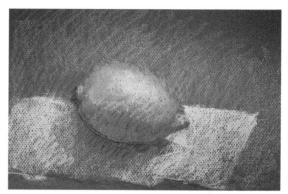

Light green paper also provides an analogous scheme, but this time there is an equal temperature balance between the cool and warm colors. The cool paper also makes the drawing appear more volumetric because the colors stand out in higher contrast to the background.

Yellow ochre paper yields an almost monochromatic scheme of a yellow subject on a darker yellow field. The effect is a weightless, golden light.

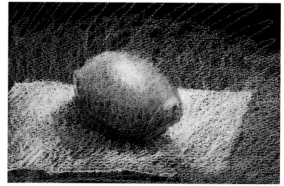

Black paper provides maximum contrast both to the colors and the values of the pastels used. The darker the paper, the more vivid the volumetric rendering, and the more dramatic the effect. Black paper is extremely effective with pastels. For best results, leave some of the paper clean and exposed so that the rich color of the pastel strokes stands out in high contrast.

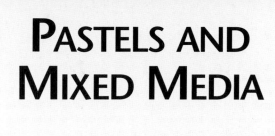

PASTELS AND MIXED MEDIA

We have seen so far that pastel is a very flexible medium that lends itself to a variety of drawing and painting techniques. But many pastelists seem unaware that pastel can also be used in conjunction with other mediums to achieve a variety of special effects impossible with pastel alone. The remarkable flexibility of pastels enables them to mix with a surprising number of other drawing and painting mediums, and thus makes them ideal for experimentation with mixed media techniques.

Pastel can be combined with mediums as diverse as watercolor, acrylic paints and gels, oil paint, and oil stick for a vast range of painterly effects. Drawing mediums such as pen and ink, pencils, ball-point pens, and monotype prints can provide an unusual starting point for a pastel painting. Pencil can also be worked into pastels to expand their textural possibilities; additives like modeling paste and marble dust can be used with pastels to create spectacular impasto effects. Any pastelist willing to try some innovative combinations will be rewarded by a dramatically enriched repertoire of drawing and painting techniques.

WATERCOLOR COMBINED WITH PASTELS

Many artists think of pastel and watercolor as very different, unrelated mediums. Yet both are water-soluble, so it is actually quite natural to combine them. In fact, both come out of the early eighteenth century and are historical "cousins."

There are many instances when pastel and watercolor can be combined to work together as a single medium with a strong, painterly, brushlike quality. For example, when you are sketching on location and need to capture something in a faster medium than watercolor, you can jot down ideas rapidly with soft pastel, and then use highly saturated brushes to work watercolors right over the pastels.

Often you can transform a discarded watercolor into a much better painting by working over it with pastels—much the way Degas used to convert monotypes into pastels.

Pastels are also a very fast way to add opaque passages over watercolor washes. This is particularly handy for rendering opaque details and highlights, or when you feel that a quick change in color is needed. Even while a freshly applied watercolor wash is still wet, you can begin adding opaque details with soft pastels.

Pastels are particularly beautiful when worked together with gouache, or opaque watercolor. Gouache has a beautiful matte finish similar to that of soft pastels, and the opacity of these two mediums helps them reinforce each other's coverage.

DEMONSTRATION

When working with pastel and watercolor, it is important to remember that watercolor is transparent and painterly, while soft pastel is opaque and graphic. Use these contrasting qualities to complement each other as you plan your painting, so that you bring out the best of both mediums.

For this painting I've chosen Multimedia Artboard, a 300 lb. sheet specially treated with epoxy so that it doesn't buckle when wet and is impervious to any chemical reactions from paints and solvents. Watercolor and pastel can also be used together on heavy watercolor paper that has been stretched and fastened, or on thick watercolor board.

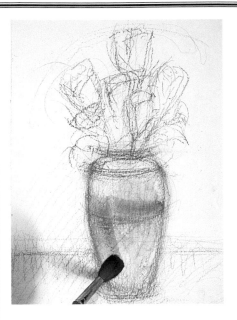

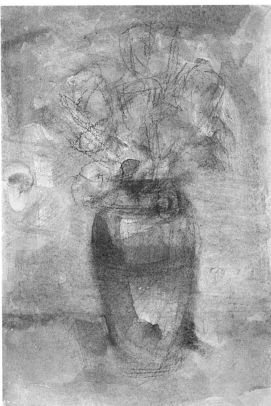

The first step is to make a simple drawing with various colors of pastel pencils. I recommend a combination of line drawing and cross-hatching. I loosely apply very light watercolor washes over the pastel pencil drawing. These highly diluted washes partially dissolve the pastel beneath. Then I add heavier watercolor washes until the entire painting has been covered with a watercolor wash.

Pastel pencils are highly water-soluble. A pastel pencil that is dipped into a container of water will make very fluid, painterly strokes. As the water dries on the pencil's tip, the line becomes thinner once more.

Here I am using a moistened pastel pencil to outline the vase and add several richly pigmented lines throughout the drawing. In some areas I spread these lines with a brush.

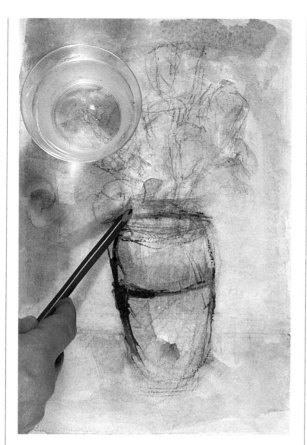

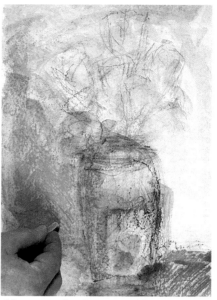

After saturating the paper with water, I drag an earth green soft pastel over it, leaving a yellow-green wash.

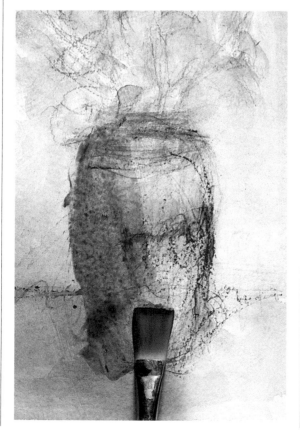

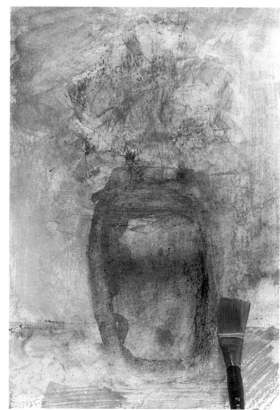

On the opposite side of the still life, I add a light blue-green watercolor wash. At this point the still life is an equal combination of watercolor and pastel. The color is still very pale, transparent, and loosely applied—more like a watercolor than a pastel—although many of the washes shown are actually pastels.

WATERCOLOR COMBINED WITH PASTELS

I add some touches of light-colored soft pastel to start building volume.

Now I carefully add pastel colors to the roses—a light red-violet for the petals and a dark indigo for the shadowed areas. The hard pastels are in chalk holders to give me maximum control. I press the color into the paper with a palette knife to prevent it from smearing.

Next I carefully outline the edges of the rose petals with a light ochre Conté hard pastel.

Here I am very carefully creating washes by dissolving some pastels with a saturated watercolor brush. Their color darkens at first, but it will return to normal as soon as the water evaporates. By dissolving the pastels directly on the painting surface, you can control the washes and keep your color exactly where you want it.

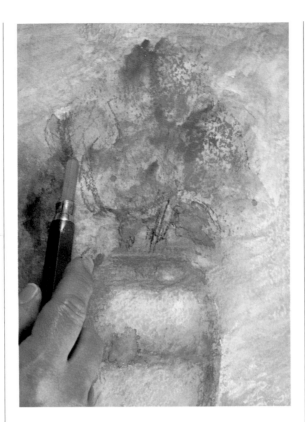

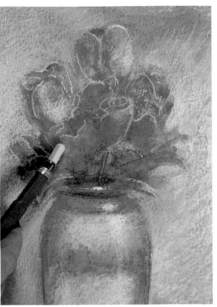

A light ochre NuPastel is my choice for rendering an important highlight on the side of the ceramic vase. I add more detail to the edges of the rose petals.

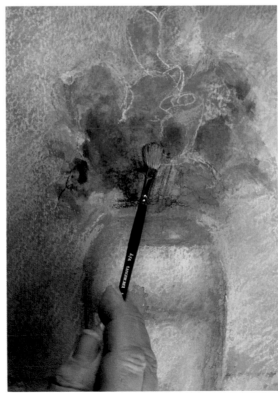

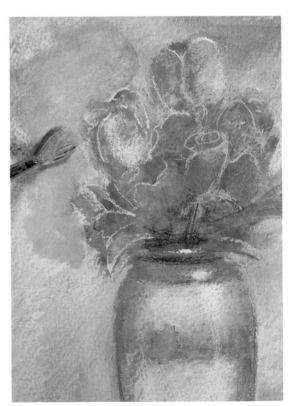

Next I add a series of highly diluted washes of gold watercolor. These final coats of watercolor work to unify the color of the ceramic vase with the cool, light blue background. The gold watercolor is very transparent, so the cool colors show through easily.

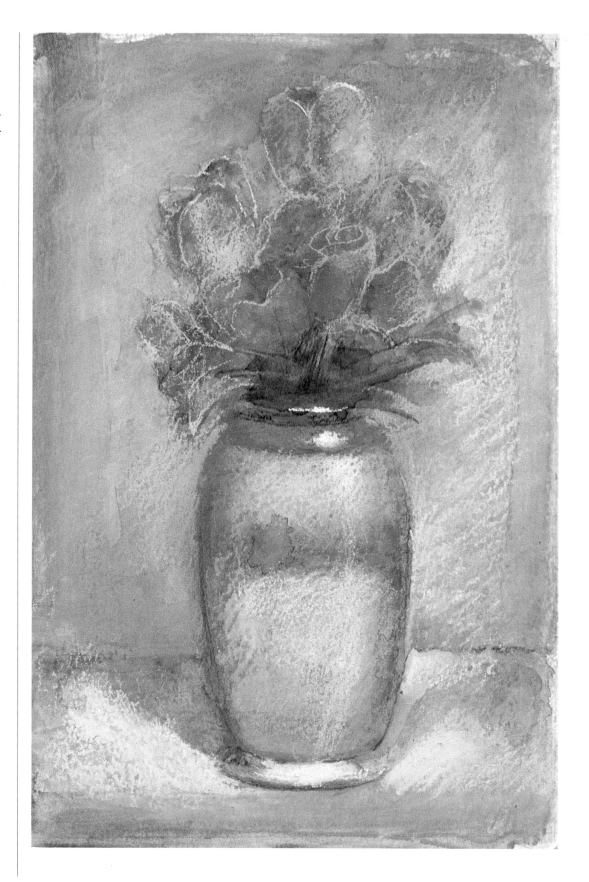

ROSE STILL LIFE
Pastel and watercolor
on Multimedia Artboard,
13 1/2 × 9" (34 × 23 cm).
Collection of the artist.

The final painting combines transparent and opaque passages of both watercolor and pastels for a unique look.

ACRYLICS COMBINED WITH PASTELS

Like watercolor and gouache, acrylics are water-soluble, so they too are chemically compatible with pastels. Acrylics are such a strong medium that they will totally overpower pastels if the two are combined directly. However, by first diluting the acrylics with acrylic mediums or gels, you can use them with pastels quite successfully. Acrylics give pastels much more body than they could ever hope to achieve by themselves. Pastels alone cannot create a true impasto, but mixing them with acrylics adds the needed ingredient for luscious impasto textures. Acrylics also make the surface of a pastel painting strong and durable.

Just as with watercolor, you can also use a finished acrylic as an underpainting for a pastel painting. Pastel can be drawn directly on top of an acrylic painting and can exploit the many variations in its surface texture. Acrylic is a strong support that can hold up to a lot of surface abrasion and heavy fixing.

DEMONSTRATION

The painting in this demonstration is of a rented house on Monhegan Island, off the coast of Maine. It is based on a drawing done on the spot; I'm making up the colors from memory. For my support I've chosen Daniel Smith Non-Buckling Painting Board. This specially treated 300 lb. paper does not buckle when wet, so I don't have to stretch it before applying the acrylic paints or mediums. Heavy stretched watercolor paper, a watercolor block, illustration board, or museum board could also be used with pastel and acrylic, but pastel paper is not strong enough.

This demonstration is a good example of the pastel dusting technique and shows what a useful tool the palette knife is for both pastel and acrylic. It also illustrates how to use an alternative to traditional fixative: a spray of diluted acrylic medium and water, which both fixes the pastel and creates a beautiful surface texture.

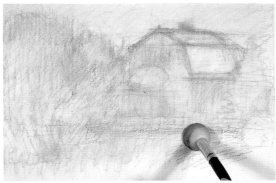

I begin the painting by drawing the outline of the composition in various colors of NuPastel hard pastels. I combine line and cross-hatching but keep the build-up of pastel color to a minimum. With a foam rubber brush I blend the color slightly to lighten up the pastel build-up even more, and to give the painting an even tonality.

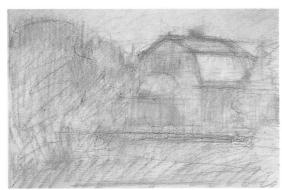

I then add more hard pastel color to the drawing to start getting a better indication of color and composition.

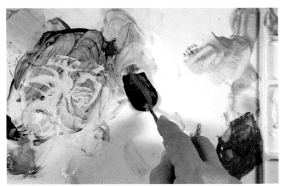

Here is my acrylic palette—a plastic tray. I will work with a palette knife instead of brushes in this painting, only because I am more comfortable with it. Either tool is fine for mixing pastels with acrylic. Before applying my acrylics to the painting, I thin them with a great deal of acrylic matte medium.

Now I start to spread a light Naples yellow wash across the pastel, using a flat, wide palette knife. The color is very transparent because it is diluted with acrylic matte medium.

Next I absorb some of the excess acrylic by dabbing the surface of the drawing with a paper towel. The paper towel leaves a slight texture, which I will leave on the drawing so that I can later build on top of it with soft pastels.

I apply more color with a palette knife until the painting is totally covered with highly diluted acrylic color. The result is an underpainting of pastel showing through transparent acrylic over it.

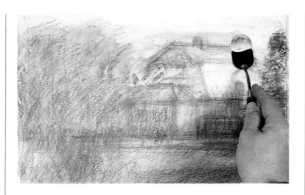

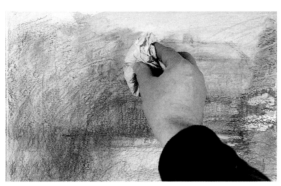

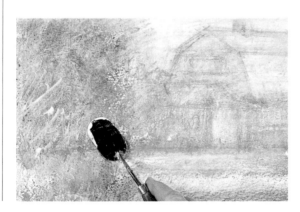

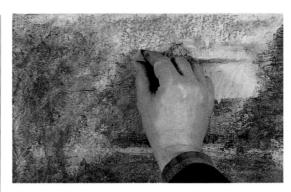

I add more acrylic paint throughout the composition, still keeping it transparent and thin. With a variety of soft pastels I begin to add a heavier layer of color on top of the acrylic. Because this is a landscape, I am keeping the color loose and open, more broken than opaque.

At this stage the landscape is an equal combination of acrylic and soft pastel. The acrylic has given the painting a strong texture and body, while the pastels have added a strong graphic quality to the color.

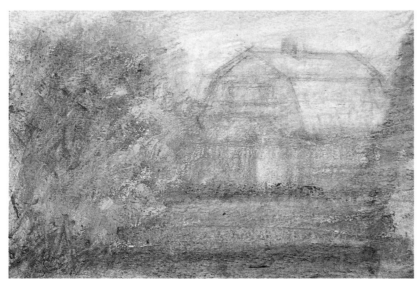

With a palette knife I now add a thick application of light yellow acrylic paint, and then spray it with a solution of one part acrylic medium to three parts water that I poured into a plastic spray atomizer.

While this solution is still quite wet, I start to dust fine particles of pastel into it. I must work fast to take advantage of the wet medium. As the medium dries, it will act as a "glue" to hold the pastel particles in place. This technique allows me to build up pastel into a very rich texture.

THE RENTED HOUSE
Pastel and acrylic on
Daniel Smith Non-Buckling
Painting Board,
10 × 14" (25 × 36 cm).
Collection of the artist.

The finished painting shows a great variety of surface textures and colors. The diluted solution of acrylic medium and water was added in several more places, such as the house and the dark trees on the right. The blue pastel sky was also spotted with droplets of medium and water to create a distinctive texture.

ACRYLIC GELS COMBINED WITH PASTELS

One interesting way to work with pastels and acrylics is to use acrylic gels and mediums exclusively, without any acrylic paint. This is one of my favorite mixed media combinations. The acrylic medium (such as matte medium) provides the basic vehicle, and soft pastels provide the color. Together they form a flexible, paintlike base that can be worked very quickly, and fresh pastel can be added over this layer once it is dry.

An important advantage of this method is that it allows you to build up many layers of pastel without using fixative; the pastel colors are actually encased within the clear acrylic medium and will not come off. These underpainted layers of soft pastel and acrylic medium, often very heavily textured, can provide a rich and varied support for later layers of pure soft pastels, which can then be worked with more traditional methods until the pastel painting is finished. Acrylic mediums do darken the pastel slightly, but less than fixative. They also allow you to manipulate the pastel colors like paint, but— unlike turpentine—the acrylic medium is completely harmless to unsized paper.

Begin your drawing with soft pastel. By using tortillion blenders or brushes, try to keep the drawing very loose and open. Also use wide palette knives to work the color across the paper and to push the pastel into the paper's surface.

Before there is too much build-up of pastel pigment, dip a large, flat, flexible palette knife into a cup of liquid acrylic matte medium. (I use Speedball matte medium by Hunt.) Spread this across your pastel drawing. The drawing will darken and the pastel will spread and become more paintlike—in effect, an acrylic wash. As soon as this first layer dries, start drawing on top of it with a fresh layer of soft pastel, and then add more matte medium. This process can be repeated as many times as you like. Acrylic medium dries very fast, so that you can apply a new pastel layer within 20 to 30 minutes.

While you are adding more medium and the pastel begins to float around, you may feel that you have lost control of your painting. But don't worry, because at this point it is important to keep things loose and flexible. Take advantage of any "happy accidents" that occur; this is part of the fun and beauty of this technique. You can always tighten up later.

In spite of the looseness of this approach, there are several ways you can prevent your original drawing from becoming obscured as you work. You can occasionally draw into the wet acrylic and pastel with a soft drawing pencil. Another way to maintain control is to keep reworking the picture with a wax crayon, a china marker, or even thin oil pastels. Since these oil- or wax-based mediums are not soluble in the acrylic medium, they will more or less stay in place as new washes are made over them, thus preserving some indication of the original drawing. Later, as the liquid mixture of acrylic medium and pastel dries to a hard finish, you can complete the painting with fresh layers of soft pastel.

DEMONSTRATION

Building a pastel in layers is one of the best ways to create an exciting range of textural colors and varied surfaces. Usually liberal applications of fixative are necessary to separate the layers—but in this demonstration no fixative was used at all. Instead acrylic matte medium was used to isolate each layer of pastel. The result is a painting whose color and drawing technique are pure pastel, and the transparent, painterly qualities of the acrylic medium yield a surface texture that would be impossible with pastels alone.

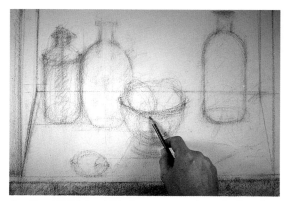

In this still life it will be important to keep the drawing and the composition intact until the very end, so I want to make a very clear preliminary drawing. I lay out the composition with various colors of hard pastels and pastel pencils. I want to make sure that there are as few ambiguities as possible in the preliminary drawing, so I erase potential errors and trouble spots with a soft plastic eraser. The painting is done on a rough watercolor paper block, so it can easily withstand a lot of erasing. I remove the excess pastel and eraser dust with a soft brush.

ACRYLIC GELS COMBINED WITH PASTELS

I use a soft, long-haired brush to spread the liquid acrylic matte medium across the pastel. The medium is white and opalescent when first applied, but as it dries and fixes the pastel to the paper, it becomes transparent. When the surface has dried, I draw in more color with a soft pastel and cover this with another coat of medium. Another way to work is to dip a wide palette knife into the medium and drag it across the drawing.

At this point the still life resembles a wash painting. The surface is very free and loose. Its rough texture makes it an ideal underpainting for further layers of pastel.

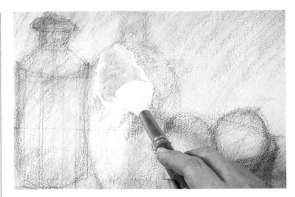

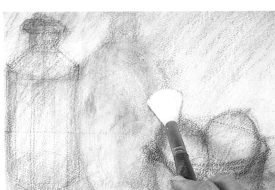

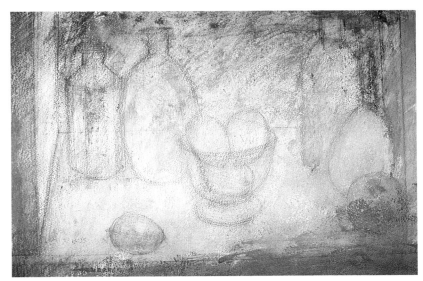

Now I continue to build up the surface with very soft giant pastels, working in very broad strokes to build up lots of color.

With a foam rubber sponge brush dipped into acrylic medium, I once again paint over the fresh coat of soft pastel—first on the arrangement of lemons and then on the various bottles. The sponge tool creates a different texture, blending and smoothing the pastel colors as well as creating dabs of wet pigment.

By now the painting is very thickly built up in many layers, and the textural quality of the lights and darks has grown very exciting. From this point on, the idea is to refine details that I want to make clearer, while being careful to preserve the appealing textures that developed from painting with the acrylic medium.

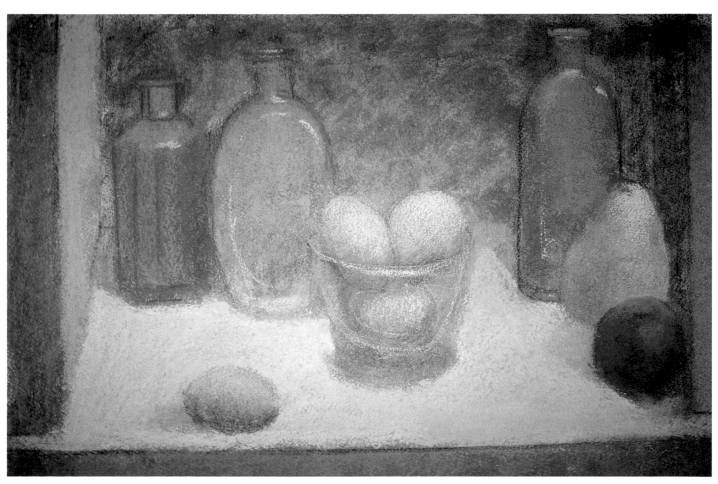

STILL LIFE WITH JARS AND LEMONS
Pastel and acrylic matte medium on rough watercolor paper, 15 × 22 ½" (38 × 57 cm). Collection of the artist.

With soft pastels I change the color of the tabletop, add pale yellow highlights to the lemons, and clarify the texture of the blue bottles. The trick to making highlights here is to resist making too many, or the illusion of transparency is lost. The final layers are applied with Sennelier giant pastels, whose texture is superb for rendering large areas of bright, broken colors.

The finished painting shows a rich combination of finely rendered objects, standing in stark contrast to brilliantly textured backgrounds. All the colors were made with both hard and soft pastels. No fixative was used.

MODELING PASTE
COMBINED WITH PASTELS

Modeling paste is a fast-drying acrylic medium designed to build heavy impasto or even to create low-relief, three-dimensional passages in acrylic paintings. Just as acrylic gels and matte mediums can successfully be combined with soft pastels, acrylic modeling paste can be mixed with pastels to create heavy impasto textures. The matte color of modeling paste is ideal for soft pastels, and the build-up of color and texture with this combination is truly amazing.

Modeling paste today usually comes in two forms: smooth or rough. For pastel work I recommend the rough version, which has granulated silica added to it. The brand of modeling paste that works best for me is Lascaux Plastik B, which is Swiss-made and has been mixed with a small portion of quartz sand. If you can find only the smooth modeling paste, such as Hyplar, add your own small amounts of finely ground sand or carborundum to this until you get the degree of texture you're after.

To use modeling paste with pastels, first select a very heavy paper or board—or even a wood or Masonite panel—for your support. Draw with pastels in a very loose manner, being careful not to create too much of a build-up. Then use a palette knife to smear wet modeling paste directly over the drawing. Some of the pastel is dissolved, but because the modeling paste is semitransparent, most of the pastel image shows through.

The added modeling paste changes the color drastically, raising the value of dark colors and making intense colors more neutral. However, this is OK because the idea is to keep loose. Remember, you're building a picture in layers, so color changes don't have to be final. The point of the modeling paste is to add a stronger, more varied texture over which you can continue to add pastel.

You can keep building up a pastel in this way for as many layers as you want. As modeling paste dries (which takes about 15 minutes), it becomes slightly opalescent. The final phases of the pastel need not employ modeling paste but can be finished by more conventional methods. You will end up with a highly textured, sandlike painting that resembles the look of a weathered fresco but was actually executed with the speed and immediacy of a pastel.

DEMONSTRATION

For this painting I am working on a handmade canvas panel. I've mounted the linen onto a thin wooden panel and sized it with a mixture of modeling paste and acrylic medium.

The first step is a simple drawing made with various colors of either soft or hard pastels.

Next I completely cover the pastel drawing with acrylic modeling paste using a large palette knife. Some of the color gets dissolved, but the drawing is still clearly visible.

Now I use soft pastels to build local color and pastel pencils to outline edges.

I add a detail to the orange with a pastel pencil, then more soft pastel with broad side strokes.

After applying more modeling paste over the fresh pastel, I spread it around with a palette knife.

Again I spread modeling paste over the new layers of pastel.

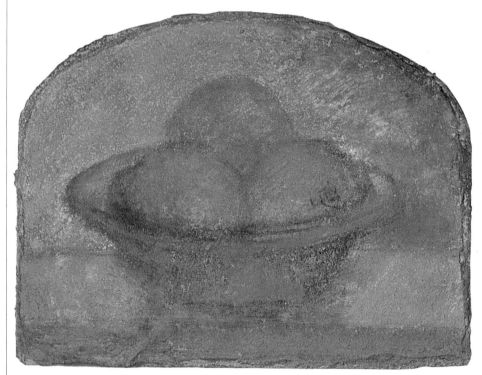

After many successive layers of modeling paste and pastel, the surface of the painting is richly textured, and its colors are heavily built up. No further applications of modeling paste are needed. From this point on, I will need to use very soft pastels because the surface is so rough that hard pastels will not hold well.

MODELING PASTE COMBINED WITH PASTELS

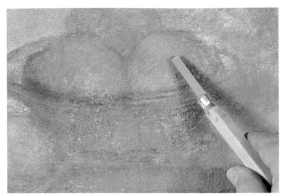

For the final stages of the painting, I use soft pastels in holders because I need the extra control in order to render the final forms and colors accurately.

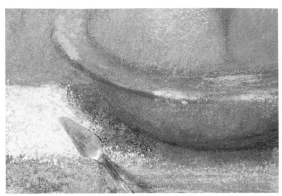

I apply a final thick layer of soft pastel for a buttery, opaque finish. Instead of using fixative, I press the final layer down firmly with a palette knife.

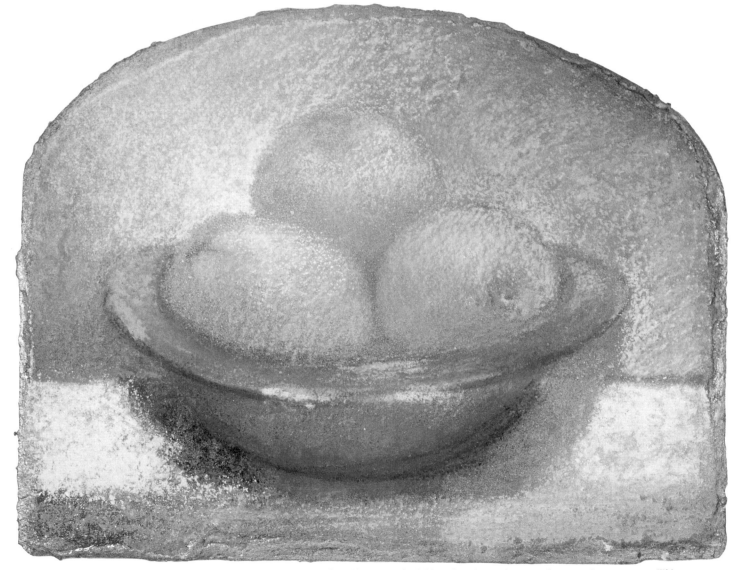

STILL LIFE WITH ORANGES IN A GLASS BOWL
Pastel and acrylic modeling paste on canvas panel, 9 × 10" (23 × 25 cm). Collection of the artist.

The finished painting is a heavily textured, richly colored pastel executed on a unique support. This combination of mediums is evidence that pastels can be painted on a variety of supports, including canvas. The final surface of a soft pastel painting can be as thick and textured as an ancient fresco.

ALKYD GELS COMBINED WITH PASTELS

Soft pastels can be worked together with alkyd gels, such as Wingel or Liquin (both manufactured by Winsor & Newton). Wingel dries to the touch in two to three hours; it is heavier in consistency than Liquin and thus suitable for impasto textures. Wingel is also more transparent for glazing techniques. Liquin dries in four to six hours; it has a thinner, more paint-like consistency.

The addition of gel makes the pastels more transparent and more paintlike, and also isolates each layer of pastel so that no other type of fixative is needed. Using soft pastels and painting gels in this way is really carrying the concept of heavy fixatives to the limit! But it makes the point once again that pastel painting is a process of building in layers. (Alkyd gels are more often used with oil pastels; see pages 148-151 for more about this combination.)

Alkyd gels can be used to dilute pastel colors to the point where they can be used as glazes. The pastel colors that work best as glazes include dark earth colors, metallic colors, and dark colors that are pure pigment. Whites and pale tints do not glaze very well because they are simply too opaque.

Start with a heavy, rough-textured paper or board, and coat it with gesso, acrylic medium, rabbitskin glue, or gelatin to make it resist staining from the gel. Better yet, use a coated paper such as Sabertooth or Multimedia Artboard.

Begin to draw with either soft or hard pastels but try to minimize the build-up of pastel dust. Once you have a simple first drawing, apply gel to the flat side of a palette knife and spread it across the fresh soft pastel. The color will darken considerably, and the drawing will become more paintlike and very loose. Keep adding gel and spread as much as is needed to cover your drawing. The pastel will initially absorb large portions of the gel and also dull much of its gloss. Remember not to worry about color change at this point because the important thing is to build an under-painting with a rich surface.

After the first coat of gel has been applied over the soft pastel, wait 30 to 45 minutes until the gel is dry to the touch. Now you can add new layers of soft pastel. After the first layer, all future layers of pastel should be done with soft pastels rather than hard pastels. The soft pastels grab the still drying puddles of gel and create an interesting texture. Keep working back and forth between soft pastel and gel until the painting is finished. The final result is a marvelously rich, textured pastel that has a variety of special effects ranging from opaque scumbles to liquid transparencies much like watercolor.

DEMONSTRATION

This demonstration shows the technique of mixing Wingel, an alkyd gel, with soft pastels. The Wingel acts as a very heavy fixative and glazes the soft pastel colors over each other. Wingel forms a slight paint film as it dries, and you can draw right into this with very soft pastels. (Wait about 15 to 25 minutes after applying the Wingel.) Once the pastels touch the Wingel, it dries even faster. It is also possible to dust particles of soft pastel into the wet Wingel, which will set as the gel dries.

I draw simple outlines of the still life with hard pastels and pastel pencils. Once again I am working on Multimedia Artboard, which is safe for alkyd or oil-based paints or solvents.

After filling in the outlines with hard pastel, I squeeze some Wingel directly onto the surface of the drawing and spread it around with a flat palette knife. The Wingel dissolves and darkens the pastel.

ALKYD GELS COMBINED WITH PASTELS

Once the preliminary coat of hard pastel has been completely covered by Wingel, I use very soft pastels for the second coat. These work extremely well because the Wingel is still tacky enough to hold them down.

I apply a new coat of Wingel over this new layer of soft pastel, using bolder, more textured strokes with my palette knife.

By the end of the second stage, the Wingel has dissolved the layer of soft pastels. The colors are now darker and more intense because I used more Wingel to glaze them.

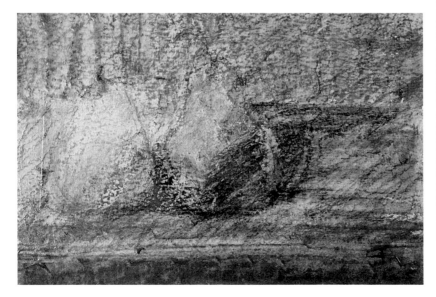

Now I dust soft pastel onto the wet Wingel and press it down with a palette knife. Again, it adheres beautifully to the Wingel-coated surface.

A handmade soft pastel dragged across the tacky Wingel catches only in certain areas, leaving a beautiful uneven surface behind.

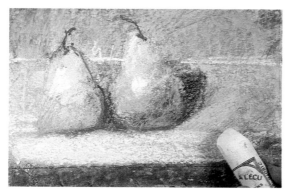

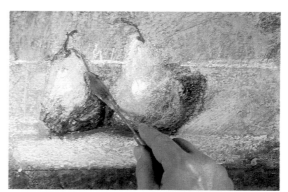

After the second coat of Wingel dries, I add some very large strokes with a giant Sennelier soft pastel. Scumbling techniques are highly successful with Wingel.

I use small amounts of Wingel for finishing touches such as darkening the edges of the pears. Wingel can be added even when the painting is almost finished—but if overused it can create shiny areas that are incompatible with the matte soft pastels.

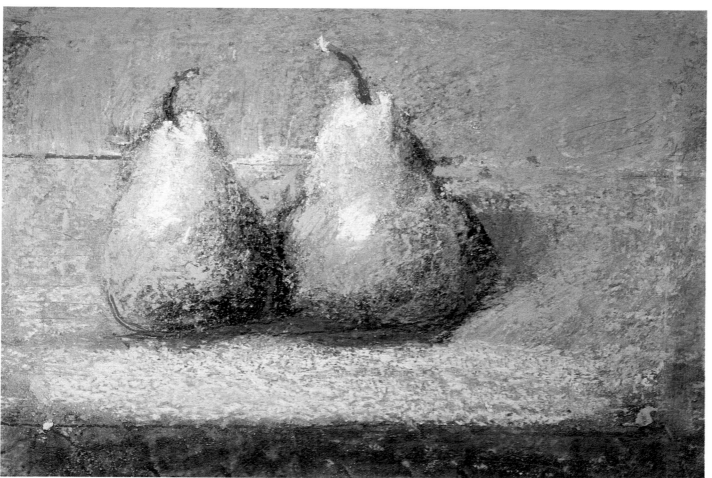

TWO PEARS
Pastel and alkyd gel on Multimedia
Artboard, 8 ¼ × 12" (21 × 30 cm).
Collection of the artist.

To finish the pastel, I apply extremely soft pastels and handmade pastels over the earlier layers held down with Wingel. The textures can be very rich and loose because the Wingel gives the soft pastel an impasto quality.

OIL PAINT COMBINED WITH PASTELS

Pastels have long been used as a drawing medium with which to start oil paintings. This is because unfixed pastels are easily wiped off the canvas or absorbed into the oil paint. Pastels can also be used with oil paintings in progress, to make temporary color or drawing notations that the artist can later either wipe off or paint over with fresh applications of oil paint.

However, there are also times when you can actually transform an oil painting into a highly developed pastel, with the oil painting serving as a foundation or underpainting. Two notes of caution: This method works best when the oil painting is on a panel or a canvas board; stretched canvas doesn't work too well. Also, the oil paint shouldn't be thick or heavily built up.

Sometimes I start to doodle with pastels right on top of a rather boring or unsuccessful oil painting, and I often find that something begins to happen. The painting seems to come to life again, and new possibilities seem to come out of the pastel work. At this point I usually decide to convert the oil painting into a pastel.

Be forewarned that this process involves multiple layers. Begin reworking the oil panel or canvas panel with soft pastels, using the old oil painting as an underpainting. Keep the drawing loose and follow the old oil painting for the design and style. At first the pastel will not adhere especially well, which means that it is easy to wipe off the pastel to correct your drawing. Fix the initial layer of soft pastel very heavily with strong fixative. Keep working several layers like this until the painting is fairly well built up with pastel. At this point spray the pastel with retouch varnish. This will of course really darken the color, but that's OK because the heavily varnished surface will provide a firm foundation for building up more layers of soft pastel.

Keep drawing and fixing the pastel layers as you work, switching to pastel fixative for the final stages. Remember to keep the canvas flat and occasionally press the pastels into the support with a wide, flat palette knife. The soft pastel will cling to the surface better with each application of fixative and retouch varnish, eventually forming a strong, interesting surface over what had been a failed oil painting.

DEMONSTRATION

Here you see an oil painting converted into a soft pastel. The process is very simple but requires fixing multiple layers to build up a pastel surface. It works best if the oil painting is on a panel or canvas board rather than stretched canvas, and if it does not have a lot of thick impasto.

Here is the original oil painting of a reclining nude. Because this painting on a canvas board is several years old and permanently dry, it is ideal for conversion to a soft pastel.

SLEEPING NUDE
Pastel over oil paint
on canvas board,
16 × 20" (41 × 51 cm).
Collection of the artist.

*After several layers
of soft pastel, the
finished work is
more atmospheric
than the earlier oil
painting. The flesh
tones are softer and
the color is more
diffused, less wooden.
The oil painting's
rather harsh light has
become gentler and
more scintillating.*

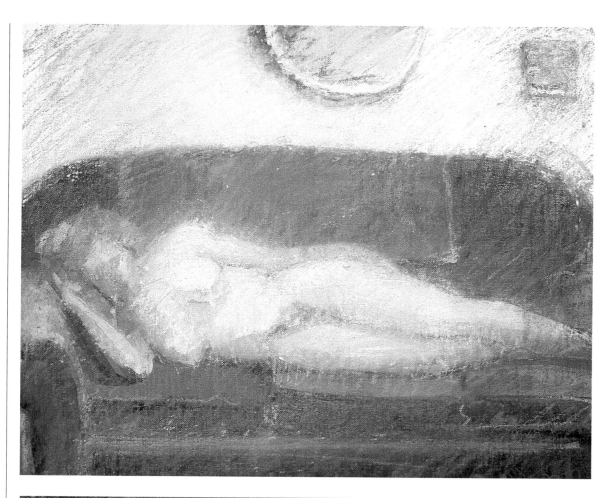

*This detail of the
final soft pastel
version shows that
the color is looser,
more broken, and
more impressionistic.
I was free to be
daring in applying
the pastel, because
the composition was
already established.*

PASTEL MONOTYPES

Monotypes are one-of-a-kind prints made by drawing with printer's ink or oil paint directly on a metal plate or plastic sheet, and then using an etcher's press to print from the plate or sheet onto paper. Because they are usually drawn while the etching inks are still wet and viscous, monotypes are characteristically loose and free-flowing. Fast, spontaneous drawing and rapid changes are the rule in monotype—and this makes the medium ideal for working in sequence. It is natural for the artist to print the plate once or twice, modify the painting slightly, and then print it again.

The first impression made from a monotype is the strongest and clearest; subsequent impressions are much paler and not really presentable as monotypes. Yet these second paler printings can provide the starting point for a pastel painting.

Pastels and monotype are highly compatible as a mixed media combination. Degas was famous for taking two impressions of a monotype and converting the second paler version into a pastel. This seemed perfectly natural for an artist like Degas, who enjoyed doing several versions of the same subject. And it seems to fit into the progressive nature of monotypes themselves that they can be instantaneously transformed into pastels. Pastels provide the opportunity for changes of color and texture that are far different from the original monotype.

A monotype gives a pastel a head start. It is a little bit like beginning halfway through a painting: The composition and the drawing have been determined by the monotype, and now all you need to do is let yourself go with the color. Pastel can transform an initial monotype image into something fresh and new.

DEMONSTRATION

I like the idea of pulling an extra second printing of a monotype for the specific purposes of making a pastel out of it later. Before working pastels over the monotype, I let the ink dry and flatten out the paper. As I work my pastels, I try to keep the monotype image always visible in some way, even in the finished painting. For this reason I do not build the pastel too thickly—I even scrape it away when necessary to keep the layer of pastel somewhat transparent. In some sense the pastel is like a glazed color worked over the monotype underpainting.

Photo by D. James Dee.

Photo by D. James Dee.

Here are two versions of a monotype. Top: The first print has a wide range of values, and the ink colors I used came through. Above: The second print is much paler, as typical in monoprinting, and it has almost no color. But the image and composition are still visible, and there is plenty of information for me to take off from. The second version is the one I will convert into a pastel painting.

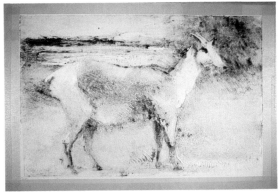

I cover the edges of the monotype with drafting tape to protect the original plate marks. It is a personal preference of mine to protect the edges of the monotype and not let the pastel exceed the original plate marks, which offer a natural, textured boundary. The tape will be removed when the pastel is completed.

I gently rub a thin layer of soft pastel into the paper. The pastel color is very transparent and much of the original monotype still shows through.

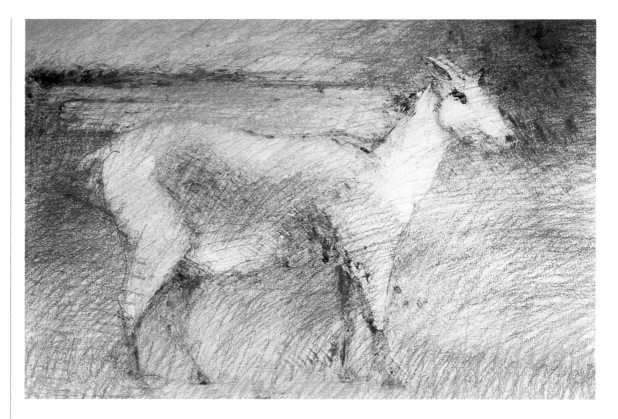

I lightly fix the first level of pastel and then add more color. At this point I am interested in building up texture, so I soak a soft-haired brush in fixative and splatter it over the painting. This creates an exciting texture and permanently fixes portions of the pastel.

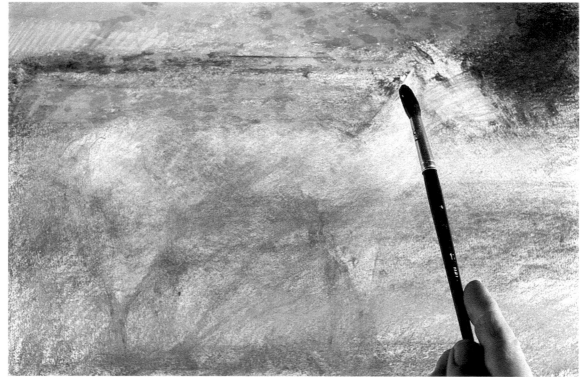

PASTEL MONOTYPES

Now I work generous amounts of soft pastel across the painting with a palette knife, keeping the color loose and open. (I can always tighten up the details later to complete the painting.)

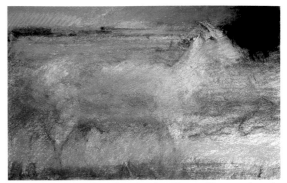

Here you can see how bands of gold metallic pastel and alizarin crimson create a strange, unearthly landscape for the background.

THE GOAT
Pastel and monotype
on Rives BFK paper,
12 × 17 ¹/₂" (30 × 44 cm).
Collection of the artist.

The final pastel shows a white goat against a twilight background of dark blues and warm reds and golds. This new pastel image is far different from the original monotype, yet it is the same composition. Experimenting with different ideas and color moods is one of the enjoyable aspects of working pastels over a monotype; the same drawing and composition can take on many faces. Even in the finished pastel, the monotype image is still visible.

Gum Tragacanth Combined with Pastels

One more unusual way to work with pastels is to use an extremely strong solution of gum tragacanth as a fixative. Gum tragacanth is the gum binder that is used in making pastels, and it holds the pastel pigments together into a firm stick. If you pour this liquid binder directly over a pastel drawing, it hardens the pigment into a very durable film. The pastel will darken at first, then lighten to its original color as the gum tragacanth solution dries. You can then apply another layer of pastel over it. The firm surface is more like a pastel stick than a typical pastel painting, and it provides an excellent support for scumbling and rough textures of broken color.

If you want to try this technique, the first thing you must do is track down some gum tragacanth. Try your local art supply store, but gum tragacanth is not exactly the hottest thing going, so don't be surprised if it is not a standard item. Your local art supply dealer may be able to order some for you. One reliable source is Daniel Smith Inc. in Seattle (see List of Suppliers on page 172), which sells gum tragacanth by the pound. One or two pounds should be a lifetime supply, even if you decide to make your own pastels for the rest of your life!

Gum tragacanth is sold as a very fine powder, which becomes a pastel binder when dissolved in water. It takes very little gum tragacanth to make a solution strong enough to hold a pastel stick together. I have found a successful solution for the technique described above to be about 1 to 48, or 1 level teaspoon of gum tragacanth per 1 cup water.

Gum tragacanth powder must soak in water for a day or two before it completely dissolves. I recommend adding two or three drops of beta naphthol (available at any chemical supply house) as a preservative. The resulting mixture will be a very thick, amber-colored solution of pastel binder. Add water as needed if it is too thick to pour or paint easily over your pastels. Once applied, it will take about 1 to 1 1/2 hours to dry naturally, but you can speed this up to 5 or 10 minutes with a hair drier.

BULL
Pastel, gum tragacanth, and oil pastel on Matière Thick Rustic paper, 8 × 12" (20 × 30 cm). Collection of the artist.

This painting was created in a series of layers of soft pastel, each fixed by pouring an extremely strong solution of gum tragacanth binder over it and allowing it to dry. Although bits of color floated up as the binder covered the pastel, very little of the color was altered. The firm surface created by the gum tragacanth made an excellent support for scumbling.

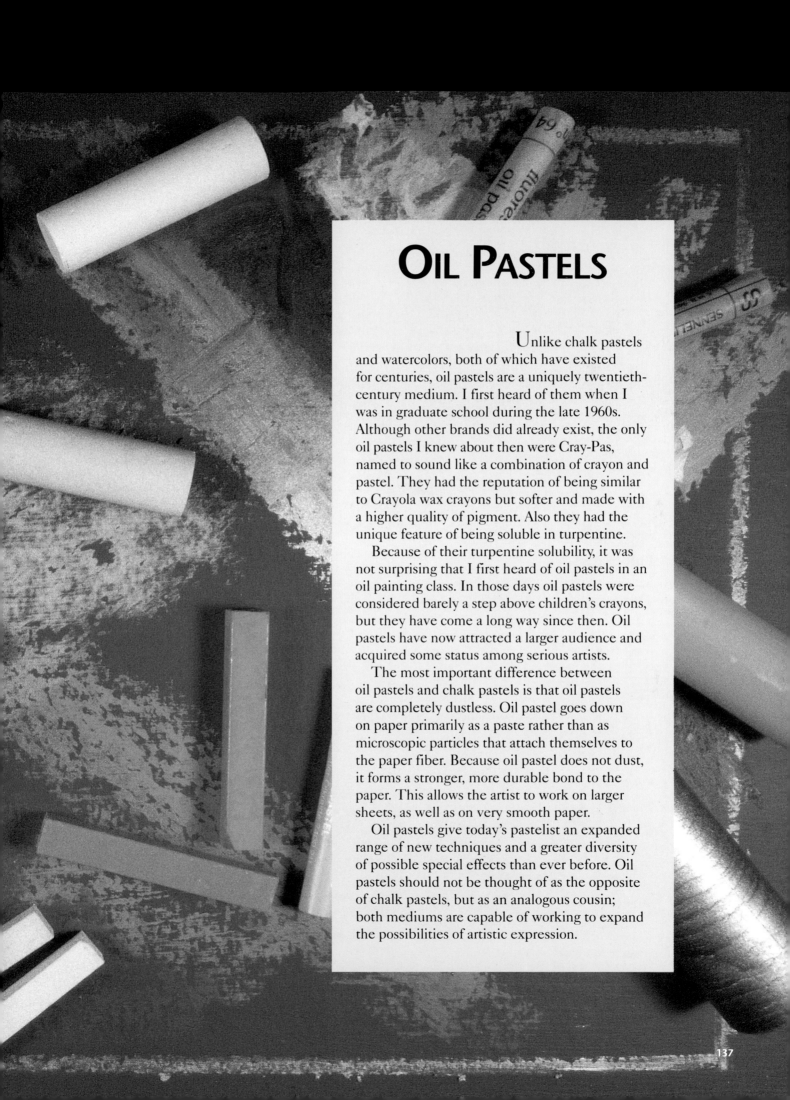

OIL PASTELS

Unlike chalk pastels and watercolors, both of which have existed for centuries, oil pastels are a uniquely twentieth-century medium. I first heard of them when I was in graduate school during the late 1960s. Although other brands did already exist, the only oil pastels I knew about then were Cray-Pas, named to sound like a combination of crayon and pastel. They had the reputation of being similar to Crayola wax crayons but softer and made with a higher quality of pigment. Also they had the unique feature of being soluble in turpentine.

Because of their turpentine solubility, it was not surprising that I first heard of oil pastels in an oil painting class. In those days oil pastels were considered barely a step above children's crayons, but they have come a long way since then. Oil pastels have now attracted a larger audience and acquired some status among serious artists.

The most important difference between oil pastels and chalk pastels is that oil pastels are completely dustless. Oil pastel goes down on paper primarily as a paste rather than as microscopic particles that attach themselves to the paper fiber. Because oil pastel does not dust, it forms a stronger, more durable bond to the paper. This allows the artist to work on larger sheets, as well as on very smooth paper.

Oil pastels give today's pastelist an expanded range of new techniques and a greater diversity of possible special effects than ever before. Oil pastels should not be thought of as the opposite of chalk pastels, but as an analogous cousin; both mediums are capable of working to expand the possibilities of artistic expression.

A Sampler of Oil Pastel Strokes

Oil pastel is a highly versatile medium capable of adapting to many styles of work. It can be used as a paint film, a wash medium, or a basic drawing tool. Just like chalk pastel, oil pastel is both a drawing medium and a painting medium. Individual sticks can deposit color directly onto the paper, or colors can be blended together to create the shades, tints, and variations in hue that are necessary for a painting.

The texture of an oil pastel drawing depends on two factors: the surface texture of the paper and the pressure of the pastel strokes. The support of an oil pastel, as with all pastels, is critically important. The rougher the surface, the more broken the color effect will be; conversely, the smoother the paper, the slicker the finish will be. The other factor is the artist's "touch"—the intensity of pressure that the artist's hand applies while working the pastels across the paper. This quality of touch is a key aspect of any pastelist's talent. The lighter the touch, the less intense the color and the more broken the surface. A heavier stroke yields a richer, meatier paint surface. Part of the pastelist's magic is the ability to vary the touch at will to create a variety of different looks.

Oil pastel colors can be applied straight from the stick, or they can be blended together to create new colors and tones. A flat tone of one color can be altered by working a second color over it—either totally, to create an entirely new color, or partially, to create a feathered or graduated effect.

Many kinds of blending tools can be used with oil pastel: paper tortillions, pencil erasers, spoons, burnishers, plastic caps from ball-point or felt-tip pens, Crayola crayons, wax markers, oil stick blenders, paintbrushes, and scraps of thin illustration board, to name a few. Experiment with various blending tools to find those that work best for you. It is also worth noting here that oil pastels can be blended not only with turpentine and other oil paint mediums, but even with acrylic mediums. See pages 147-153 for more on these special mixed media techniques.

Blended oil pastel colors can be quite beautiful, but blending must be done in moderation or there is a real danger of muddying the color. I find that oil pastel builds up very fast, so that it is difficult to blend more than a few colors together. The solution to this problem is to scrape off all the color with a palette knife or razor blade, and start over. Oil pastel can be scraped off many times, leaving a thin residue that can easily be worked over again. In fact, scraping is such a basic technique with this medium that a palette knife and a razor blade should be a permanent part of your oil pastel tool box. The small ridges sometimes left by scraping add a textural element that is part of the look of an oil pastel painting.

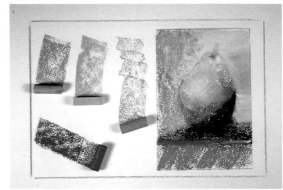

Side strokes. A variety of effects can be attained by drawing with the flat side of an oil pastel, usually a half-size stick or smaller. Oil pastels are available in both flat and round sticks, and either kind can be used for side strokes. The color density of such a stroke is determined by the softness of the oil pastel crayon as well as by the pressure of the stroke.

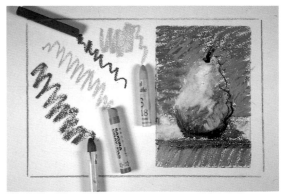

Linear strokes. The tip of an oil pastel makes a more linear mark, which can be used for outlining and cross-hatching. Although it is possible to make a very thin line with oil pastel, a more typical linear stroke is thicker with a waxlike texture.

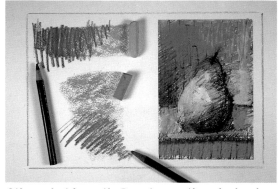

Oil pastel with pencils. Drawing pencils and colored pencils can be worked into a broad area of oil pastel to create a graded tone, to add line, or to activate a flat surface with an incised texture. Pencils are also one of the best ways to establish a hard edge with oil pastel.

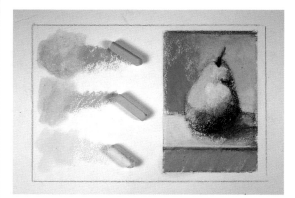

Oil pastel with turpentine. When dipped into turpentine, oil pastels dissolve and become very soft; they are easier to blend together. Turpentine washes look much like watercolor washes, but dry fast so that many layers can be worked on top of one another.

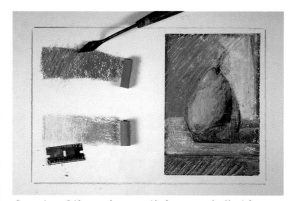

Scraping. Oil pastel can easily be scraped off with a single-edged razor, a palette knife, or almost any pointed tool. This works especially well on a beautifully textured paper because a small residue of the original color is left in the crevices. Scraping off excessive oil pastel means that a fresh layer can be applied without muddying the colors.

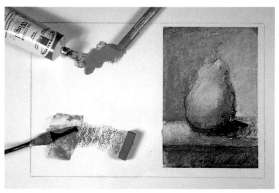

Oil pastel with oil paint mediums. Oil paint mediums help oil pastels dry faster and give the surface a paint film. They can also be used to build up impasto textures and to make transparent oil pastel glazes.

DEMONSTRATION

Oil pastel can be built up in layers, blended directly or with tools, or manipulated with various paint mediums for special effects. The still life in this demonstration was done on an uncoated sheet of Daniel Smith Non-Buckling Painting Board. This epoxy-treated support is unaffected by turpentine and oil solvents, so it is perfect for oil pastel work.

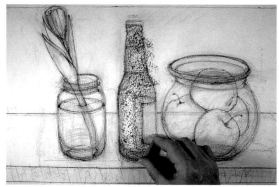

I begin this still life by outlining the objects with pastel pencils. In the early stages of an oil pastel painting, small amounts of traditional chalk pastel can easily be mixed with oil pastels, especially if the chalk pastel is applied first. Next I use side strokes to apply very thin layers of oil pastel. The idea is to have a thin veil of oil pastel that will be easy to spread with a solvent or paint medium.

A SAMPLER OF OIL PASTEL STROKES

Here I am squeezing some Wingel onto a palette knife, and then smearing it over the oil pastel. This alkyd-based medium, manufactured by Winsor & Newton, makes the oil pastel more transparent and easier to spread.

After the entire painting has been covered with Wingel and dried, I apply a second coat of oil pastel. I add light lemon yellow to the apples and light blue to the background.

By this stage the still life has several layers of oil pastel. The local colors and an overall light have been established. Now it is time for refinements.

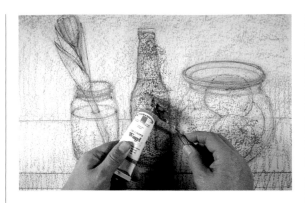

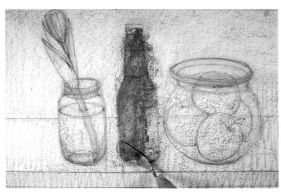

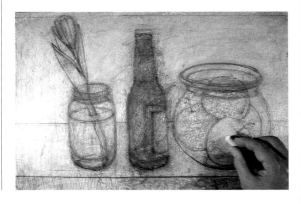

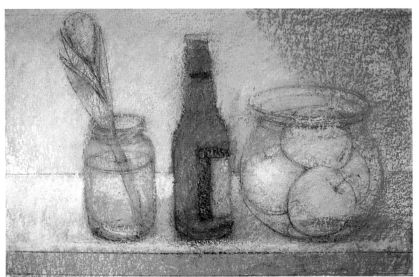

I add a flat tone of yellow to the side of the apple, and then work a lighter yellow over that to create a slight highlight. Lime green along the bottom of the apple creates a color change and a suggestion of volume.

I blend these freshly applied colors first with a palette knife, then with a pencil eraser. Finally I add a further highlight on top of the blended colors. The apple is starting to look three-dimensional now, especially in contrast to those behind it.

Next I work a cadmium yellow oil pastel very loosely over the bottle's label. To create a hard edge, I use a piece of masking tape. This holds very well on top of oil pastel and pulls off very little color when it is removed.

Masking tape can also be used to make a template—for example, to create a thin line with hard edges. In this case I want a hard white edge on the bottle's label.

I use plenty of masking tape for my template to prevent the new oil pastel from smearing into unwanted areas. Next I dab a little Wingel onto a white oil pastel to make it dissolve into a smooth gel as I work it along the inside of the template. Then I scrape off the excess with a wide palette knife. After the oil pastel has dried, I pull off the masking tape. (Do this carefully so that the oil pastel on the tape doesn't accidentally smear other areas of the painting!) The final result is a hard-edged shape that would have been impossible to draw freehand.

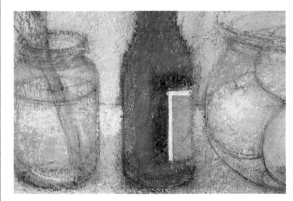

I add more orange to the beer bottle and scrape it with a palette knife to make the bottle look more transparent.

With a palette knife I add more dark color to the bottom of the beer bottle, and I use a straight edge and a dark colored pencil to darken the far edge of the label seen through the glass.

To emphasize the faint diagonal shadow cast by the clear jar, I drag a light-colored oil pastel along the edge of a piece of mat board.

A SAMPLER OF OIL PASTEL STROKES

By drawing with a dark purple oil pastel, I add a deep shadow coming in from the upper right. I then add more texture and interest to this purple tone by scraping away some of the color, using a palette knife loaded with Wingel. Finally I use a sponge paint roller to soften the shadow even more, and to remove any excess Wingel.

STILL LIFE WITH BEER BOTTLE
Oil pastel and mixed media on Daniel Smith Non-Buckling Painting Board, 12 × 18" (30 × 46 cm). Collection of the artist.

With a white oil pastel I add the final highlights and finishing touches on the edges of the glass bowl and on the beer bottle.

The finished painting shows the very rich build-up of texture and buttery colors that are possible with oil pastel. The dark purple shadow in the upper right helps create a contrast of light and dark with the yellow apples.

OIL PASTEL COLOR

Oil pastel undoubtedly offers the pastelist more variety of handling techniques and surface textures than ever before, but there is a price to pay for their flexibility and permanence. Oil pastels are simply not as bright as chalk pastels. This is not because of inferior pigments; the professional brands use pigments of excellent quality. Rather, it is because oil pastels contain more ingredients than chalk pastels. Some of the oils and waxes required to give the oil pastel its desired consistency have the unfortunate side effect of dulling the pigments. Exactly the same thing happens with oil paints; anyone who has ever made them has seen how linseed oil dulls the vibrant color purity of the raw pigment. (It is true that the gum tragacanth added to chalk pastels sometimes darkens them, but the pigment recovers its original color almost completely once the pastel has thoroughly dried.)

This color discrepancy is particularly noticeable in the earth tones. As mentioned earlier, the earth browns, terra cottas, terra vertes, and yellow ochres of soft pastel have a richness and purity of color unequaled by any other medium. In oil pastel some of this color freshness gets lost even though the pigments used are the same.

However, oil pastel color has its own unique appeal. Its waxy sheen is quite different from the dusty surface of chalk pastels and can be used to advantage in a painting. The softly glowing matte surface of an oil pastel is reminiscent of encaustic paintings, or even frescoes. This quality gives the medium its unified look and helps the artist keep the color under control. It also means that adding oil paint mediums to the oil pastel will not significantly change the color—and for any artist intrigued by mixed media, this can be important. Nevertheless, the greater color purity of chalk pastel is one of the main reasons why many pastelists remain loyal to it, in spite of everything oil pastel has to offer.

CHEVROLET EXPERIENCE
Oil pastel and mixed media on paper mounted to panel, 12 × 15 ½" (30 × 39 cm). Collection of the artist. Photo by D. James Dee.

This painting began as a pen-and-ink drawing on paper. Eventually I added soft pastels, mounted it onto a panel, and began adding oil pastel. Finally I combined the chalk and oil pastel using Liquin and Wingel. Gold oil pastels were added to the edges and glazed over with other oil pastel colors to create a patina similar to tarnished gold leaf. In many ways this painting has a contemporary medieval feeling— an unexplained spirituality rather than an accurate depiction of reality.

METALLIC, IRIDESCENT, AND FLUORESCENT COLORS

Iridescent and metallic colors were available in oil pastels before chalk pastels caught up with them. In both mediums, these special pigments add an exciting luster to a painting by reflecting a touch of light. Iridescent and metallic colors are very transparent and work beautifully as a glaze over more traditional colors; they can be spread very thin with Wingel or Liquin. It is also worth noting that iridescent chalk and oil pastels work well together.

Sennelier has 25 iridescent and metallic oil pastels that are amazing to work with, available in a complete boxed set or as individual crayons. More exotic brands of oil pastels, such as Chardin and R&F Pigment Sticks, now have iridescent colors as well.

Sennelier also has five fluorescent oil pastel color sticks—unusually bright, glowing colors that are visible under black light. These are not always easy to find at art supply stores, but they are available through Pearl Paint (see List of Suppliers). Unfortunately, fluorescent colors are not recommended as permanent, so you may prefer not to use them for certain kinds of work.

DEMONSTRATION

For this painting I used metallic and iridescent colors of both chalk pastels and oil pastels. Pastelists should be aware that iridescence is very tricky to photograph! Because these paintings are almost impossible to reproduce accurately, they have an extra fascination when viewed in person.

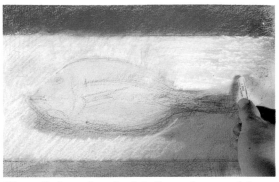

The preliminary layer is of chalk pastels, some of them iridescent. After laying in dark blue iridescent pastel for the background, I use a hard pencil eraser to spread the color and simultaneously press it into the paper. For now the tabletop and fish are rendered in light, noniridescent local colors.

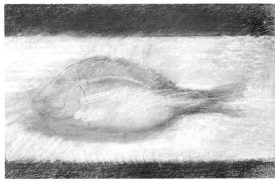

Once this layer is finished, I apply acrylic spray to hold the pastel firmly to the paper. At this point the painting is a combination of iridescent chalk pastels mixed in with conventional colors. All the colors are loosely applied, and much of the original drawing still shows through to guide me with later details.

This painting begins as a line drawing with light cross-hatching added for tone. I use various colors of pastel pencils to leave light marks, which can easily be erased for corrections and will be absorbed into the later stages of the work.

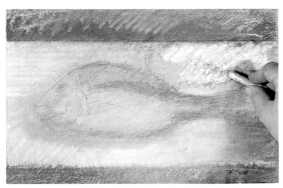

Now I turn to iridescent oil pastels. After dipping a transparent yellow one into Wingel, I begin to work it over the yellow ochre soft pastel. This combination creates a thick, buttery texture. In other areas I squeeze Wingel directly onto the painting, and work the iridescent oil pastel into it, until the entire tabletop glistens with iridescent color.

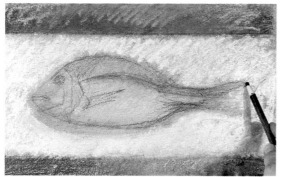

Before applying oil pastels to the fish itself, I outline its edges with a dark china marker. This keeps the outline of the original drawing clear as I begin to work over it with the oil pastels.

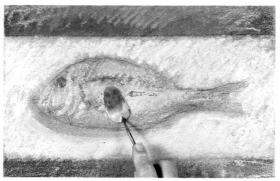

I dab Wingel directly onto the painting and use a palette knife to smear it over the entire fish. This simultaneously spreads and mixes the iridescent colors. I use a small sponge paint roller to even out the Wingel and color.

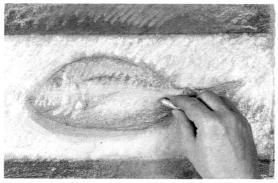

I add a pearlescent pink along the bottom of the fish, a layer of pale rich gold above that, and silver near the top. The strokes are open and loose and at this point there is a minimum of blending.

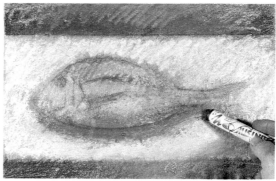

With a dark blue iridescent Paintstik I draw in a shadow, and then spread it with a palette knife dipped in Wingel. Paintstiks work well with oil pastels, especially when used in combination with quick-drying paint mediums like Wingel.

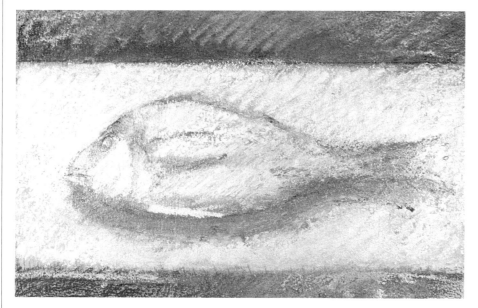

The painting is now entirely covered with a mixture of iridescent and noniridescent oil pastel colors. Now I need to give more attention to detail, and to bring the form and light of the still life into focus.

METALLIC, IRIDESCENT, AND FLUORESCENT COLORS

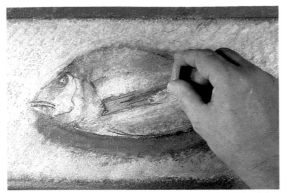 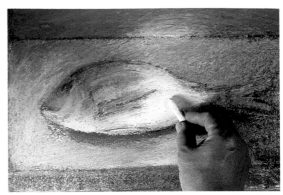

After applying a little Wingel to the top of the fish with a small palette knife, I drag a soft blue-gray oil pastel over it to leave a scumble of color. I then exaggerate the texture of the scumble even more by lightly scraping the small palette knife over the freshly applied oil pastel. Later I change the color of this area to a greener hue and apply more rich gold along the surface of the table.

Even though many of the details on the fish are designed to create an illusion of pearlescence and iridescent light, there are places where the color is absolutely opaque, such as the fish's white underbelly. Here I apply heavy amounts of pure white oil pastel to emphasize that this is where the light is striking the most strongly. Remember that iridescent oil pastels are quite transparent, so highlights should be rendered in more opaque colors.

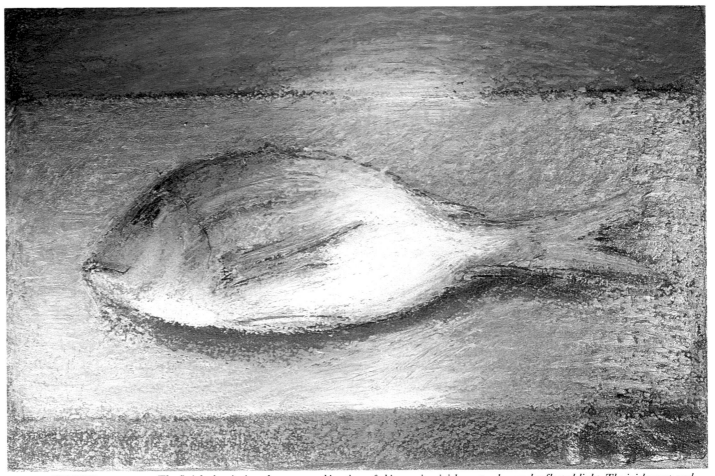

SILVER FISH
Oil pastel and soft pastel on paper,
9 × 12" (23 × 30 cm).
Collection of the artist.

The finished painting shows a combination of shimmering iridescent color and reflected light. The iridescent and metallic colors convey a sense of mystery rather than a bright display of color.

SPECIAL EFFECTS WITH OIL PASTEL

It is very easy to build up an impasto, or heavy paintlike surface, when working in oil pastels. This makes it possible to exploit the textural qualities of oil pastels in several ways for interesting special effects not achievable with chalk pastels.

Creating ridges. Small raised ridges of built-up oil pastel are a unique quality of the medium, so exploit them to the fullest. One quick way to build up a ridged texture is to apply direct, cross-hatched strokes. The individual marks leave direct color, and the cross-hatching leaves small raised ridges on the paper.

You can also create ridges by bringing the oil pastels up against a hard edge, such as a ruler or a strip of masking or drafting tape. When you pull up the tape, a ridge of oil pastel color is left behind in relief. This is an effective method of separating colors while you work. Oil pastel strokes are normally soft and imprecise, and it is a challenge to get a hard edge. A straight edge of tape is the best way to achieve a hard, clean boundary between two colors. You can put the tape down either over clean paper or over oil pastel, and neither surface will be damaged when you pull the tape off.

Working with templates for control. When you need to apply a lot of color in a small area, a template can help you control where your oil pastel strokes go. Like masking tape, a template sharpens the area's edges and helps keep colors clean and fresh—but a template is better for curves, and can be used to surround the whole area rather than one edge at a time. Choose something thin, flexible, and firm enough to be cleaned off afterward. One of my favorite templates is an architect's erasing shield.

Scraping large areas with a razor. As mentioned earlier, a razor blade is a handy tool for correcting an oil pastel by scraping off large areas at a time. This technique can also be used deliberately to create a thin film of color that resembles a wash, which can then be left as it is or serve as an underpainting for a new layer of oil pastel.

Sgraffito effects. Because oil pastel leaves a creamy, paintlike surface that can be built up into an impasto, it lends itself beautifully to sgraffito effects. (Sgraffito is an Italian term meaning marks incised into a surface.) The pastelist can draw into a thick layer of oil pastel with a sharp tool (such as a palette knife, razor blade, or etching stylus) for a graphic, textural effect.

Soft lead pencils, colored pencils, and colored graphite sticks (such as Berol's Prismacolor Art Stix) also make excellent incising tools for creating mixed media effects. A colored incising tool leaves a slight haze of its own hue as it scrapes the oil pastel away. This is also a good method of getting a thin, hard edge to define the outside of an object, or to sharpen the edge of a colored plane.

Wash effects. As mentioned earlier, oil pastel is soluble in turpentine or mineral spirits, and this quality is what makes it very close to a painting medium. If you want to use oil pastel in this way, first size your paper or other support with a coating of acrylic gesso or acrylic medium. This protects the paper from oil-based solvents, which could otherwise weaken the paper and shorten the life of your finished painting.

There are several ways to use oil pastels with turpentine. You can make a diluted wash by dipping one or more oil pastel sticks into a small jar of turpentine, and then spread the colors with a brush or a rag. The resulting underpainting will look much like a watercolor and will dry very fast—which means that you can keep working on the painting without lengthy interruptions. You can then add new washes or more opaque oil pastel strokes once the first layer is dry. Since the oil pastel dissolves in even a small amount of turpentine, you can also drag a partially dissolved stick across earlier washes to produce a scumbling effect.

You can also dip an oil pastel stick into turpentine and then draw with it to make thick, gooey strokes. Another method is to draw with oil pastels first and then smear the colors with a brush dipped in turpentine.

OIL PASTELS COMBINED WITH ALKYD-BASED GELS

Because oil pastels can be used with oil painting solvents like turpentine, they are also chemically compatible with other oil painting mediums, such as alkyd-based gels, for even more dazzling special effects. The gels that I use most with oil pastels are Wingel, Liquin, and Oleopasto. All three are alkyd-based painting mediums manufactured by Winsor & Newton and intended for either oil paints or alkyd colors.

Oleopasto creates wonderful impastos when mixed with oil pastel. Wingel has a heavier consistency than Liquin and dries faster. Both gels make oil pastel more transparent, so that it can be glazed over an earlier layer very much like glazing with oil paint. An oil pastel stick dipped into the gel will leave a semitransparent glaze on the paper; you can also spread the gel over an oil pastel painting with a palette knife. Of course, oil pastels can be thinned only so far, and never quite reach oil paint's level of transparency. But when oil pastels are mixed with Wingel or Liquin, they do create very interesting opalescent glazes.

When glazing with gel and a palette knife, be careful about dragging darker colors over onto the lighter ones. Sometimes this will unnecessarily darken the subtle blending of lighter colors. On the other hand, dark particles deliberately glazed over light colors can create a beautiful patina.

Perhaps the most useful characteristic of all these alkyd-based gels is that they dry very quickly. (Alkyd paints are like quick-drying oils.) Oil pastel mixed with Wingel or Liquin creates beautiful glossy strokes that dry to a hard, durable finish in less than an hour. The hard finish makes it possible to add many more coats of oil pastel without muddying the colors, because the individual layers of oil pastel are clean and separate. (In this sense the gels serve a function analogous to workable fixative with chalk pastel.) Also, a whole variety of previously inconceivable materials can be worked over the hard surface: pen and ink, colored pencils, soft pastels, even oil or alkyd paints. Alkyd gels also work well *over* mixed media combinations, such as oil pastel with ball-point pen or pen and ink.

Alkyd-based gels dramatically expand the pastelist's repertoire of special effects. Experimenting with the sophisticated range of possibilities this medium has to offer is a good way to develop a more personal, flexible style.

DEMONSTRATION

The Dove began as a pen-and-ink drawing and ended up as an oil pastel. (This is also true of *Oldsmobile* on page 153, but for that painting I used acrylic medium rather than Wingel to separate the layers of oil pastel.)

As I gradually built up the texture of *The Dove*, I had in mind those beautiful Pompeian frescoes of still lifes showing birds and small animals along with bowls of fruit and food. The Wingel allowed me to create the textural illusion of an old wall.

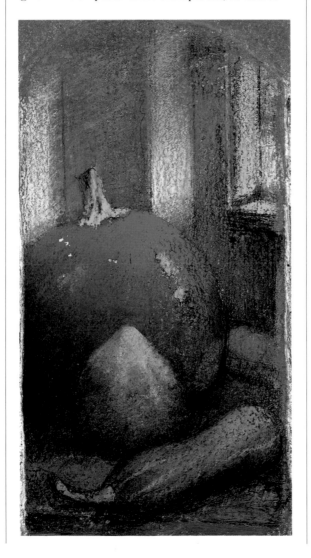

PUMPKIN
Oil pastel and alkyd gel on handmade panel, 11 × 5" (28 × 13 cm). Collection of Fritz John. Photo by D. James Dee.

Here is another painting that was developed through many levels of oil pastels glazed on with Wingel. The rounded arch is actually another three-dimensional canvas embedded into the panel, with gold oil pastel outlining its edges.

The first step of this painting is a simple cross-hatched drawing of a bird on a ledge, rendered in a combination of pen and ink and ball-point pen on a small sheet of handmade paper. The paper was heavily sized, so it is easy to draw on with pen and ink.

In the second stage I apply a basic layer of oil pastel, spreading it lightly over the pen-and-ink drawing. I make sure enough of the pen and ink still shows through to guide me with details. Much of the local color has been established by this point, and so has the boxlike ledge that serves as the central compositional element.

THE DOVE
Oil pastel and mixed media on rough handmade paper, 9 × 14" (23 × 36 cm).
Private collection.
Photo by D. James Dee.

The finished painting is the result of building many layers of oil pastel on top of each other until a richly textured impasto is achieved. Each layer of oil pastel is separated from the next by mixing it with Wingel; this technique allowed me to glaze and scumble colors on top of each other. But in spite of the thickly built-up surface and intriguing texture, the pen-and-ink drawing is still visible in many places.

OIL PASTELS COMBINED WITH ALKYD-BASED GELS

DEMONSTRATION

The evolution of *Fire Island Porch* shows many of the advantages of using oil pastels and transparent gels together. The original pencil drawing provided the framework for adding new color ideas and compositional elements. Because the oil pastel was highly diluted with Wingel, the glazes were completely transparent, and none of the graphic quality of the original drawing was lost. I had no idea of how the final painting would look when I began to rework this old classroom drawing into an oil pastel—but all forms of pastel are the perfect medium for transforming one idea into another, and for coaxing out the best from one's imagination.

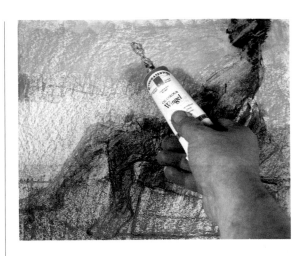

I decide to convert this pencil drawing of a male nude, drawn on smooth paper, into an oil pastel.

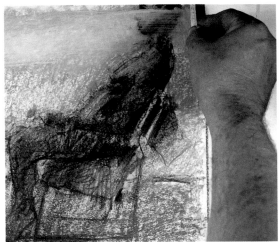

Then I apply a small dab of Wingel and smear an oil pastel across it, creating a semitransparent glaze.

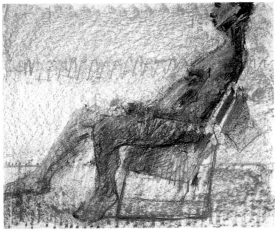

With side strokes of oil pastel, I gradually add color to the pencil drawing. I am careful to keep the oil pastel open, loose, and thin enough so that the pencil drawing still shows through.

With a palette knife I scrape away part of this oil pastel glaze to expose the drawing beneath. One advantage to working on very smooth paper is that it is very easy to scrape away the oil pastel film.

As I continue working oil pastels and Wingel across the painting and scraping with a palette knife where needed, the piece becomes more painterly.

Now I decide to reintroduce a more linear quality to the oil pastel. I do this by taking a soft lead pencil and drawing through the oil pastel. The pencil works well as a scraping tool for adding linear detail.

FIRE ISLAND PORCH
Oil pastel, pencil, and alkyd gel on
Basingwerk paper, 10 × 12" (25 × 30 cm).
Collection of the artist.

I use oil pastel to add a few last-minute details, giving more volume to the figure and more color and definition to the chair. The painting is now finished.

OIL PASTELS COMBINED WITH ACRYLIC MEDIUM

Yet another way to use oil pastel is with acrylic medium. This is an experimental technique, but it is worth mentioning. The combination of mediums sounds strange because acrylic medium is a water-based solution that logically should not mix with oil pastels. But for some inexplicable reason, they do work together—especially if you avoid heavy build-up of oil pastel and use a brand that is not too oily. (Holbein and Caran d'Ache oil pastels work better with acrylic medium than Sennelier, which have a higher oil content.)

First draw a loose layer of oil pastel over a canvas or a sheet of watercolor paper. Then isolate that layer by brushing a coating of acrylic medium over it. (I usually use Speedball matte medium by Hunt, occasionally adding a touch of gloss medium for a slightly semigloss finish.) The medium may pick up very small amounts of oil pastel color, so it can serve as a subtle glaze as well as a sealing fixative to cover the oil pastel. Once the acrylic medium has dried, which takes about 15 minutes, you can work a fresh coat of oil pastel on top of it.

One word of caution: Don't thin the acrylic medium with water. Oil pastel really does repel water, even though it works well with acrylic medium or acrylic gel.

DEMONSTRATION

Most of my car paintings are inspired by old *Life* magazine ads, and this one is no exception. I like to work from ads because they give the subject a built-in glamour that always helps my own imagination get moving. *Oldsmobile* is a freehand copy of an ad for a 1952 Oldsmobile, which I transplanted into my own imaginary landscape.

This was a very experimental painting for me. I chose to work on stretched canvas—an unusual support for oil pastel, which usually needs a more rigid support for successful blending. Each layer of oil pastel was separated with a layer of clear acrylic medium, applied with a very soft nylon brush that left almost no brushstrokes. (I used a gloss medium because I wanted to simulate the look of an oil painting.) After several layers, I finally had the image of the car that I was after, and I was happy with the color.

This oil pastel starts out as a very loose drawing in pen and ink and felt-tip pens on canvas. The canvas is stretched cotton primed with acrylic gesso.

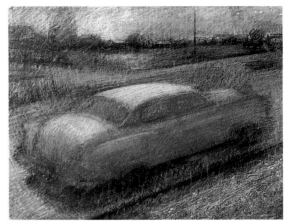

I apply the first coat of oil pastel, laying in the basic color and establishing the distribution of light and dark. When the first layer is complete, I paint on a coat of undiluted medium. The medium must not be diluted with any water, or it will not work with the oil pastel.

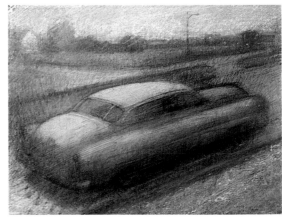

Once the medium has dried, I start to add a little more volume and detail to the car and to emphasize details in the background. I build up several new layers of oil pastel, each protected by a coating of acrylic medium.

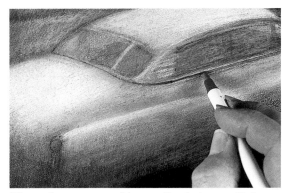

The surface now resembles an oil painting, and it is hard enough to withstand pens and pencils.

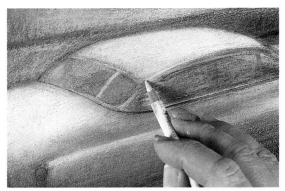

I add a few linear details with ball-point pens and colored pencils.

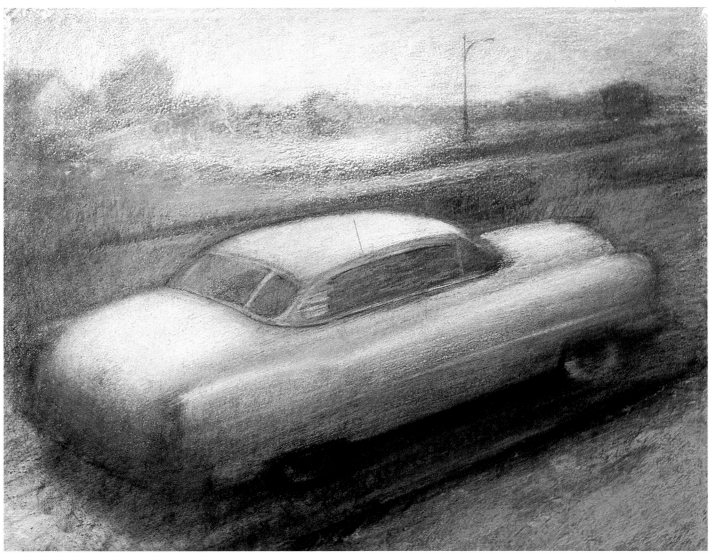

OLDSMOBILE
Oil pastel, acrylic gloss medium, pencil, and ball-point pen on gessoed canvas, 11 × 14" (28 × 36 cm). Collection of the artist.

The finished painting consists of multiple thin layers of oil pastels isolated by layers of clear acrylic medium. The oil pastels are finely rendered, and the fine linear details added with pen and colored pencil enhance the overall effect of the image.

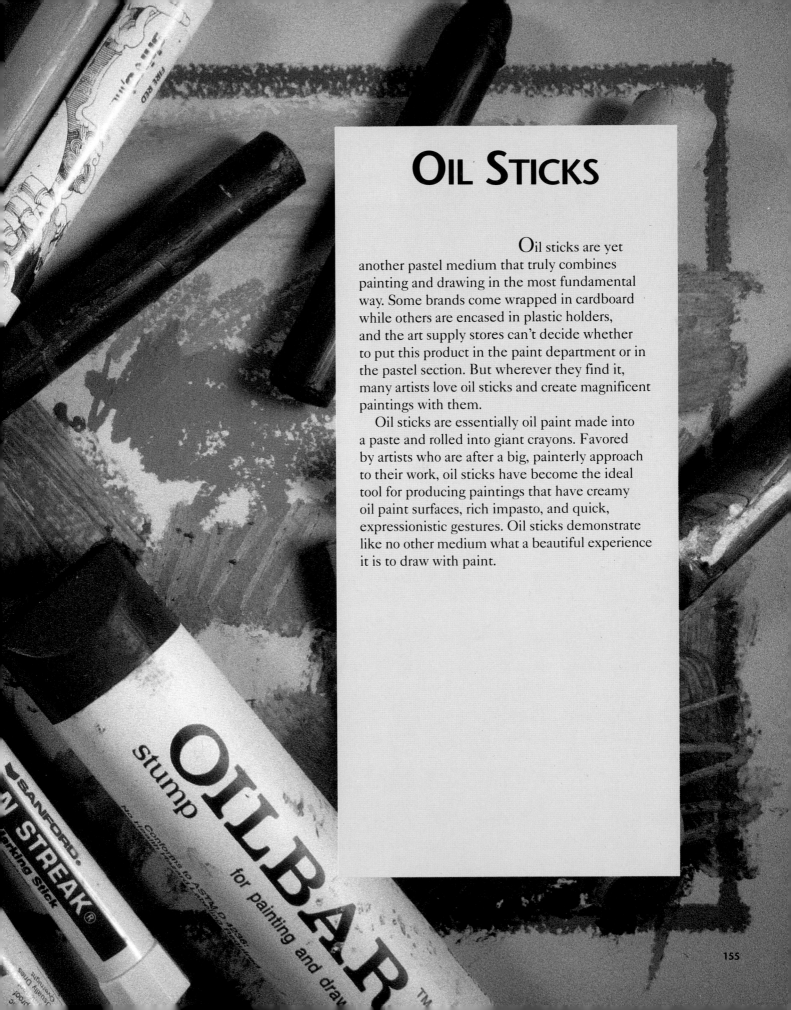

OIL STICKS

Oil sticks are yet another pastel medium that truly combines painting and drawing in the most fundamental way. Some brands come wrapped in cardboard while others are encased in plastic holders, and the art supply stores can't decide whether to put this product in the paint department or in the pastel section. But wherever they find it, many artists love oil sticks and create magnificent paintings with them.

Oil sticks are essentially oil paint made into a paste and rolled into giant crayons. Favored by artists who are after a big, painterly approach to their work, oil sticks have become the ideal tool for producing paintings that have creamy oil paint surfaces, rich impasto, and quick, expressionistic gestures. Oil sticks demonstrate like no other medium what a beautiful experience it is to draw with paint.

SUPPORTS AND HANDLING CHARACTERISTICS

This is a painting of an imaginary 1955 Cadillac Coupe de Ville. It began as a landscape in soft pastel, but certain color combinations—and the long shape of the composition—began to suggest the need for a large horizontal shape in the foreground, such as a very long American car. As the painting evolved, more and more oil sticks colors had to be worked in with the original soft pastels. These two mediums combined to form a beautiful texture and a rich, and varied surface.

Oil sticks are remarkable for their ability to adhere to almost any surface. The most common supports used are 100 percent rag paper and stretched canvas, but oil sticks work equally well on mat boards, wood panels, Masonite, vellum, and even plastic and vinyl. However, it is important to remember that most of these supports should be coated with a ground first, to protect them from any harmful effects of drying solvents and oils. This is particularly true of fibrous supports like canvas and paper, which are vulnerable to oxidizing.

The most common method of protecting supports is to coat them with acrylic gesso. Acrylic medium can also be used as a sizing, and it dries clear so that the beauty of the paper fibers is still visible. Rabbitskin glue is another, more traditional method, but many contemporary painters find this too complicated and time-consuming.

Another option is to work on papers that have been commercially prepared to resist the chemical reactions of paint solvents and oils. Two notable and easily obtainable examples are the clay-coated St. Armand's Sabertooth paper, which is especially designed for oil pastel and oil stick, and Multimedia Artboard, which has been treated with epoxy to be impregnable to anything put on it. Both of these supports need no prior preparation for oil stick.

Because of their flexibility as a drawing tool, oil sticks are used in a variety of ways. The artist can draw directly onto the support, and large, free strokes will cover a flat surface in a hurry. Oil sticks can also be combined with turpentine or oil painting mediums to blend subtle color, using wet-on-wet painting techniques.

Although oil sticks resemble giant oil pastels, there is one fundamental difference: Oil sticks dry relatively fast, leaving a hard surface that can be reworked over and over again. This firm, paintlike surface is unique among all types of pastels and gives artists the opportunity to continue working and making changes just as if they were doing an oil painting.

Once dry, completed oil stick paintings are extremely durable and can be moved with relatively little fear of the accidental smudging that plagues unframed chalk pastels. This also means that a finished oil stick painting does not necessarily have to be displayed under glass as most pastels are. For example, if you have done an oil stick painting on stretched canvas, you have the option of framing and displaying it just like an oil painting. The hard surface of a finished oil stick painting can even be worked with sandpaper to produce a special patina that resembles old frescoes.

Only a few brands of oil sticks are readily available on today's market. Each has its own characteristics, so the next few pages will discuss several different brands individually. (See pages 26-27 for a description of Oilbars, a brand of oil sticks not mentioned here.)

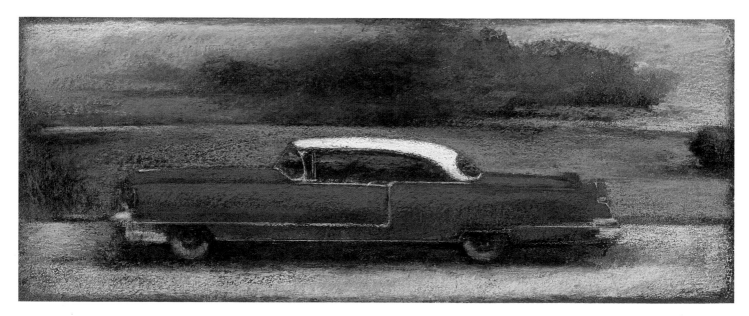

BLIMP
Oil stick on plastic,
9 × 18" (23 × 46 cm).
Collection of the artist.

*This painting,
rendered on 1/8-inch
white plastic, was
built up in layers of
Shiva Paintstiks
and Edding 650
Grafic Painters. The
colors were worked
loosely in the
beginning stages; as
these colors dried,
I used a more refined
blending approach
for the details.*

APPLE
Oil stick and mixed media
on museum board,
10 × 9" (25 × 23 cm).
Collection of the artist.

*This small still life
has a tremendous
variety of textures as
well as beautifully
glazed colors. I
built up layers of
Shiva oil sticks and
oil pastels, creating
glazes by mixing
them with Oleopasto
and Wingel. Glazing
with oil sticks is
unique because it
creates impasto
and transparency
simultaneously.*

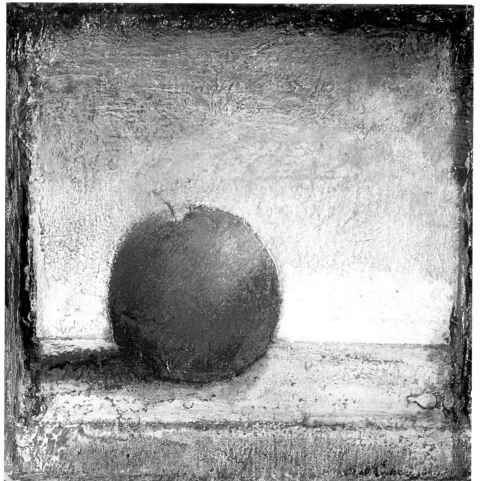

Oil sticks can be used in small pieces, not just as large crayons. In this partially finished painting, I am making side strokes with a small piece broken off of a Shiva Paintstik, just as I would use a chunk of oil pastel.

Next I use a Shiva colorless blender—a combination of wax and oil but no pigment—to blend freshly applied oil stick colors. It softens and thins the colors, making them easier to blend, and also makes them slightly more transparent. The colorless blender can also be used with oil pastels.

Since oil sticks are thick and blunt, they are not the ideal medium for making fine lines. Soft lead pencils work well for this, but use only the softest available. Pencils are also great for making incised textures and sgraffito passages.

DEMONSTRATION

This demonstration is a small sampler of a few methods and tools used in working with oil sticks. This versatile medium is soluble in turpentine and other oil painting mediums. Each brand has a slightly different consistency, but in general oil sticks handle like a combination of oil pastels and oil paint.

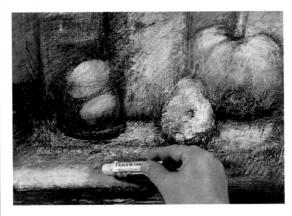

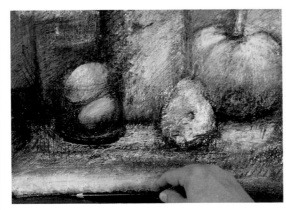

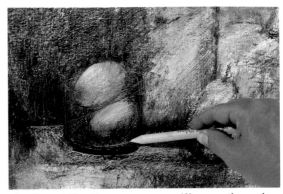

Cardboard blending stumps or tortillons can be used with oil sticks to spread and blend fresh wet color, or (as shown here) to remove color to create highlights. Palette knives can also spread or scrape away wet color. You can scrape off oil stick color with a razor whether it is wet or dry; the results are cleanest when it is wet.

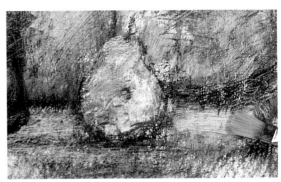

You can paint over oil stick colors with a bristle brush soaked in turpentine. Oil sticks can also be dissolved in mineral spirits or turpentine and spread as thin washes.

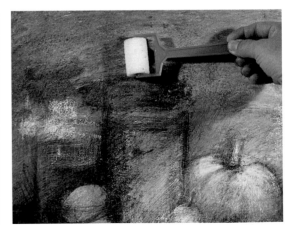

Foam rollers like this one are effective for smoothing out areas of color and can also be used to apply mediums and turpentine for subtle color blending. Small house-painting rollers are useful for smoothing out rough build-ups of heavy impasto color when oil stick is mixed with gel mediums such as Zec or Oleopasto. Paint rollers also work well with a colorless blender to soften paint strokes.

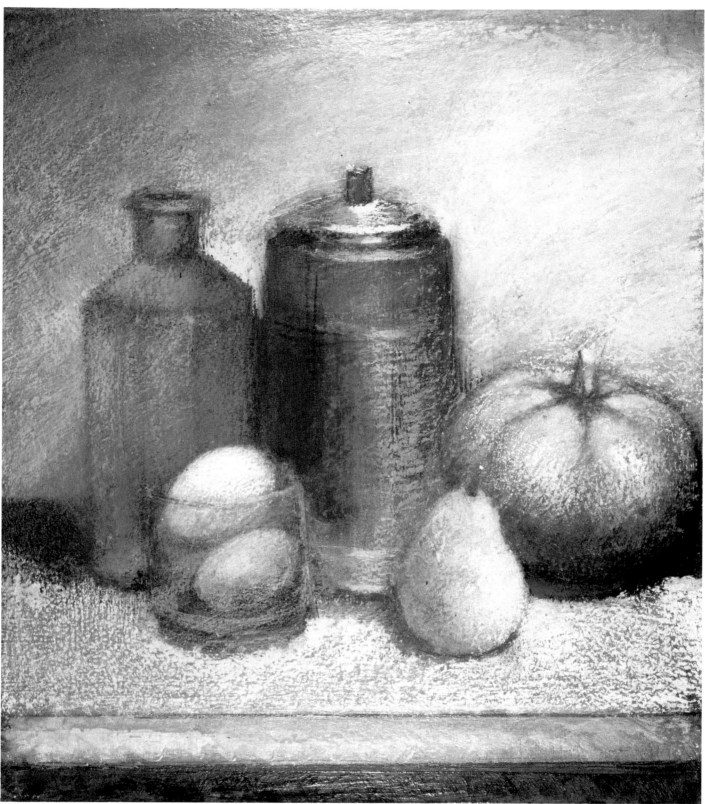

STILL LIFE
Oil stick and mixed media
on museum board,
15 × 15" (38 × 38 cm).
Collection of the artist.

To complete this painting, I've added some refinements and highlights with Edding 650 Grafic Painters, which dry quickly and are easy to control. The finished result is a still life that resembles an oil painting but was executed very much like a pastel—that is, by working many colored crayons together to create images, textures, and forms.

PAINTSTIK

Artist's Paintstik, manufactured by Shiva, is a large oil stick crayon that measures 5 1/2 inches long and 1/2 inch in diameter. Paintstiks are available in 40 colors, including silver, gold, and a new line of 12 iridescent colors. Since Paintstiks are made with oils that dry, each crayon is covered with a thin paint film that must be shaved off with a razor. Once this paint film is removed, the Paintstik spreads its color with smooth, oily strokes on almost any surface, including stretched canvas and wood panels. The colors stay wet for hours and can easily be blended with each other or with a special colorless blending stick of wax and oil.

Paintstiks can be thinned with turpentine, either by brushing a wash directly onto the painting surface or by drawing with a turpentine-dipped stick for a more fluid stroke. They can also be used with oil painting mediums and gels for interesting effects. With Grumbacher's Zec, Paintstiks produce paintings with full-bodied color and exaggerated impasto. With glossier oil mediums such as Winsor & Newton's Liquin, they achieve a more varnished look. Paintstiks are also excellent for scraping and sgraffito techniques; many artists scrape away the wet paint to expose the white support beneath. Gessoed panels and rag bristol boards are best for this kind of effect.

Although Paintstiks are wonderfully loose and flexible, they're also very likely to cause a mess if used carelessly. Always have lots of small rags or paper towels handy to wipe off the excess paint, and to clear away the film that inevitably builds up on the tips of the crayons as they're used. Also keep a small pair of scissors handy to cut the cardboard sheath around the Paintstik, which is sometimes too stiff to peel off with your fingers.

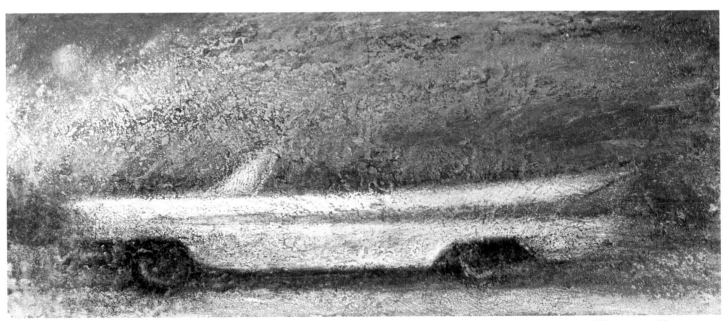

CONVERTIBLE
Oil stick on wood,
10 × 25" (25 × 64 cm).
Collection of the artist.

This painting was done with Shiva Paintstiks on a wood panel. Oil sticks work very well on hard supports such as wood, Masonite, or canvas panels. In this instance, acrylic modeling paste was also added to the panel to create a heavy texture. Silver and gold Paintstiks were used in the sky; in many cases metallic colors are more useful for portraying exotic earth tones than for representing metals.

HONEY JAR
Oil stick on wood,
10 × 10" (25 × 25 cm).
Collection of the artist.

This painting was also executed with Shiva Paintstiks on wood. Here I used Zec, a colorless oil painting medium by Grumbacher, to build up and exaggerate the ridges and impasto of the oil stick strokes.

DEMONSTRATION

The evolution of this painting shows how easy it is to start working directly with oil sticks. I first put in the basic composition with a simple monochromatic color scheme and then blocked in colors with turpentine washes before adding heavier applications of oil stick. This method allows corrections in the early stages and a gradual build-up to a thick impasto texture.

This painting is done on a handmade linen canvas panel, which has been sized with a combination of acrylic medium and modeling paste. I start with a simple outline drawing of the subject, done with phthalo green and phthalo blue Thinline Paintstiks. Both are cool transparent colors that become clear and bright when mixed with turpentine. They are great for underpaintings because they mix so well with other colors.

Next I use broad strokes to block in the drawing with large areas of Paintstik colors. I then mix these colors with turpentine washes, which fill out the painting with thin veils of color. The turpentine also accelerates the drying time, so that I can proceed after an hour or two.

I then apply fresh colors directly over the dried washes. The linen surface of the canvas panel is perfect for building up heavy impasto. I keep the color broken so that the underpainting will show through, especially in the shadows. I let the Paintstik colors dry for about a day and a half before moving on to the final stage.

TWO RABBITS
Oil stick on handmade
canvas panel,
16 × 12" (41 × 61 cm).
Collection of the artist.

*In this final stage
I'm combining
Paintstiks with
Edding 650 Grafic
Painters. Working
gently on top of the
impasto surface, I
gradually blend my
colors to create the
gently rounded
forms of the two
rabbits. The result
is a full-bodied
painting with a rich
surface and subtle
color.*

EDDING 650 GRAFIC PAINTER

This slender, beautifully designed oil stick comes encased in a disposable, airtight plastic holder that keeps its colors (and your hands) spotlessly clean—always an advantage with any pastel medium.

Grafic Painter colors are lacquer-based and unique for their absolute opacity. They remain wet long enough for them to be blended with one another, yet in less than ten minutes they dry to an enamel-like finish solid enough for a second coat of color to be applied over it, and in less than half an hour they are absolutely dry and rock-solid. No other oil stick dries so quickly. The hard, fast-drying surface, the opaque color, and the convenient design of its holder make the Grafic Painter an extremely useful tool for today's pastelist.

The soft colors of the Grafic Painter blend well with other mediums, like colored pencils and felt-tip markers. The finish is hard enough to serve as an underpainting not only for other kinds of oil sticks and oil pastels, but even for mediums as diverse as watercolor, soft pastel, oil paint, and ball-point pen. Acrylics thinned with gel medium can be glazed directly over dry Grafic Painter drawings, creating almost infinite color possibilities.

The fast-drying surface of Grafic Painters also makes it possible to build extremely interesting textured impasto surfaces. A heavily encrusted painting in this medium can closely resemble, for example, an impressionist or pointillist painting.

For all these reasons, the Edding 650 Grafic Painter is a truly amazing oil stick and possibly a forerunner of what might be coming for pastels in the near future. But despite all its advantages there are some problems. Sadly, Grafic Painters come in only 20 colors. Ideally a product this good should come in sets of 50 or 75 colors, with a few metallic and iridescent hues thrown in. Another problem is that these oil sticks are comparatively rare; they can be difficult to find in art supply stores. The Sam Flax stores carry them as a standard item, although they are sometimes out of stock; they can be ordered through the Sam Flax catalog. (See the List of Suppliers on page 172). Your local art supply dealer might be able to obtain them directly from the manufacturer, and you may even discover them in a good stationery store. But once you've found a source for these wonderful oil sticks, you'll discover that their versatility makes them almost indispensable.

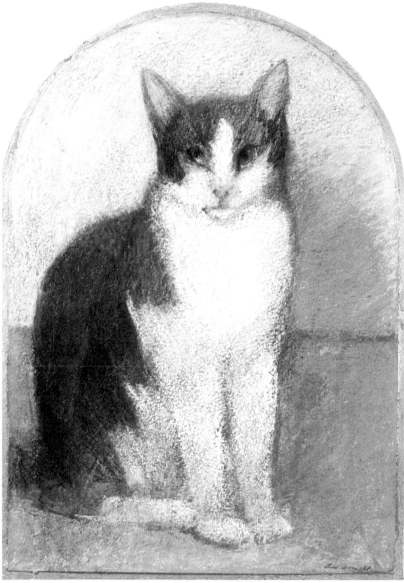

SAM
Oil stick and oil pastel on paper mounted on museum board, 12 × 8" (30 × 20 cm). Collection of Marge Lawler.

This portrait of a cat named Sam is rendered in Edding 650 Grafic Painters, with a background and edges of oil pastel. The panel was hand-cut.

SEA WATCHER
Mixed media on heavy
American etching paper,
12 × 8" (30 × 20 cm).
Collection of Mr. and
Mrs. Craig D. Ripley.
Photo by D. James Dee.

This painting is a good example of how well all forms of pastel can be blended together, if you have a consistent vision.

The essential drawing was done in pastel pencil. I then coated it with a layer of Wingel and let it dry for about 45 minutes. Next I mounted the paper to a slightly larger piece of museum board and coated the edges of the paper and board with a combination of metallic oil pastels, red Edding 650 Grafic Painter, and Wingel. The idea was to create a tarnished gold border around the painting to make it look like a panel. I then worked the painting through a series of layered mixed media, alternating between glazing on soft pastels mixed with Wingel and scumbling on coats of Edding 650 Grafic Painter. The strange dark blue along the base of the bird's tail was the result of glazing on dark blue metallic soft pastel with Wingel.

DEMONSTRATION

Edding 650 Grafic Painters are permanently dry and rock-solid in less than half an hour—a quality unique to this kind of oil stick. This allows you to add linear details over opaque color, which is difficult with most mediums.

I begin this painting with a simple sketch of the composition on a gessoed board. The colors are very simple at this stage—yellow ochre and raw umber for a warm underpainting. I am concentrating on form and space only.

Using fast, light strokes, I now work color throughout the composition. I try to stick to local colors by making the pears red and yellow, but choose complementary hues for the shadows. Edding 650 Grafic Painter colors go down soft and wet, but they dry quickly, so any blending must be done within ten minutes. One of the best tools for blending them is the common pencil eraser, available at any stationery store. Use the soft rubber tip for heavy blending and the plastic brush for lighter touches, as I am doing here.

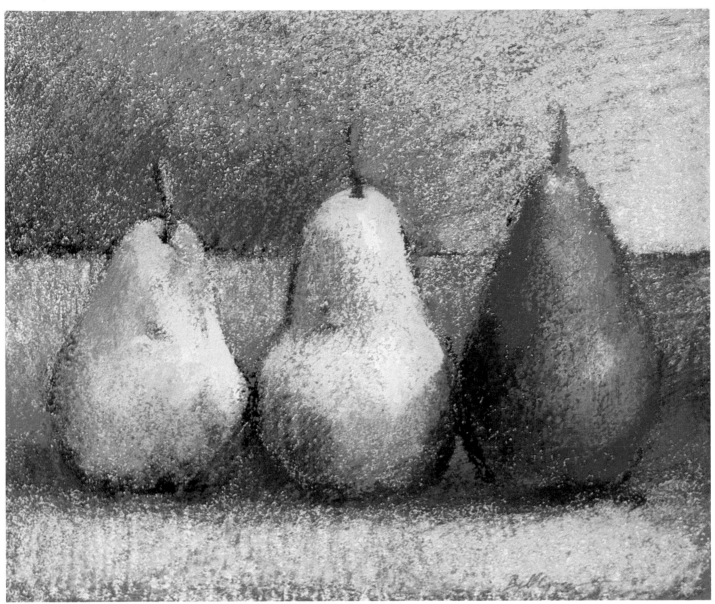

PEARS
Oil stick on gessoed board,
8 × 9 ½" (20 × 24 cm).
Private collection.

In the final stage I refine the colors of the still life. I want the colors to be strong and bright, so I build up many layers on the pears and blend them together for a polished look. By contrast I'm keeping the background relatively loose to create a sense of air surrounding the fruit. The deep cobalt blue shadow heightens the warm colors of the pears.

Oil Stick Combined with Mixed Media

If you are fond of doodling with pen and ink, you have probably wished, as I have, that you could add other mediums to a pen-and-ink drawing without completely covering the gestural lines. You might even want to pen in some linear details over a layer of color. Under most circumstances this is impossible with chalk pastel, because the pastel dust clogs the pen point. But oil stick works beautifully for adding color to a drawing done in pen and ink or felt-tip markers, and it dries to a surface hard enough so that more ink lines can be added right over it. I've also discovered that chalk pastel and oil stick can be blended into a paste that dries to a similar hard surface, over which I can then draw with pen and ink. This is a rather unusual technique, but it has tremendous appeal for me because much of my work begins as pen-and-ink drawings on paper. When one of these intimate little drawings develops into something more, I love the freedom of being able to add color with oil stick or chalk pastel, and line with pen and ink, in whatever order I choose.

To "fix" a layer of chalk pastel, I draw over it with lacquer-based oil sticks such as Grafic Painter or Sanford's Mean Streak. Mean Streak is a fast-drying, oil-soluble marker available in either white or light yellow, and it is an ideal blender for chalk pastel. Either of these types of oil stick will mix with the chalk pastel to form a paste that will dry very hard in minutes. The pastel becomes somewhat thicker and more textured than before. Once it is dry, I can either build up more pastel or draw over the hardened surface with pen and ink.

Although the oil stick does change the color of the chalk pastel a bit, giving it a strange blanched look, I find this faded, humid-looking color oddly satisfying and somewhat reminiscent of gouache or casein. Ultimately the purity of the chalk pastel colors gives me the finished results I need. And there are times when color is not as important to me as the interplay and natural flow of the combined mediums of pen and ink, chalk pastels, and lacquer-based oil sticks—an intriguing combination.

STILL LIFE WITH GOURDS
Mixed media on gessoed museum board, 11 × 14" (28 × 36 cm). Collection of the artist.

Here is an example of soft pastel mixed with Mean Streak and Edding 650 Grafic Painters. Both kinds of oil sticks were used to blend the soft pastel colors. After the mixture dries, "fixing" the soft pastel to its support, more soft pastels can be added. This combination of mediums also creates varied rough textures that are impossible to obtain with soft pastels alone.

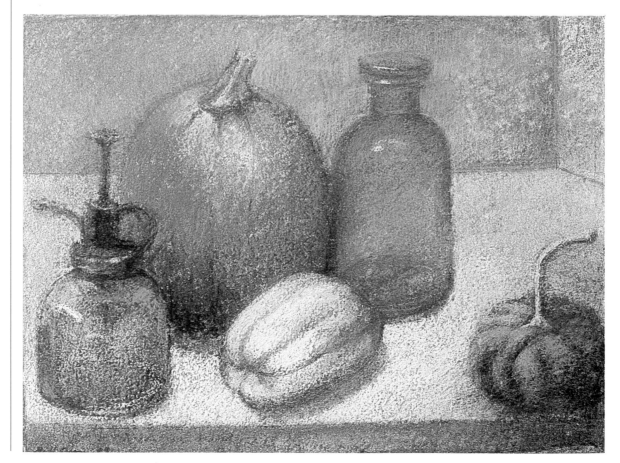

FISH
Mixed media on
drawing paper,
3 × 9" (5 × 23 cm).
Collection of the artist.

This painting combines pen and ink, soft pastel, Edding 650 Grafic Painters, and Mean Streak oil sticks. Here the pen and ink dominates the finished work.

THE VISION
Mixed media on
drawing paper,
9 × 12" (23 × 30 cm).
Collection of Allan Petrulus.
Photo by Aldo Mauro.

This began as a pen-and-ink drawing but developed into something very different by working small amounts of soft pastel across it. Highlights and atmospheric effects were created by lightly feathering the drawing with *Edding 650 Grafic Painters, which act as a strong binder for the soft pastels. When the Grafic Painters dry, they form a surface hard enough to hold more pen-and-ink passages.*

DEMONSTRATION

This painting was done with three very graphic mediums: ball-point pens, felt-tip markers, and Edding 650 Grafic Painters. These oil sticks dry very quickly without puckering the paper, and form a tough film much like illustration board. Almost anything can be drawn over it. This particular mixed media combination is ideal for achieving color with speed of execution and linear detail.

On top of this I gradually add a few colors of Grafic Painters, using a freehand doodling motion. I let the underdrawing show through, even though oil stick color now covers the entire drawing.

This small still life starts out as a cross-hatched drawing done in several colors of ball-point pens.

I continue by building up thick opaque color, using various Grafic Painters.

I now use felt-tip pens to add more detail to the flower and to give the background a cross-hatched texture. Felt-tip pens can be used almost instantly over Grafic Painters for thin lines and details.

ROSE IN VASE
Pen and ink, felt-tip markers, and oil stick on Multimedia Artboard, 11 ½ × 6" (29 × 15 cm). Collection of the artist.

The finished painting shows an interesting combination of cross-hatching, detailed pen-and-ink drawing, and opaque oil stick colors. These contrasting styles offer a wide range of textural possibilities, but can be worked together in a matter of minutes.

LIST OF SUPPLIERS

Some of the materials mentioned in this book may seem about as rare and unobtainable as the Dead Sea Scrolls. Where can you get all those imported pastels, exotic papers, and unfamiliar chemicals? In fact the supplies needed for serious pastel painting can probably be found at your local art supply store, and even in such unlikely places as stationery and five and dime stores.

If your local art supply dealer can't order what you need, try the following art supply houses. These well-known dealers have catalogs from which you can obtain just about any imaginable art supply, often at a significant discount—and shipped directly to your door.

Daniel Smith, Materials and Information for Artists, 4130 First Avenue South, Seattle, WA 98134-2302. Toll-free: (800) 426-6740. The Daniel Smith catalog is an absolute must for any artist interested in quality materials, pastels or otherwise. It is more than a source of supplies for artists; the Daniel Smith catalog brings a valuable service to artists by presenting an immensely wide range of artist's supplies at incredible prices. The items offered are of the highest quality and priced at or below list price. Whatever the quantity, the Daniel Smith store will individually wrap it and ship it.

This is a catalog that is fun and informative to read for its own sake. The materials offered for sale are often accompanied by brief illustrated commentaries and histories of the products described. And the knowledge and experience of many artists are shared throughout the catalog, so that readers somehow feel reassured that their interests and needs will be understood in a personal way.

The Daniel Smith catalog carries all the highest-quality pastels available. Pastels are sold individually and in sets, including the complete deluxe sets of such pastel brands as Schmincke and Sennelier. The Daniel Smith catalog also carries other important items for the pastelist, such as gum tragacanth and pumice grit, which is used to create a stronger tooth for pastel supports.

Pearl Paint, 308 Canal Street, New York, NY 10013. (212) 431-7932. Toll-free: (800) 221-6845. Pearl Paint is the world's largest art supply chain, with branch stores in New York and throughout the East Coast. The Pearl Paint chain offers a wide selection of high-quality artist's materials at extremely low prices through its fine art catalog. Almost anything can be obtained from the Pearl Paint catalog, including a full line of quality oil and chalk pastels and a wide assortment of papers at great prices. Pearl Paint is also the main distributor of several rare but high-quality materials, such as R&F Pigment Sticks and Chardin jumbo oil pastels. Chardins are made in France exclusively for Pearl Paint.

New York Central Art Supply Co., 62 Third Avenue, New York, NY 10003. (212) 477-0400. Toll-free: (800) 950-6111. New York Central is internationally famous for its many unusual and beautiful papers, available from its catalog. This supplier also carries a full line of the highest-quality chalk pastels and oil pastels. It is the sole distributor of several unusual pastel materials of the highest quality: Arc-en-Ciel handmade soft pastels, Townsend metallic and iridescent soft pastels, Oilbar oil sticks, and Pastelle Deluxe paper. A visit to this New York store is a wonderful experience for any serious pastel artist, but its catalog offers a great many of the store's items as well. This store prides itself on being able to obtain anything an artist needs. When calling to request a catalog, remember that the fine art papers and other art supplies are in separate catalogs, so be sure to ask for both.

Dick Blick Art Materials Catalog, Dick Blick Central, P.O. Box 1267, Galesburg, IL 61401. Toll-free: (800) 447-8192. Dick Blick is a large art supply mail-order house with four locations across the United States, whose policy is "Dick Blick Ships Quick." Choose whatever you need from the extensive catalog, and you will get fast delivery at discount prices. Dick Blick carries a number of quality pastel sets at good prices, as well as Mean Streak oil sticks.

Sam Flax, 39 West 19th Street, New York, NY 10011. (212) 620-3000. Sam Flax is another large art supply house in New York City. Its beautiful catalog offers a wide range of pastels and related materials, including the relatively rare Edding 650 Grafic Painter oil sticks.

Art Supply Warehouse, 360 Main Avenue, Norwalk, CT 06851. Toll-free: (800) 243-5038. The Art Supply Warehouse offers many quality chalk and oil pastels at tremendous discounts, with free shipping for orders over $100 anywhere in the continental United States.

INDEX

ANTIQUE AIRPLANE
Mixed media on
drawing paper,
9 × 12" (23 × 30 cm).
Collection of the artist.

Senior Editor: Candace Raney
Associate Editor: Janet Frick
Designer: Areta Buk
Graphic Production: Ellen Greene
Text set in Caslon 540